# Treasure Chests

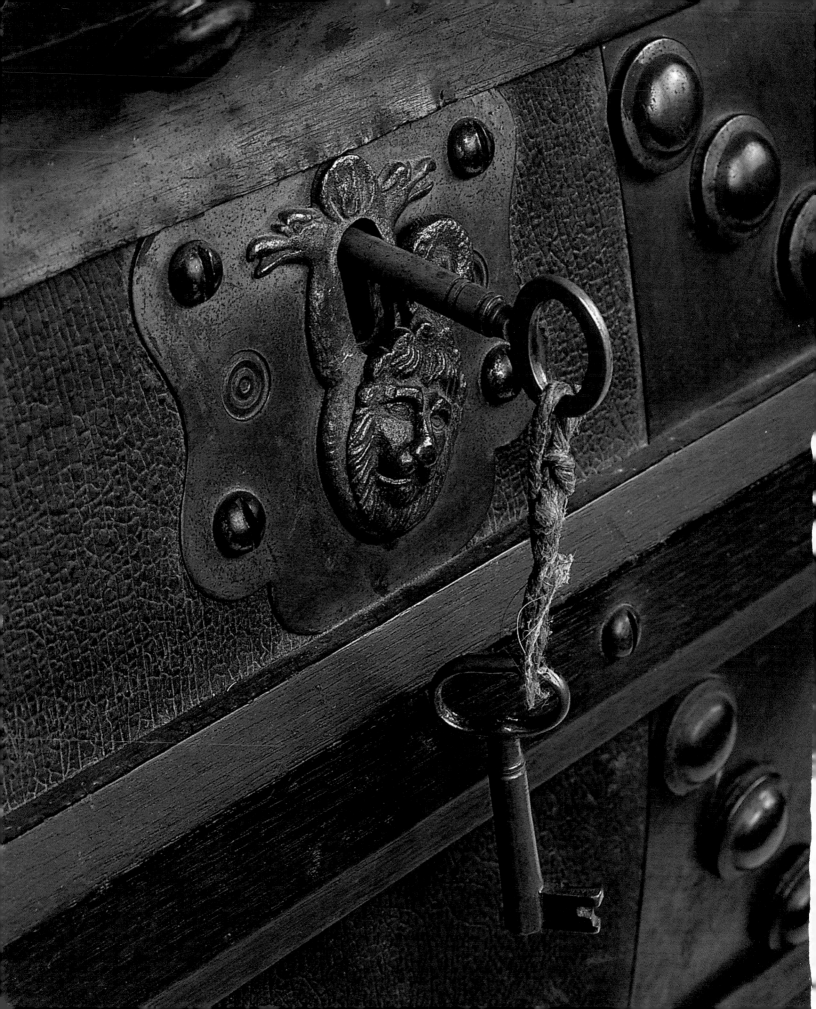

# Treasure Chests

## The Legacy of Extraordinary Boxes

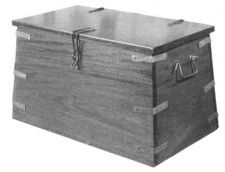

Lon Schleining

*Photographs by Randy O'Rourke*

The Taunton Press

**The Taunton Press**
Inspiration for hands-on living®

The Taunton Press, Inc., 63 South Main Street, PO Box 5506, Newtown, CT 06470-5506
e-mail: tp@taunton.com

Distributed by Publishers Group West

DESIGN AND LAYOUT: Susan Fazekas
COVER DESIGN: David Skolkin
ILLUSTRATOR: Michael Gellatly
COVER PHOTOGRAPHERS: Photos © Randy O'Rourke.

LIBRARY OF CONGRESS CATALOGING-IN-PUBLICATION DATA:
Schleining, Lon.
    Treasure chests : the legacy of extraordinary boxes / Lon Schleining ; photographs by
Randy O'Rourke.
        p. cm.
    ISBN 1-56158-362-6 hardcover
    ISBN 1-56158-651-X paperback
        1. Chests.  I. O'Rourke, Randy. II. Title.
    NK2725 .S35 2001
    749'.3--dc21                                                                    2001027387

Printed in Singapore
10 9 8 7 6 5 4 3 2 1

*Treasure Chests* was originally published in hardcover in 2001
by The Taunton Press, Inc.

*To Julianne,*
*the magic person*
*with wings on her feet.*

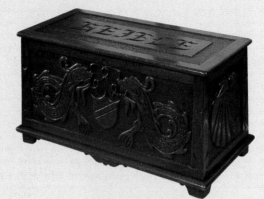

"It's not quite an antique and
not quite an heirloom, but
I have hopes that eventually
it will become both."

—Dr. King Heiple

# Acknowledgments

A PROJECT LIKE THIS pools the talents of people from museum curators to Federal Express drivers. The many people who have played a part in this project, who go unnamed below, have made their presence felt nonetheless. I thank you all, for without your energy this book would surely have remained just another harebrained idea.

Photographer Randy O'Rourke's professional, get-the-job-done attitude never wavered despite shooting in some 30 states and driving 25,000 miles in eight months and despite the author's incessant demands for yet one more shot. Stephanie O'Rourke nicely and persistently phoned ahead to set up photo shoots along the route. Son Tiernan helped set up tripods and find extension cords.

Photo researcher Barbara Scott found photos no one even knew existed.

The Smithsonian's tool specialist David Shayt really cares about the artifacts he watches over, epitomizing what a museum curator should be. The West Point Military Museum is lucky to have Walter Nock. Peter Muldoon, Smithsonian preservation specialist, has generously given his time and energy. A special thank-you goes out to the private collector who so graciously provided access to study and photograph the Studley tool chest.

Amber Okuno, Anne Smith, Cassie Berrisford, Joe Carlson, and Debbie Hughes each gave the project a great boost of energy when it needed one.

All of those at The Taunton Press whose contributions are behind the scenes deserve my appreciation, but especially Paul Roman, John Lively, Jim Childs, Paula Schlosser, Susan Fazekas, Helen Albert, Jennifer Renjilian, and Ellen Williams.

Without the support, demands, hundreds of e-mails and phone calls, hand-holding, advice, guidance, fine-tuning, and most of all friendship of Strother Purdy, you would not be holding this book in your hands.

Jon Binzen shepherded the project through its final and in some ways most difficult stages. Thank you, Jon, for your sensitivity, your patient manner, and most of all for your hard work.

My researcher, editor, organizer, courier, confidant, friend, cheerleader, and, oh yes, wife Julianne deserves the most thanks of all. No one but the author will ever know how hard she's worked on this project in addition to teaching fourth grade. Thank you, Julie.

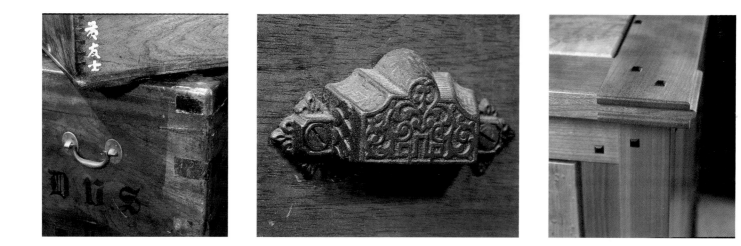

# Contents

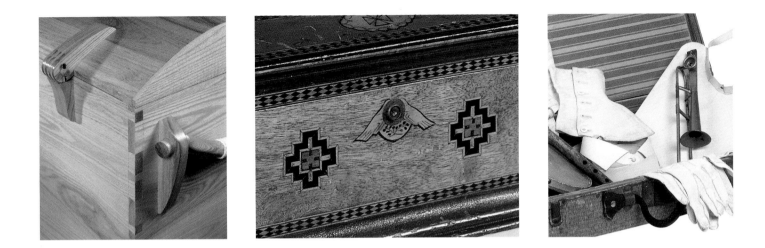

# Introduction

ON A SHELF, wrapped in a canvas bag, lies a carefully crafted cherry chest that's about four feet long. It's made with hand-cut dovetails in the corners, has a handle designed to fit my hand, and has solid-brass catches and concealed hinges. Inside, there are painstakingly designed holders to keep its precious contents clean and protected. I probably have put 40 to 50 hours into its construction so far but I'm not counting. As I acquire more gizmos to put inside, I add new partitions so they won't rattle around and ding the finish on one of my favorite possessions—my prized graphite fly rod. It's one of the prettiest things I've ever had in my hands, a deep chocolate color that looks black until you get it out in the sun.

There's something wonderful about having my fly rod and reel safely tucked away in a chest custom-built just for that purpose. Even though I don't get it out much, I know it's safe. Making the chest for it continues to be great fun, but doing so for such an impractical purpose somehow makes it even better. In fact, it's surely more impractical even than you think. I've never been fly-fishing in my life.

Chests, no matter how humble, always seem to have a story. My fly-rod chest speaks of my reverence for the rod and my other gizmos. My mother's hope chest, originally a humble apple crate housing the linens her mother painstakingly made her during the Great Depression, hints at a dedication to tradition, even if a traditional chest was out of reach. My mother later got a more traditional hope chest, but that apple crate served its purpose, treasuring her precious gifts for her future home.

In the summer of 1998, I proposed a book on chests as part of The Taunton Press' furniture series. *Fine Woodworking* magazine ran a small ad to solicit contributions from readers. The mail started pouring in, sometimes 100 responses a week! In addition, I tapped friends, family, students, neighbors, and anyone who would listen for leads about interesting chests. In the process, we discovered that nearly everyone has a chest or two with an interesting story. If not,

they know someone who does. Of contributions from woodworkers who saw the ad, there were enough beautiful and intriguing chests to fill at least another book by themselves.

Traveling around the country teaching seminars, I sought out chests at museums in different cities and followed leads wherever they led, meeting curators and in general feeling like Cinderella at the ball. I quickly discovered I could have written the whole book just on chests at the Smithsonian. It was overwhelming.

Not a day goes by, even now that the book is finished, when I don't get a new lead on some fabulous chest. No doubt everyone reading this knows of a piece that should be on these pages. The task, after finding the chests, was to narrow the field of inclusion—a matter of making difficult choices.

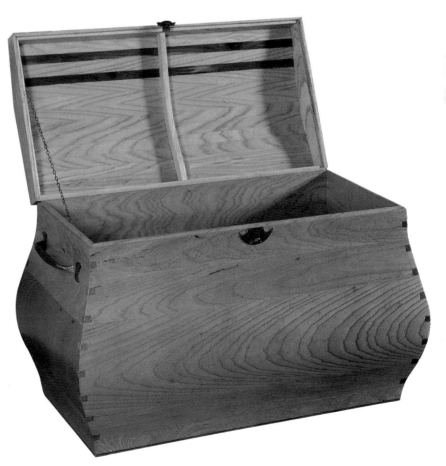

Having chapters with chests used for different, rather broad purposes seemed the most logical way to organize the various chests, although we got enough blanket chest contributions to write an entire book on that category alone. Telling the stories of the chests—how they were acquired, who owned them—presented only part of what they had to say. How they were constructed, the materials they were made from, the purposes they served, how they survived for hundreds and sometimes thousands of years— these details made for rich stories.

The three years I've spent making this book have been a great adventure. The chests, in telling their stories, reveal stories of people, and it's the people who've contributed along the way who have made this project so rewarding. My fly-rod chest holds not only my fishing rod itself but also my daydreams of fly-fishing in the High Sierra. The chests on these pages connect with people and often hold, in addition to precious items, reflections of dreams past, present, and future.

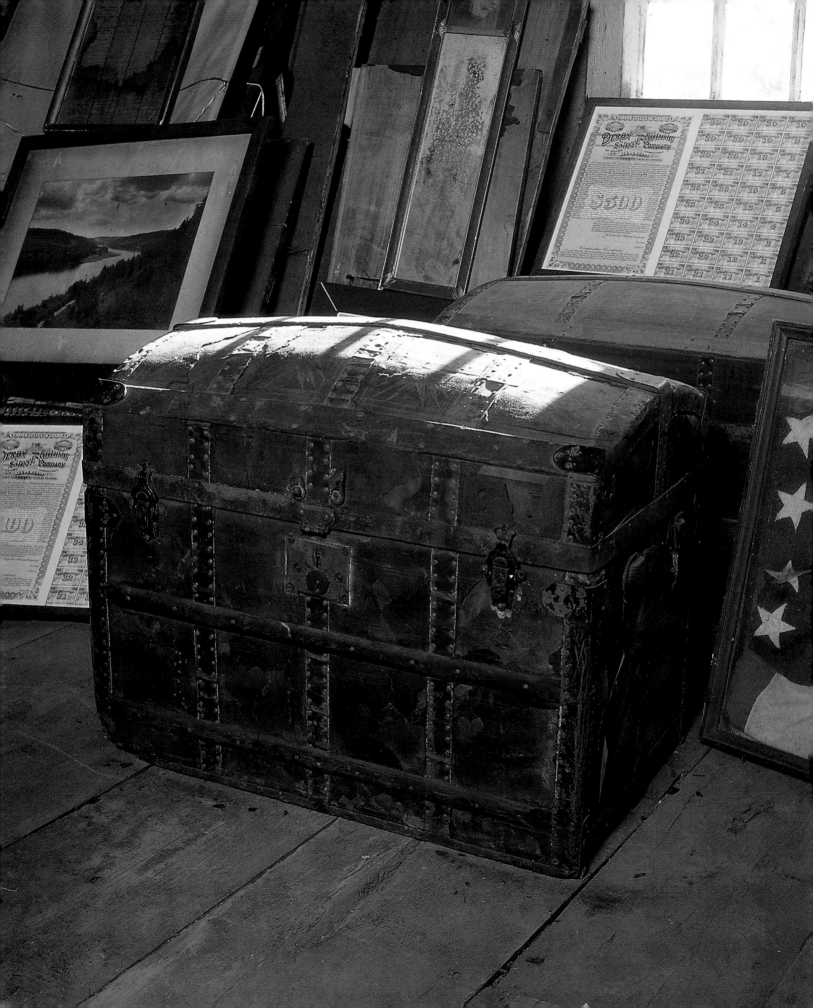

# The Legacy of Extraordinary Chests

ANCESTOR OF THE SAFE, PRECURSOR of the closet, the chest is perhaps the most universal and enduring form of furniture.

Chests are found from one end of human history to the other. Exquisite chests of ebony, cedar, and ivory were stacked in King Tutankhamen's tomb to accompany him in the afterlife. Officers in Caesar's well-traveled Roman armies carried their belongings in wooden chests. In Japan, where for centuries little other furniture was used, tansu chests were made in many forms. And when the Mayflower landed at Plymouth Rock in 1620, chests accounted for nearly all the furniture in her hold. As for today, well, look around your house and you will doubtless find somewhere a chest for tools or blankets, finery or firewood.

Much has happened to the chest between Tut's time and ours—a million variations in its size, shape, structure, and materials. The one constant has been our need for it; the need for a place to store the things we value.

*Chests hold history* **along with their more tangible contents. They can provide a link to distant places, to obscure professions, and to historical figures and events. The trunk on the facing page was used by American soldiers in World War I.**

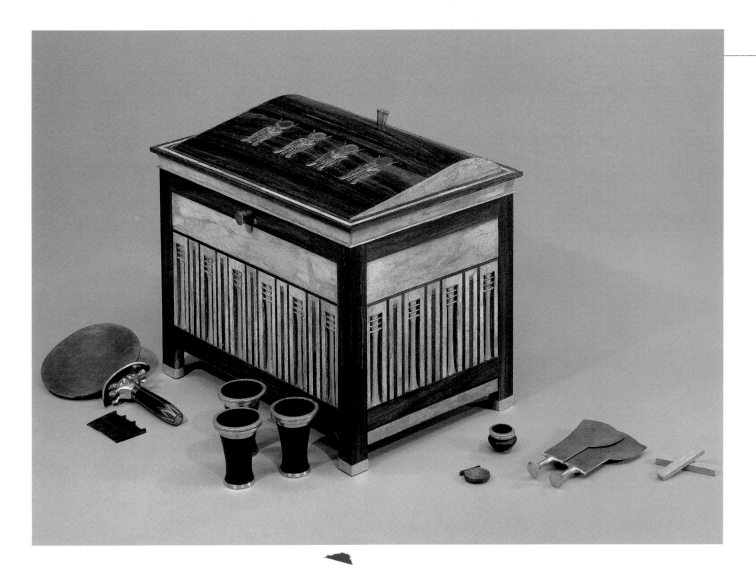

*Chests have been with us throughout recorded history, as this 3,000-year-old Egyptian cosmetics chest demonstrates. Chests for a range of functions in a wide variety of sizes and shapes were found in the tombs of the pharaohs.*

# The Spectrum of Chests

So what is a chest? The short answer is a large storage box with a lid. The long answer, spelled out in the scores of examples in this book, suggests that a chest can be made of anything from cardboard to solid aluminum; it can be straight sided or beautifully curvy; and it can be too big and heavy to lift without a team of assistants or small and light enough to rest comfortably in your lap.

Storage and safekeeping are the two main functions of the chest. In the years before the first safes were built, there was no better place to protect one's treasures than in a chest. Medieval chests for valuables were often made of such thick timbers and on such a scale that they were virtually unmovable. And some were trussed up with iron strapping until there was sometimes more iron than wood in view. In the centuries since, chests for security have been built to protect everything from stolen treasure to diplomatic messages and from love letters to moon rocks.

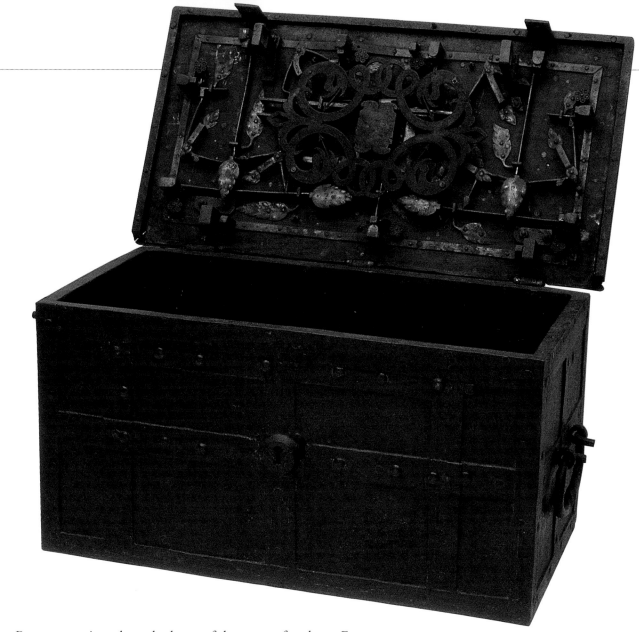

Pure storage is perhaps the heart of the matter for chests. For many years, in the days before closets and cabinets, chests were the only available form of domestic storage. They were made simply and generally offered a single, undivided storage area inside. This worked well for storing large items such as blankets but couldn't have been convenient for clothes, dishes, tools, and the many other small things that accumulate in a household. With nothing else available, people made do. As more specialized forms of chests evolved, the original undivided chest was reserved for blankets, quilts, and other large items used seasonally.

Transport is another key function of chests. Until the advent of lighter forms of luggage in the 19th century, wooden chests were the best way to get your belongings from here to there. From medieval times, travel chests were made with domed lids to shed water and were often sheathed in leather. Domed lids persisted in many types of travel chests, from sailors'

*Chests were the first safes.* **Early wooden chests were often made at enormous size to deter removal and were bound with iron strapping. This solid-iron 18th-century strongbox takes the next step toward the modern safe, employing a complex lock beneath its lid.**

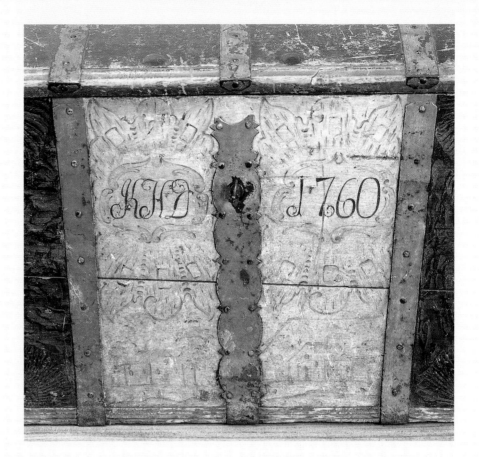

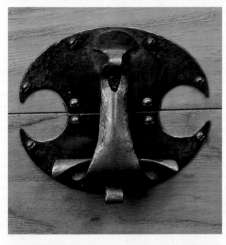

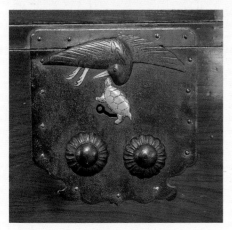

# LOCK IT UP

For as long as people have been making chests, they have been devising ways to keep other people out of them. Chests were the precursors of safes, and safeguarding valuables is still the primary function of many chests. A chest is only as secure as its lock, so a great deal of ingenuity has been directed toward making locks impregnable.

But even in chests intended to store nothing more valuable than blankets, the lock is often a visual centerpiece. The lock escutcheon—the metal plate through which the key is inserted—is often the most decorative metalwork on a chest. Sometimes it is the only metalwork. Some of the most beautiful locks are found on Japanese tansu chests, in which plain woodwork often serves as a backdrop for virtuoso metalwork (see the top and bottom photos at left).

Most locking chests have integral locks, which are locks with only a keyhole and escutcheon showing on the outside of the chest. The alternative is to use a padlock and hasp. An integral lock is generally a more elegant alternative, but padlocks are powerful and the hasps for them can be beautifully wrought. ▪

chests to stagecoach chests and some steamer trunks. The domed lid had an additional advantage—when chests were stacked for transport, the chest with a domed lid wound up at the top of the stack rather than at the bottom. Such lids are also found on other types of chests—Scandinavian marriage chests are an example—where the curved lid is clearly made more for the eye than for the weather.

In addition to serving these universal functions of storage, safekeeping, and travel, chests have been designed and modified to serve all sorts of specialized functions. Many trades and professions—from shoemaking to medicine—have modified the basic chest to suit their needs by shrinking it, expanding it, dividing up the interior, and adding trays, tills, and closed compartments so their tools and materials would be easily accessible.

*Carrying a traveler's belongings* was for many centuries one of the primary functions for which wooden chests were built. This Spanish Renaissance-style oak traveler's chest was the 17th-century version of Samsonite.

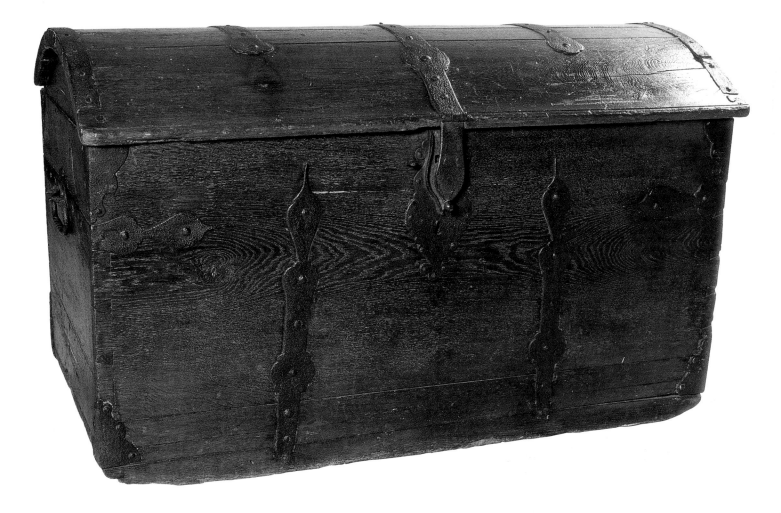

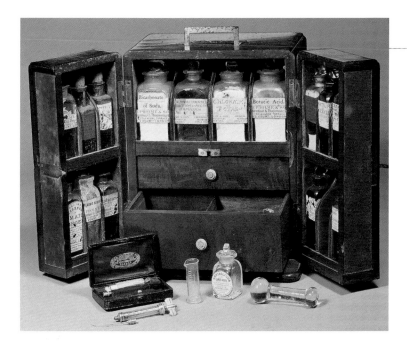

*Endlessly adaptable,* the basic chest has been customized to carry the goods for any number of professions. This cleverly compact 19th-century English medical chest was built to hold bottles of drugs, syringes, and other medical equipment.

And then there are the functions so specialized that you might never have imagined there would be a specific chest to serve them. These specialized chests indicate the flexibility of the form; the word chest may conjure up an image of a blanket chest or a pirate's chest, but the term belongs just as much to a beautiful Dutch traveling cabinet (see the photo at right) or to a solid-aluminum container for moon rocks.

## Evolution of the Chest

Perhaps evolution is the wrong word. The story of furniture has often proceeded in a series of meanders rather than in a steady spiral of progress. Some of the oldest chests known—those found in the tombs of ancient Egyptian pharaohs—are also some of the most sophisticated. Four thousand years ago, Egyptian craftsmen were using dovetails, mortise-and-tenon joints, frame-and-panel construction, inlay, veneers, hinges, and drawers; the state of the art of the ancient Egyptian chest is not far removed from the state of the art today.

The Greeks and Romans, too, judging by the record left on vases, in carved scenes, and in writing, had a sophistication equivalent to the Egyptians in furniture-making design and technique. As the Egyptians had, Greek and Roman craftsmen applied their skills to a wide range of furniture types, from beds and chairs to stools and tables as well as to chests.

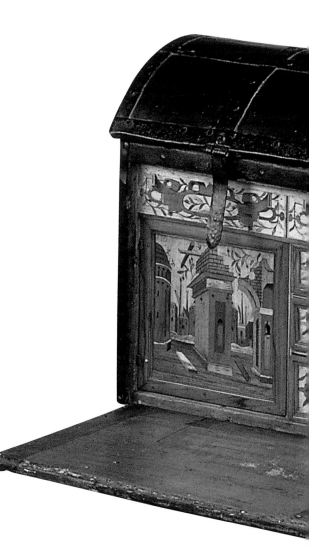

But in the centuries of political and social upheaval that followed the decline of the Roman Empire in the 4th century A.D., much of what had been learned and passed down about furniture making was lost. Throughout the early Middle Ages, Europeans seem to have lived with only the crudest furniture. And then, in the first stirrings of the dormant craft, chests began to appear once again.

A good number of medieval chests survive in ancient churches, which had them built to safeguard their records, vestments, and other valuables. Some early medieval chests are as crude as woodworking gets: A chest was simply a hollowed-out log that was hewn roughly square on the outside and fitted with a lid.

*Fine work from ancient Egypt* **rivals the best chests built anytime since. Egyptian craftsmen employed nearly the entire range of techniques used by fine cabinetmakers today. This chest was made to hold a scribe's equipment.**

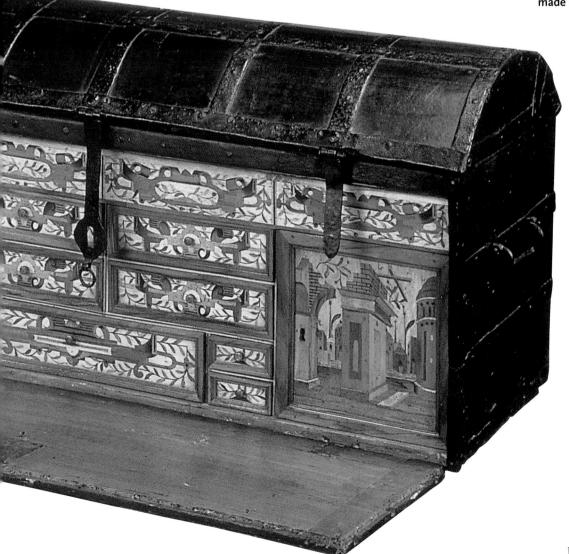

*A beautiful hybrid,* **this Dutch traveling cabinet expresses the versatility of the chest form. With complex marquetry on its drawers and doors, it marries fine cabinetmaking with stout trunk making.**

In English churches, some 11th- and 12th-century plank chests can still be found, in which thick, rough boards were nailed together to form large, cofferlike chests. The thick boards invariably warped and split, so metal strapping was added to make the chests safer from vandalism and less likely to fall apart at the joints.

Over the next few centuries, the joinery in these coffers remained rudimentary, but the chests received increasingly fine decoration in various forms—many were extensively carved, others were painted, and some, in the medieval custom, were draped with tapestries or fabrics. And nearly all of them featured ironwork, from utilitarian hinges, braces, and handles to highly artistic strapping that in some cases covered much of the chest.

During the Renaissance in the 15th and 16th centuries, furniture, like art and music, evolved quickly. Renaissance craftsmen rediscovered construction methods lost for centuries. Chests were made with dovetailed corners or with frame-and-panel construction, two approaches to structure that greatly improved chests' strength and were so well suited to the chest that they are both still employed today.

In the centuries since, chests have been made in a blizzard of styles for many purposes, but the basic construction of the solid-wood chest has remained fairly constant.

## Higher forms evolve

Chests served for centuries as the only form of closed storage furniture.

## HINGES: PIVOTAL HARDWARE

*Strap hinges* Perfectly suited for chests, strap hinges have long leaves that spread the load a heavy lid exerts. Because the load is distributed across a wide area, strap hinges greatly reduce the chances that hinge screws will pull out.

*Butt hinges* Butt hinges are common as well on all but the largest chests. Normally installed in pairs, butt hinges are mortised into mating surfaces. On chests, the hinge is typically only as wide as the thickness of the chest's back.

*Piano hinges* Piano hinges are typically cut to the full length of the two parts to be hinged. This provides great strength by distributing the load evenly along the entire hinge. Attached with screws every inch or so, the piano hinge also resists any warping in the lid of a chest.

*Pinned-cleat hinges* Developed particularly for chests, the pinned-cleat hinge takes advantage of the cleats, or battens, attached to the underside of solid-wood lids to keep them flat. The pinned-cleat hinge uses no metal. Wooden pivot pins are inserted in holes drilled through the cleats and the chest's sides. ▪

But with the resurgence in skills among furniture makers and the growth of the merchant class in the 15th through 18th centuries, other more specialized forms of storage furniture began to evolve.

Earliest among them was the wardrobe, or armoire. Essentially a chest stood on end, it was used as a freestanding closet. Once the body of the chest had been stood upright and fitted with doors, it spawned all manner of cabinets for food, plates, and other household goods.

Then came the chest of drawers. In America, it appeared in the 17th century. The earliest American immigrants stored their clothes in lidded chests. Fifty years or so after the arrival of the Mayflower, someone thought to build a chest with a drawer at the bottom, which made better use of the lower regions of the chest. Before long, lidded chests with two drawers

*A bright light in the Dark Ages,* **this Spanish chest with its carved ivory panels represents work of an extraordinary caliber for its time. It was built around 1050, when very little craftsmanship of this quality was evident in Europe.**

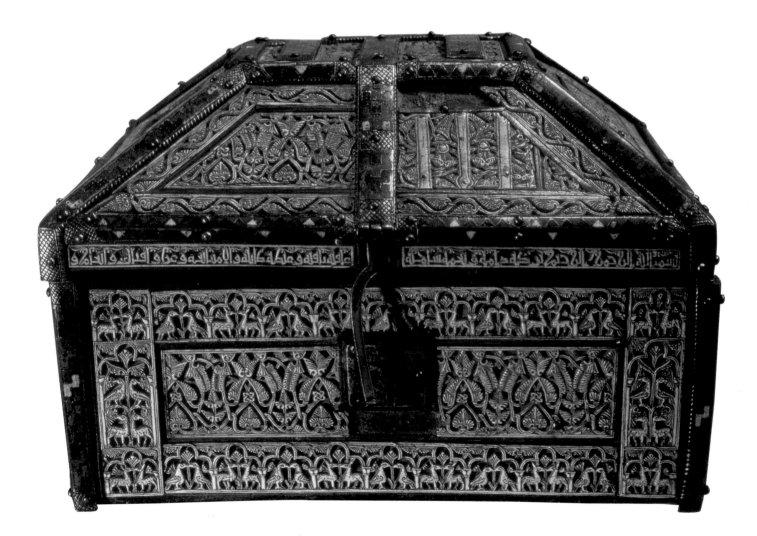

*The first stirrings* of the chest of drawers in America were seen in the 17th century. Cabinetmakers first added a single drawer at the bottom of the lidded chest, then two drawers, then three. This Hadley-style chest was made near Deerfield, Massachusetts, in the early 18th century.

appeared, then three, and by 1700, the lid vanished in some versions and the chest was full of drawers.

The 18th century, thought by many to be the golden age of furniture, brought a profusion of new and sophisticated forms that traced their earliest roots to the humble chest. The chest-on-frame, the chest-on-chest, and the secretary all were introduced and built with remarkable skill in this period, bringing luster to names such as Chippendale and Queen Anne.

When the Industrial Revolution introduced mechanization to woodworking, many operations previously done with only semiskilled labor, such as hand-sawing logs into planks, became obsolete. Jobs previously performed exclusively by experienced hands—carving, joinery, turning—were suddenly being handled by unskilled workmen simply loading parts into a machine.

Chests continue to evolve as materials and machinery change the way in which they can be made. Plywood is a perfect material for utility tool chests. Routers and biscuit machines have revolutionized certain kinds of joinery. It's not that a traditional, solid-wood chest made entirely by hand will ever go out of favor, it's just that these newer materials and methods make building something like this accessible to a larger cross section of people.

## Essential Forms of the Wooden Chest

Many materials have been used to make chests—from stone to steel, with side trips through leather, plastic, and cane—but wood is the preeminent one. It is a marvelous material that perfectly suits the chest. Readily available in most countries, it is easily worked with simple tools and accepts all sorts of decoration—relief carving, surface carving, inlay, staining and painting,

stamping, pickling, ebonizing, marquetry, parquetry, and distressing—but with its infinite natural variations of color, texture, and grain, it also looks fine if left entirely alone.

The pleasures of working wood are available to the beginner but never seem to pale even for the most accomplished craftsman. It can, with equal success and satisfaction, be hammered together with nails or joined with precisely fitting dovetails. Perhaps most important, wood is as appealing to the user as to the maker of the chest. Other materials have their advantages—steel with its security, plastic with its lightness and moldability—but if you're going to live with the chest for long, you want it to be wood.

Wood is not infinitely amenable, however. It has one character trait that a craftsman must always bear in mind: It moves with the seasons (see the sidebar on p 16). When humidity rises, wood swells; when humidity falls, wood shrinks. From the dampest month to the driest, the top of a dining table might shrink and swell as much as $1/4$ in. across its width. (Due to wood's cellular makeup, this expansion and contraction takes place almost solely across the grain, so the seasonal change in the table's length would be negligible.)

This one characteristic of wood drives the design (or the destruction) of nearly everything made from it. The three main types of solid-wood chests—the six-board chest, the dovetailed chest, and the frame-and-panel chest—contend with wood movement in different ways and with varying degrees of success.

## Six-board chests

The simplest type of solid-wood chest is made with six planks nailed together: four planks for the sides, one for the bottom, and one for the lid. At first, these chests were made without feet (or had separate feet added) and with the grain of the end planks run-

## NAILS AND SCREWS

Nails, the universal solution to holding wood together, go back 3,000 years, but until the industrial age, nails had to be made by hand one by one, a very time-consuming and expensive process. Nails are also not the best way to hold chests together for the long haul. Seasonal wood movement enlarges the nail holes, and eventually the connection of the nailed parts weakens. If a box is to be strong enough to hold prized possessions, it needs a strong, permanent connection.

Wood screws, which originated in the 16th century, might seem to be the answer. The thread of a screw bites into the wood, giving it more purchase and a stronger connection. But this advantage can also be a problem. If wood is pinned together too strongly, it may crack or split when it expands or contracts in response to moisture changes. Even nails can create this problem, which is why so many nailed chests split.

Although nails and screws have their place in furniture construction, their use must be planned in conjunction with the natural movement of wood rather than fighting against it. ■

# Wood Moves

Strong and attractive, easily obtained and easily worked, wood is prime material for making chests. But wood does have one nettlesome characteristic: It moves. Anything made of wood must account for this or risk breaking apart.

*Wood moves with the seasons, expanding in humid weather, shrinking when the air is dry.*

*A plank of wood will swell and shrink in width and thickness.*

*The length of a plank remains virtually constant.*

Even after it has been cut into boards and kiln-dried, wood remains hygroscopic: Like a sponge, it takes on moisture from the atmosphere in humid weather and loses it in drier times. Wood expands when it takes on water (hence the door sticks in sticky weather) and shrinks when it loses water. The hydraulic force this can create is astonishing. One demonstration of this is found in quarrying, where enormous stone blocks are sometimes split using the force of water in wood. A line of holes is drilled in the rock, plugs of wood are pushed down into the holes, and water is poured into the holes. When the wood absorbs the water and expands, the rock splits in two.

Seasonal movement takes place almost exclusively across the grain of the wood. Wood has cells that are long, thin, and hollow like a bundle of drinking straws. As the cells absorb and release water they grow and shrink in diameter but not in length. A plank of wood, therefore, will grow and shrink in width and thickness through the seasons, but the change in its length will be negligible.

ning horizontally—the same direction as the grain of the front and back planks. To add feet in the simplest way possible, chest makers developed a design in which the end planks extend downward and serve to raise the chest off the floor.

In solving one problem, however, this design created another. To make the footed end panels, chest makers turned the end plank 90 degrees, so its grain was oriented vertically—perpendicular to the grain in the front and back planks of the chest. The chest was now designed with cross-grain construction, a recipe for disaster. The end panels, if tightly secured to the front and back, would serve to resist their expansion and contraction.

Many chests built in this manner (and many cabinets built the same way) bear evidence of this unwinnable tug-of-war, with planks that have split or joints that have failed. The impact of this cross-grain problem is reduced in some chests, such as the one shown in the sidebar on p. 18, by making the joints less rather than more secure. If the parts are joined with just a few nails, the nails may be able to give enough to permit the panels to move with the seasons and thereby prevent cracking.

## Dovetailed chests

The dovetail joint is named for its resemblance to the modestly tapered tail of a dove, and that taper is the key to the dovetail joint's great strength. Essentially a variation on the finger joint, the dovetail combines the excellent long grain-to-long grain glue surface of the finger joint with mechanical resistance to being disassembled. Unlike the finger joint, which, before being glued together, can be pulled apart in any number of directions, the dovetail joint will only oblige if it is pulled perfectly perpendicular.

Dovetails give craftsmen a way to make a plank chest that is not only supremely strong but also resists warping, accommodates wood movement, and is very attractive to boot. To make a dovetailed chest, the end planks, like the front and back planks, are oriented with their grain running horizontally. The pins and tails of the dovetails interlock at the corners, creating a joint with excellent structural redundancy, one that if properly cut will even hold together without glue or fasteners. But this joint provides so much excellent gluing surface that when glued together, it renders a piece practically indestructible.

Dovetailing resurfaced in the 15th century and quickly became the joinery of choice on a wide range of chests. Although it takes some care to cut precise dovetails, a dovetailed chest is considerably quicker to make than a frame-and-panel chest. With its full-thickness planks, the dovetailed chest is also harder to break into, easier to clean, and less prone to damage in transit. It quickly became standard construction for any boxes that would see hard or heavy use—for seamen, craftsmen, and travelers.

As other forms of furniture such as bureaus, armoires, and various types of cabinets developed from chests, many of them were also made with this sturdy and handsome joint.

## A SIMPLE SIX-BOARD CHEST

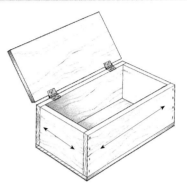

*The grain runs horizontally on all four sides.*

## 18TH-CENTURY SIX-BOARD CHEST WITH FEET

Cleats keep the lid flat.

Strap hinge

Grain direction

Grain direction

Rabbet joints add stability.

## A DOVETAIL CHEST

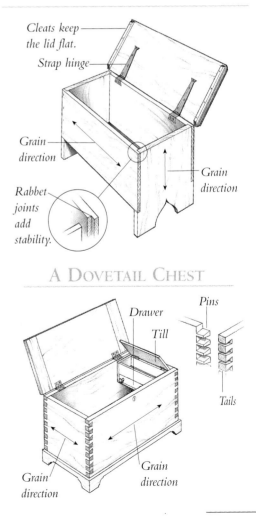

Drawer

Till

Pins

Tails

Grain direction

Grain direction

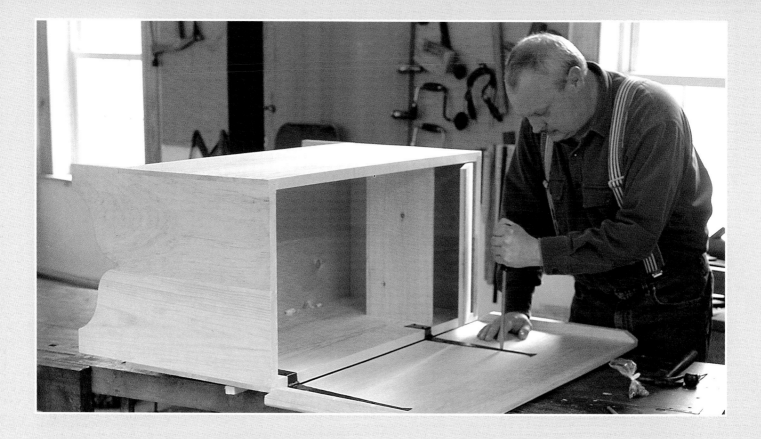

# Six-Board Construction

The six-board chest Michael Dunbar is building in these photos is made from a design common in the late 17th and early 18th centuries (see the center drawing on p. 17). The design copes with its cross-grain construction in an interesting way. Rather than attempting to constrain the inevitable movement of the front and back panels, it is built to accommodate it to some extent. The front and back panels are notched, or rabbeted, at either end to accept the end panels. The chest is then nailed together with the nails spaced widely apart. Because the nails are few in number, they give slightly, allowing the front and back panels to move. The rabbets act as a stop, providing structural integrity. ■

## Frame-and-panel chests

Frame-and-panel construction is a very clever solution to the problems created by wood movement. A frame-and-panel structure is strong, light, less wasteful of precious wide boards, and, best of all, greatly reduces the impact of wood movement. It does this by isolating wide panels of wood within a framework of narrow pieces (called rails and stiles), which are firmly joined at their ends. The panels are set into grooves in the framework, but the panels are not glued or fixed in place—the grooves are cut extra deep and the panels are permitted to float, expanding and contracting with the seasons without affecting the rest of the structure. For a fine example of the concept, look no further than the nearest solid-wood door.

In Europe in the 15th century, frame-and-panel construction was adopted for everything from wainscoting to stools, chairs, doors, beds, and, of course, chests. After a century-long vogue of the style, chairs and stools reverted to styles more suited to their sculptural form, but for paneling, cabinets, and chests, the frame-and-panel technique never lost its value.

## A FRAME-AND-PANEL CHEST

*Frame-and-panel construction controls wood movement by permitting wide panels to expand and contract with stable frames.*

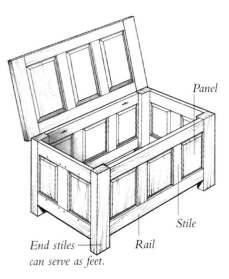

Panel

Stile

End stiles can serve as feet.

Rail

## THE MORTISE AND TENON

The mortise and tenon, like the dovetail, is one of the fundamental methods of joining two pieces of solid wood. Mortise-and-tenon joints are typically used to join parts of a frame structure—the rails and stiles of a door or chest, the arms and legs of a chair, the rails and legs of a bed. The tenon, which can be flat sided or round, is the male half of the joint, and it is held in a corresponding mortise with glue, transverse pegs, or both. The key to the joint from a structural point of view is the shoulder on the tenon. The tenon is driven into the mortise until the shoulder contacts the mortised workpiece. It is this contact that gives the joint its resistance to distortion. ■

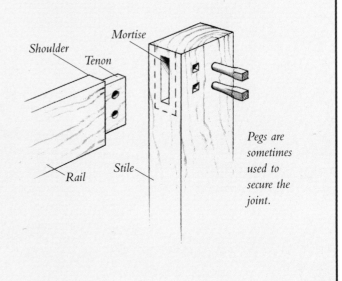

Shoulder

Mortise

Tenon

Rail

Stile

Pegs are sometimes used to secure the joint.

# FRAME-AND-PANEL CONSTRUCTION

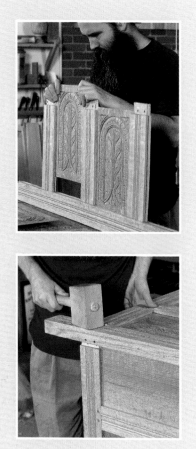

**F**rame-and-panel chests such as this one being made by Peter Follansbee were the state of the cabinetmaker's art in the first years after the Mayflower landed at Plymouth Rock. But the advantages of frame-and-panel—its strength, economy of materials, the way it copes with wood movement, and its visual appeal—are just as attractive today, as witnessed by the many contemporary chests shown in this book that use the system.

Each side of the chest is composed of narrow boards called rails and stiles that are joined to form a frame. The rails and stiles are grooved on the inside edge to accept a panel. In the top photo at left, Follansbee drops a carved panel into place between two stiles. In the bottom photo at left, he taps home the tenons joining the front to one side of his 1620s reproduction chest. ■

Frame-and-panel construction changed chests visually as well as structurally. Where the plank chest presented an unlimited canvas for decoration, the frame-and-panel chest broke up the surface into a series of smaller panels. This provided even entirely unadorned chests with a new level of visual interest. The chest maker could create symmetry, rhythm, and texture without ever picking up a carving tool or paintbrush—the structure alone could be the design. And the panels created a grid within which carving and painting appeared even stronger. The unusual power of the frames was soon felt even on plank chests, where carvers and painters began working faux panels into what were in fact solid planks.

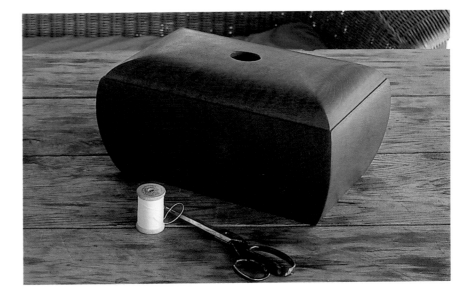

### Beyond wood

As various manmade materials have become available, the options for building chests have increased. Plywood and medium-density fiberboard (MDF), for example, which have none of the expansion and contraction problems of solid wood, offer excellent surfaces for veneering while also allowing for simpler joinery and therefore faster construction.

## The Treasure in the Chest

The words treasure chest may conjure up an image of an old wooden trunk brimming with gold bars, but when you look across all the different ways chests have been built and the purposes and people they've served, it becomes clear that the real treasure is often not a chest's contents but the chest itself.

In some chests, the very materials or methods they're made with constitute the treasure. Wood from a rare tree or from a tree cut on family property, a fine set of dovetails, or some particularly expressive ironwork are all things that can bestow value on a chest. In other cases, a historical connection elevates the status of the chest. Thomas Jefferson's lap desk and the tea chests tossed overboard in the Boston Tea Party are both chests that would receive scant notice if not for their presence at a critical event in our history.

But some of the most valuable chests, perhaps, are also the most prevalent. These are chests with a family history. Whether made by a father, carved by a daughter, or carried by grandparents arriving from the old country, these chests offer those of us lucky enough to have them tangible evidence of our place in the world, the particular pleasure of feeling the presence of our families in something we use every day. They carry treasure indeed.

*Wood is not the only way* to build a chest, as this detail of Jim Lewis and Jean Gallagher's chest demonstrates. A combination chest and footstool, the piece was made of medium-density fiberboard but expertly finished to look like stone.

*The treasure is often* in the eye of the beholder. Some chests carry aesthetic or emotional value that far outweighs the monetary value of their contents. This mahogany sewing box, with its patina of long use, was made by Maine furniture maker Duane Paluska for his wife.

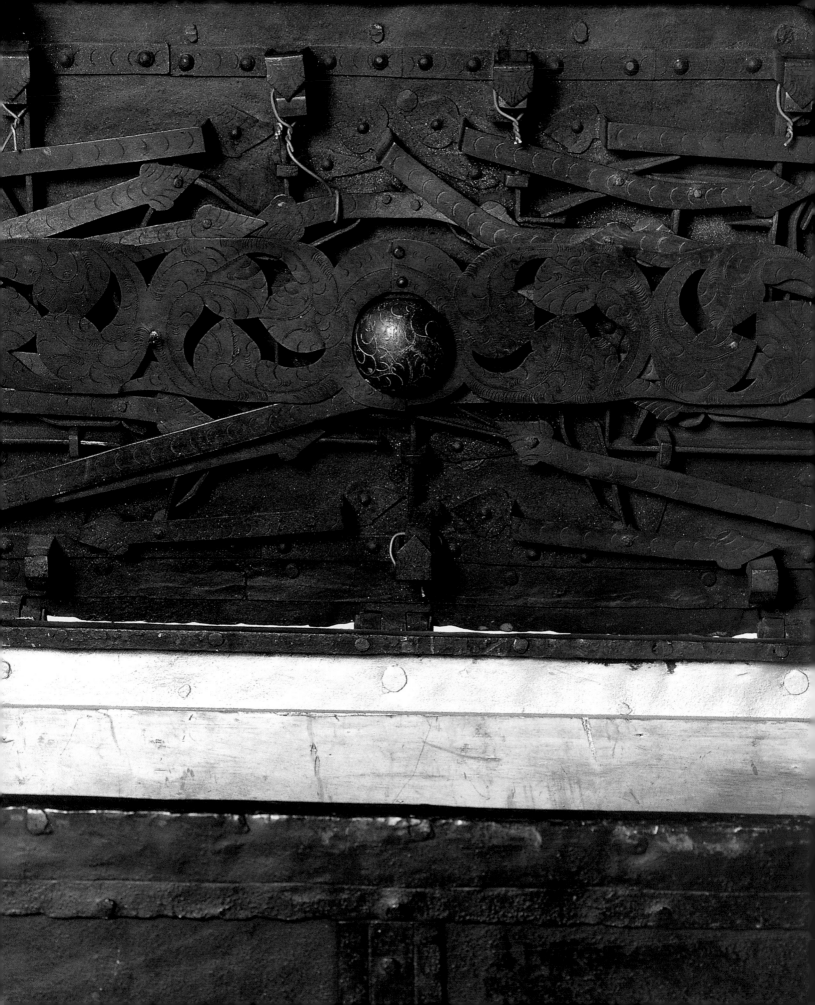

# Treasure Chests

## *Protection for the Priceless*

W E ALL RECOGNIZE A TREASURE chest—it is a dome-topped wooden box girded with iron strapping and trussed up with chains and massive locks. It's so heavy with ill-gotten doubloons and gold ingots (not to mention spare daggers and sidearms) that two pirates can barely lift it, and for extra security, it bears a crudely painted skull and crossbones.

That's the romantic ideal, anyway. We'd feel shortchanged if the illustrations in *Treasure Island* showed anything less imposing. And there's certainly some truth to the depiction. But chests for treasure can't be pigeonholed quite so easily. They've been made in a wide range of forms and sizes and have served a variety of purposes.

For many thousands of years, if you didn't want to trust your treasures to a hole in the ground, you put them in a chest. Locking chests were essentially safes and were often built with a similar massiveness.

In the Middle Ages, churches commissioned large locking coffers to safeguard their valuables. These chests were extremely imposing not simply for their size but also for their extensive ironwork. The sophisticated wood-working skills evident in classical antiquity had largely been lost by the early

*To lock up* the loot, chests have used mechanisms ranging from the elegantly elaborate iron one shown on the facing page to the far simpler wooden one shown on this page.

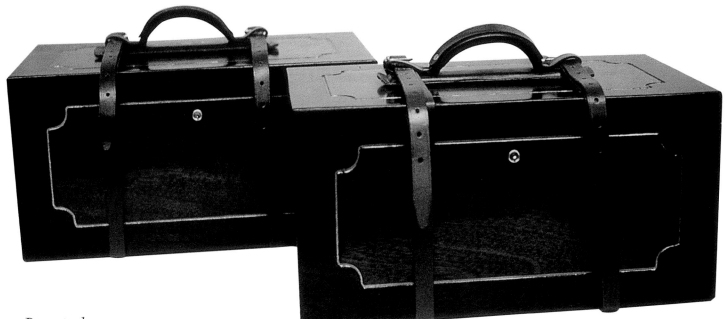

*Paper is the treasure* stored in these two chests. They are designed to hold Electoral College ballots for American presidential elections. When the electors from the 50 states convene to cast their votes after a presidential election, their ballots are secured in these boxes until they are counted a month later in Congress.

Middle Ages, and on many chests beautifully wrought strapping, hinges, locks, and handles outshone the woodwork by far.

The earliest and roughest of these ecclesiastical chests were simply hollowed-out logs that had been hewn roughly square and fitted with lids. The next step up were coffers made of thick planks that were crudely and insecurely joined, typically with butt joints and nails. The ironwork that distinguishes these chests and that was also used on the doors of many churches served not only as decoration but also as critical reinforcement at the inadequate corner joints.

By the 15th and 16th centuries as methods of joinery improved, it was no longer necessary to reinforce the corners of a chest with iron to keep it from falling apart. But even after the vogue for strapwork faded, chests for valuables were typically bound with iron to make them harder to break open.

Some of the most dazzling chests ever made were those discovered in Tutankhamen's tomb. Made of cedar of Lebanon and ebony, they were inlaid with gems, gold, silver, and ivory. The chest shown on p. 6 was built to hold cosmetics, which were precious at the time but not nearly so precious, it would seem, as the materials with which the chest was made.

Another sort of status was conferred by Japanese tansu chests with elaborate wrought ironwork. A sea merchant would have his goods packed in such chests, and when his ship docked in a trading port, the chests would be stacked up into an imposing wall on the wharf. In a show of his power and wealth, the merchant would stand before this wall of chests to greet and negotiate with his buyers.

And then there are chests whose value is mainly emotional. By virtue of age, almost any chest that has been around a long time acquires a certain gravity. But a chest that has been in one's own family for generations or has been owned or made by a relative can sometimes, in its embodiment of otherwise intangible memories and emotions, become the most treasured chest of all.

*Keeping others out* is the strong suit of a strongbox. This English Renaissance-style strongbox would have served the purpose admirably. The body of the chest is made of wood and clad with metal; the lid is solid metal. The enormous lock mechanism, shown on p. 22, covers the entire underside of the lid and includes nine latches that secure the lid to the chest sides when the lock is engaged.

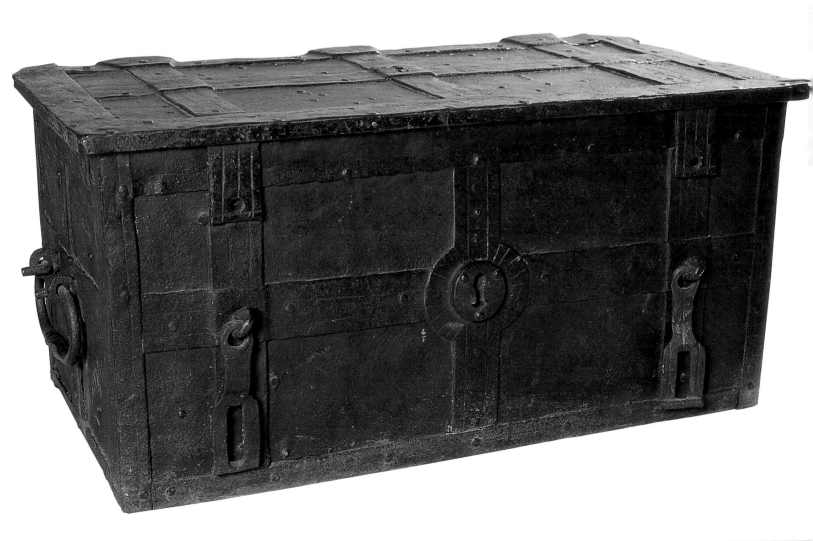

# Old-time, hand-forged hardware

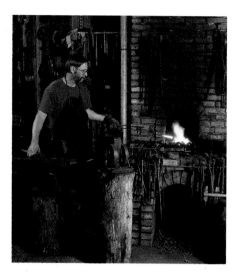

*A fine forge* is the heart of a blacksmith's shop. Pat McCarty, a self-taught smith, built this brick forge himself.

*Making strongboxes out of scrap,* McCarty uses discarded wood and scavenged iron to handsome effect. He got started blacksmithing when he couldn't find just the right hardware for his house and decided to make some himself.

FOR CENTURIES, CHESTS BUILT TO HOLD PRECIOUS CONTENTS have been reinforced with iron bands and brackets and decorated with artfully forged hinges, locks, and handles. Pat McCarty partakes in this old tradition, specializing in building chests with handsome hardware.

Pat is a self-taught blacksmith. He took up the trade when he was building his house and realized he wanted custom hand-forged hardware. When he started out, he used an old cutting torch and a modified barbecue for a forge. Soon he was happily beating odd remnants of steel into useful hardware. He began reading books on blacksmithing, joined a local blacksmithing club where members exchange tips, and eventually joined a national organization.

Blacksmithing requires high heat to make the metal pliable, and although Pat got by for a while with his barbecue forge, these days he can work much more efficiently with the new forge he built of brick. It has a fan that blows air up through the fire, increasing its temperature. Pat burns Pocahontas coal, which produces a lot of heat with very little smoke. To keep the temperature constant, he periodically adds fresh coal around the perimeter of the fire and moves it toward the center as it heats.

When he has forged a piece of hardware, Pat lets it cool, then he wire-brushes it to remove most of the slag. Next, he buffs it with emery cloth (sandpaper with a cloth backing). To protect both the metal and the wood, Pat concocts his own finish. To make a batch of it, he mixes a pint of varnish, a quart of linseed oil, and a quart of turpentine and adds a lump of beeswax about the size of a golf ball. After heating these ingredients in a double boiler to melt the wax, he slathers the entire chest, metal and all, with this mixture and then wipes off the excess.

*A skilled smith* turns iron into ivy. These strap hinges look almost as if they grew across the surface of the chest.

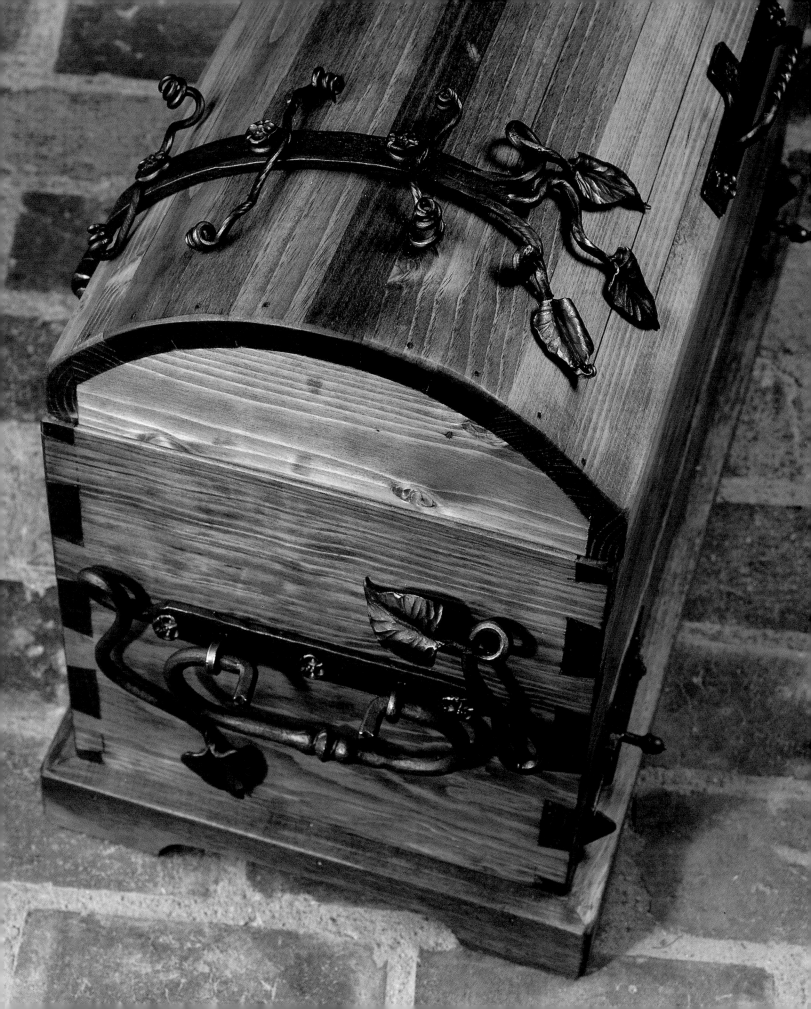

# A precious Chinese chest
# that landed in the sea

*One valuable piece of driftwood,* this lacquered chest, which once held precious Chinese tea, was rescued from the harbor after the Boston Tea Party. Only two such chests are known to survive.

HOPESTILL FOSTER FOUND THIS SMALL LACQUERED CHEST bobbing in the frigid waters of Boston Harbor one morning in December 1773. The previous night, about 100 local men disguised as Mohawk Indians had boarded three British East India Company ships docked at Griffin's Wharf and dumped the ships' precious cargo into the harbor. The cargo was tea from China, and the night raid—in protest of import taxes imposed by the British on their colonies— came to be known as the Boston Tea Party.

The tea was shipped in brightly lacquered wooden chests made in China. They were quite small, about a foot high and wide by about a foot and a half long, made of ½-in.-thick wood and painted with red and black Oriental scenes on every side, which still catch the light after more than 200 years. Even full of tea, one of these chests would have weighed only a few pounds. But because of the price of Chinese tea at the time, they would have been worth their weight in gold.

When you look at the splintered top edges of the chest, you might be able to picture one of the men hurrying up from the ship's hold. Carrying the chest by its brass handles, he stops by the rail, smashes the lid free, dumps the contents into the water below, and throws the empty chest after it. Then he rushes below for another.

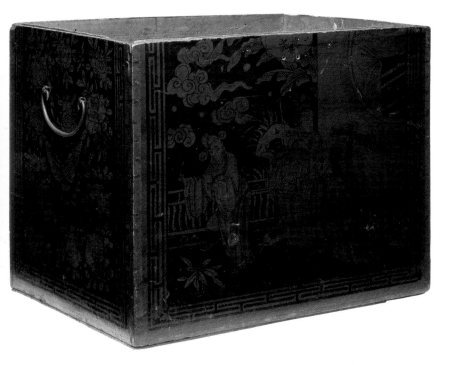

Hopestill Foster died in 1801, and his tea chest passed down through his family until 1902, when his heirs donated it to the Daughters of the American Revolution. This remarkable piece of American history now sits in a small room at the DAR Museum in Washington, D.C. To glimpse the Boston Tea Party Chest, you follow a docent up a staircase and down a long, narrow hallway. She unlocks doors and turns on lights as she goes. Suddenly, she stops, turns on a light, and there it sits—in the back of a small room, a seemingly unremarkable, painted wooden chest. It's small in size but looms large in the history of the United States.

# Elegant protection for a prized commodity

I N A TIME WHEN ANYONE WHO could afford it drank tea, Samuel Johnson, the 18th-century English essayist and lexicographer who wrote the first English dictionary, was notorious for his tea drinking. His biographer, James Boswell, said of him, "I suppose no person ever enjoyed with more relish the infusion of that fragrant leaf than Johnson." Johnson is said to have drunk 20 to 30 cups of his hosts' tea at a sitting. An amazing feat in itself, it's even more astounding when you consider the cost of tea at the time. In England 200 years ago, tea cost about £1 per pound. That may not sound like much until you realize that a middle-class family could live quite well on £100 a year. If tea were as expensive today, it would cost about $1,000 per pound. It's amazing that Johnson was ever welcomed back to his friends' homes.

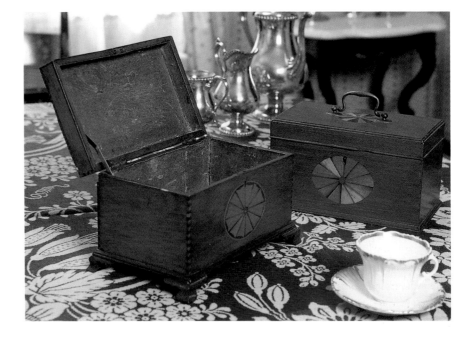

*Tin kept tea fresh,* so boxes like these were lined with it. The elegant exteriors of these 18th-century tea caddies— mahogany, brass hardware, and inlaid sunbursts—reflect the value of tea at the time.

In America as in England, small tea chests, or tea caddies, were made for storing the precious leaves. Befitting their valuable contents, they were often exquisitely constructed with fine joinery and elegant inlay. These two mahogany tea caddies, originally owned by Lodema Knapp of New Milford, Connecticut, are fine examples of the form. Family records indicate that Knapp acquired the caddies sometime before 1790. They were passed down through the generations in fine condition. By the 20th century, though, with low tea prices and modern storage containers, tea caddies like these had lost their use in the home. In 1933, Ella Knapp donated them to the New Milford Historical Society.

The Knapp caddies are lined with tin to preserve the flavor of the tea and to keep out humidity and insects. Each chest is also fitted with a lock to keep out pilferers. The only protection against a prodigious tea drinker such as Johnson, however, would have been impoliteness, which was practiced only rarely over tea.

# A father, a mother, a son, and a maple tree

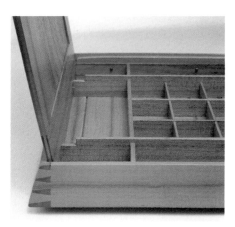

*Designed to hold silver* **but destined to hold much more, this box carries proof of a reconciliation between father and son. The interior partitions were originally arranged to accommodate silverware but were later changed to hold jewelry.**

WOODWORKING IS NOT A PROFESSION REVERED BY ALL. John Nesset's parents wanted him to become a doctor and pushed him as far as medical school. When John abandoned medicine and turned to furniture making, his father practically disowned him.

After years of fighting between father and son and many failed attempts at reconciliation, John's mother decided to try something new. There happened to be a dead maple tree in a neighbor's yard that needed to be removed. Perhaps, she thought, if she could get her husband and son to work together to fell the tree and cut it up for firewood, they might just find some common ground. She wrote a letter to her son, wondering if he'd care to come and help. Although his expectations of an enjoyable afternoon were slim, John couldn't say no.

The day arrived and the two men settled into their work in a cooperative mood. They planned their strategy, divided the tasks, and made progress. The tree came down, was quickly limbed, and was cut into fireplace lengths.

All that remained was to split the logs into firewood. As they split the first logs, John saw at a glance that the wood was nicely figured. He took a closer look and casually announced that he was taking the logs home for his woodworking. His father was furious—here his son was going to waste perfectly good firewood on his woodworking. John loaded up the wood and took it home, leaving his father fuming and his mother crushed.

Four years later, John had some furniture in a woodworking show. At John's mother's prodding, John's father went to the show. There he saw a table John had made with wood from the tree they had cut down together. It was a handsome table—handsome enough to have won the award for "Best in Show"—and John's father began to realize that his son was a gifted crafts-

man. Not long after, father and son started to speak again and finally achieved the mutually respectful peace so elusive to many fathers and sons.

For his parents' 50th wedding anniversary, John used the last of the maple from the tree to make them a silver chest. The chest would store a set of sterling-silver flatware they had received as a wedding present. John had quartersawn the maple boards, revealing a prominent pattern of medullary rays, or ray fleck, in the grain. His dad couldn't stop marveling at the beauty of "that wood" and what had become of it.

*A fine chest made from firewood.*
**A Norway maple cut for firewood was rescued by John Nesset and used to build a number of fine pieces of furniture as well as this chest. When he began to split the logs, Nesset noticed the figure of the wood and decided it was too beautiful to burn in the fireplace.**

# Iron-clad chest for hard-earned pay

FINANCING THE CIVIL WAR DEMANDED UNPRECEDENTED sums of money on both sides. In addition to the costs of arms and ammunition, food, shelter, horses, and wagons, there were wages to be paid—hundreds of thousands of soldiers expecting their promised $12 per month. To receive their pay, soldiers lined up by their units and each man would take his turn at the paymaster's station. The paymaster would look up the soldier's pay record, compute the amount he was owed, and count it out in cash.

The Union army used this paymaster's chest to distribute wages to its soldiers. Like a modern bank safe-deposit box, the paymaster's chest has two keys, both of which are needed to open it. The paymaster himself would carry one of the keys, and another officer would carry the other.

Such chests were a major prize for the opposing army and were made to be practically bulletproof. The powerful lock mechanism takes up nearly the entire underside of the lid. And the chest's corners were heavily reinforced with iron to make the chest nearly impossible to break open even if it were stolen.

The enormous sums spent on the war created a severe shortage of currency. Both North and South responded by printing money freely as needed. The Legal Tender Act, passed in 1862, enabled the U.S. government to print paper money without the backing of gold. Union soldiers were paid with these paper bills, which became known as greenbacks because the reverse side was printed with green ink. The South also relied on printing paper money to continue the fighting. As it became increasingly obvious that the war was not going well for the South, inflation soared as high as 9,000%, making the Confederate soldiers' hard-earned pay almost worthless. A state-of-the-art strongbox might have prevented the Confederacy from losing its freshly printed bills, but it could not prevent the bills from losing their value.

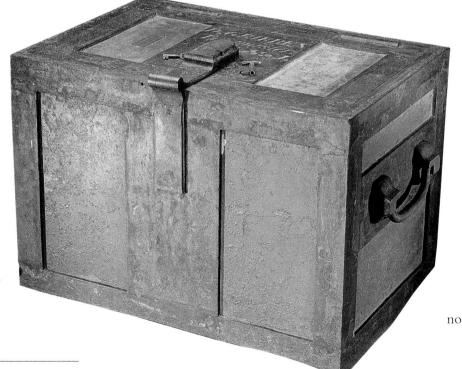

*Securing soldiers' pay,* this Civil War paymaster's chest was bound with iron to withstand unauthorized attempts to open it. Two different keys were required to open its lock.

# The most valuable rocks on Earth

W HEN APOLLO 11 TOUCHED DOWN ON THE MOON in July 1969, the first Apple computer was still eight years off and Ed Sullivan had the most popular show on television. Although it was a technological miracle at the time, the moon landing's success would have been diminished if the astronauts had returned to Earth without bringing back a moon rock.

Neil Armstrong made no such mistake. When he stepped down onto the lunar surface, he was wearing a space suit with a specially designed rock pocket. As soon as he took his "giant leap for mankind," he reached down, picked up the nearest rock, and secured it in his pocket. That way, just in case he and fellow astronaut Buzz Aldrin had to blast off again suddenly, they would bring back at least one moon rock.

Approximately 50 lb. of rock and soil samples returned with the first lunar mission, carefully packed into sealed Lunar Sample Return Chests—rock boxes, as they were called. The chests were machined out of solid blocks of aluminum to eliminate seams or weak spots. To cushion the moon rocks during the turbulent descent through Earth's atmosphere, the boxes were lined with a metal fabric akin to steel wool but made of stainless-steel threads woven into a soft, clothlike padding.

Rubber seals on the lid and extremely strong latches made the chests airtight. The hermetic seal was intended to protect the Earth from foreign organisms. When the eight-day mission ended safely with a splashdown in the Pacific Ocean, the astronauts were quarantined for 14 days in an isolation chamber. The rocks, too, in their aluminum boxes were isolated in a chamber before they were opened.

The original rock boxes and others like them were used on later missions in the continuing quest for lunar samples. In all, American astronauts visiting the moon have carted back 842 lb. of rocks. Even so, the moon is lighter by only 143 lb.—an unfair exchange posing the puzzle of gravity.

*Not just any old box for rocks,* this chest carried on missions to the moon was specifically designed to bring back samples from the lunar surface. The chest was machined out of solid blocks of aluminum to eliminate seams.

# Time is the treasure in a silver chest that wouldn't be rushed

*A lasting statement* in disposable times, Brent Markley's silver chest, with its magnificent mahogany and uncompromising craftsmanship, is built to make a trip down through the generations.

BRENT MERKLEY ORIGINALLY TRAINED AS A MANUFACTURING engineer and worked at Atari, but then he followed his heart and decided to make his living working with wood instead of computer components. Setting up shop in his one-car garage, Brent began building furniture in the mid-1980s.

The client who commissioned this silverware chest offered the sort of opportunity Brent changed his life to pursue. The only constraints placed on the job were these: that the chest hold eight place settings, a ladle, and a set of serving spoons; that it be elegant; and that it be nice enough to pass down to the client's daughter. Brent repaid his client's confidence in him by putting extraordinary effort into the chest. Brent says, "I told him that if he would be patient, I would make this chest as if I were making it for my own grandmother."

The care Brent took at every turn is exemplified by the finish he chose for the mahogany chest. To highlight the beautiful crotch-mahogany veneer outside the chest and to relate to the polished silver inside, he decided to use high-gloss lacquer to create a perfectly smooth surface and an elegant sheen.

Mahogany is an open-grained wood, and its surface is covered with microscopic peaks and valleys. When you apply a coat of lacquer, it covers the peaks and valleys with a film of the same thickness. When it dries and you sand the surface, lacquer is removed from the peaks and left in the valleys. After a second coat and a third, the valleys are slightly shallower. The finish is building up. When valleys are filled to the level of the peaks, the surface becomes absolutely flat and smooth and it gleams. To achieve the glassy finish he was after, Brent lacquered and sanded the chest every day for a month.

Brent's one-man shop in San Carlos, California, will probably never make him a rich man, but as he will quickly tell you, money is not his first priority. By way of explaining the pleasure he gets from his craft, Brent quotes a line James Krenov wrote: "It's in the little things, enjoy them."

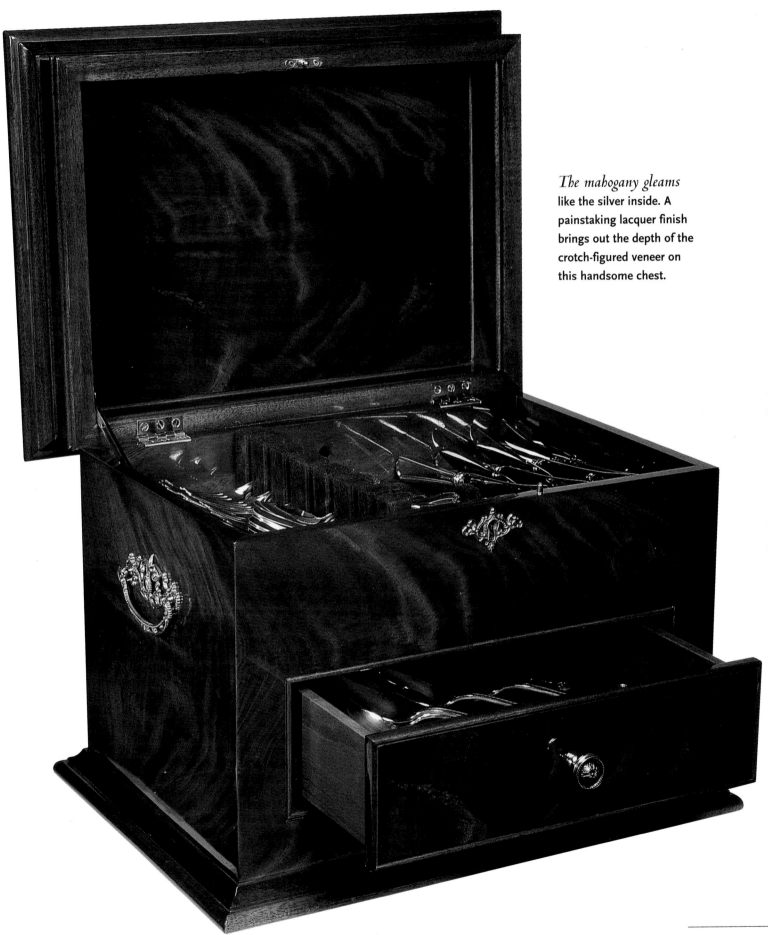

*The mahogany gleams* like the silver inside. A painstaking lacquer finish brings out the depth of the crotch-figured veneer on this handsome chest.

# *What do you mean it doesn't look like a piggy bank?*

*Swirling grain and rich color* give the sides of this chest a strong visual appeal. Visible splines crossing the corner joints add another distinctive touch.

## A WOODEN LOCK

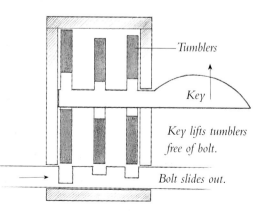

*Tumblers*

*Key*

*Key lifts tumblers free of bolt.*

*Bolt slides out.*

NIALL BARRETT'S CLIENTS SAVE LOOSE CHANGE. When they empty their pockets in the evening, they put the coins into a piggy bank. This practice won't replace their retirement savings plan, but they have saved enough money this way to put a new floor in the kitchen and a new rug in the living room. Their first change bank was a large, pear-shaped, green-glass jar. When it broke, they called Niall and asked him to build them a piece of furniture that would double as a bank.

Niall decided it would be fun to give them plenty of room to collect their loot, so he designed a chest big enough for blankets and panchos, let alone pocket change. He made a frame-and-panel lid for the chest and left a gap between the panel and the frame to serve as the coin slot. He added a stand so the chest would look more like a piece furniture. And on a whim, he decided to add a wooden lock.

The principle of using a key of some kind to move an internal mechanism so a bolt can slide or a cylinder can rotate is indeed a very old one. A lock and key found in ancient Egyptian ruins that goes back 4,000 years would be quite familiar to any modern locksmith. The lock Niall made is similar to one the Romans designed.

Wooden locks rely on a series of pins called tumblers. These pins engage holes in a bolt, locking it in place. The key is inserted into the lock and used to raise the pins out of the way, freeing the bolt. For the lock to work properly, the tumblers have to slide easily. The heavier and more slippery the tumblers, the better. Niall made his lock's tumblers from cocobolo, a dense Costa Rican wood that contains a natural lubricant. After several years of use, Niall's lock still works just fine.

*A very big piggy bank,* or a chest full of loose change? Niall Barrett's chest made of New Guinea walnut and purpleheart is both furniture and strongbox. The purpleheart panel in the lid has a gap around its perimeter that serves as a coin slot.

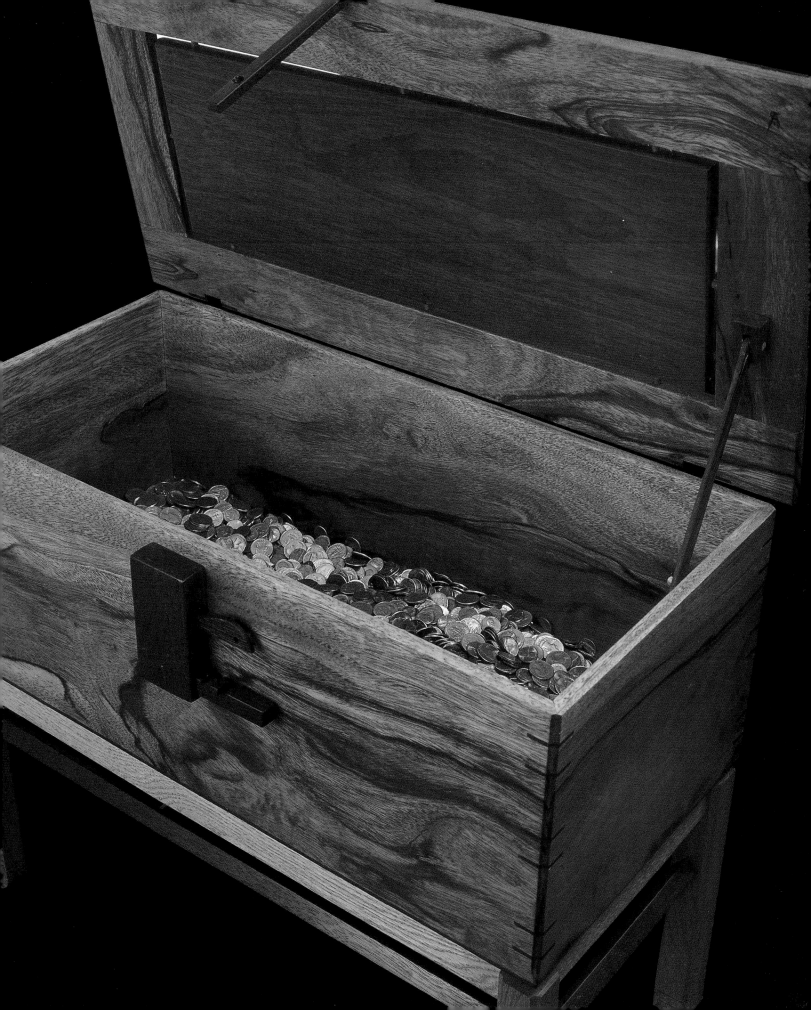

# Coaxing a small chest from three planks of precious wood

S OMETIMES THE TREASURE IS NOT SO MUCH the contents of the chest but the materials it is made with. So it was with the smaller of these two chests, made of beautiful bubinga. Bubinga is a favorite wood among those who savor exotic species. Growing best along the equator in west Africa, especially in Cameroon, bubinga is a reddish-brown hardwood with purplish veining and a rich color reminiscent of rosewood.

Pret Frazier, a woodworker in Idaho, hoarded his stash of bubinga for 15 years before committing it to use. He had bought three pieces, each 4 ft. long and 4 in. square. This is not much material when it comes to solid-wood furniture making, but Pret was determined to squeeze a whole piece of furniture from his supply. He had a design for a blanket chest in mind, something he'd been wanting to make for a long while. He knew the bubinga couldn't be stretched nearly far enough to make the full-sized chest, so he decided to shrink the design. That's how he wound up making the jewelry box, a miniature version of the blanket chest.

Even building at the reduced size and using black cherry to fit out the interior of the chest, he had almost no margin for error with the bubinga. Before he sawed up the wood, he had to lay out his cuts with ingenuity and great care. When the pieces were all cut, what remained of the three precious planks fit into a coffee can. That pleased him very much. Sensitive to the notion that he was working with one of Earth's treasures, he didn't want to waste an inch of it.

*The bubinga only* went so far, so the interior trays and fittings are made of black cherry.

*The little brother came first.*
Pret Frazier squeezed the smaller of these two sibling chests from three short lengths of bubinga he'd been saving for 15 years. He later made the full-scale chest in Honduran mahogany and sapele.

# Love letters
# under lock and key

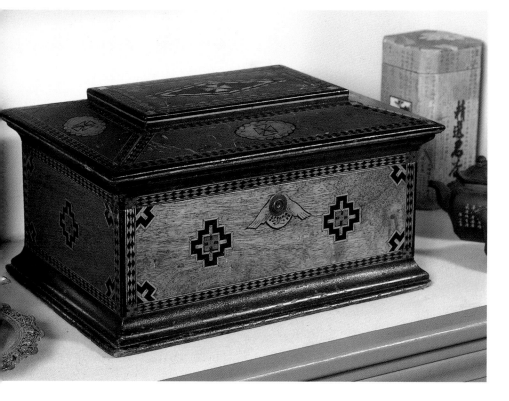

*A real family heirloom,* **this chest was made by Richard Hatch's grandfather around 1900, was treasured by Richard's mother, and then passed on to him. His grandfather made the chest while teaching cabinetmaking at a prison in Massachusetts.**

RICHARD HATCH WAS ONLY six years old when his grandfather died in 1926. Understandably, his direct memories of his grandfather are faint, but Hatch has much to remember him by. His grandfather, William Chaplin, was an accomplished woodworker, and Hatch has inherited a number of the things he made.

There are the two tool chests and the collection of tools they held, which Richard, himself a woodworker, still puts to use. Chaplin made the pieces around 1900, while he was teaching cabinetmaking at the Reformatory, a prison near his home in Concord, Massachusetts.

And then there is this marquetry chest. A technique developed many centuries ago, marquetry involves cutting out and fitting together small pieces of veneer in various species to create often intricate patterns. The veneers are taped together and then glued to a solid substrate beneath. A hundred years after it was made, Richard's marquetry chest remains in excellent condition.

The marquetry chest is doubly meaningful to Richard because when his mother owned it, she used it to hold the love letters his father sent her while they were courting. The memory of his parents and his grandfather lives on in the little, felt-lined chest, a touchstone sitting on a table in his living room. ⌐══⌐

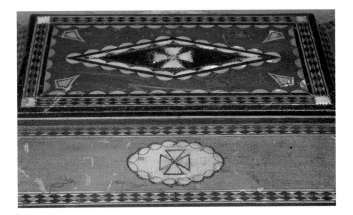

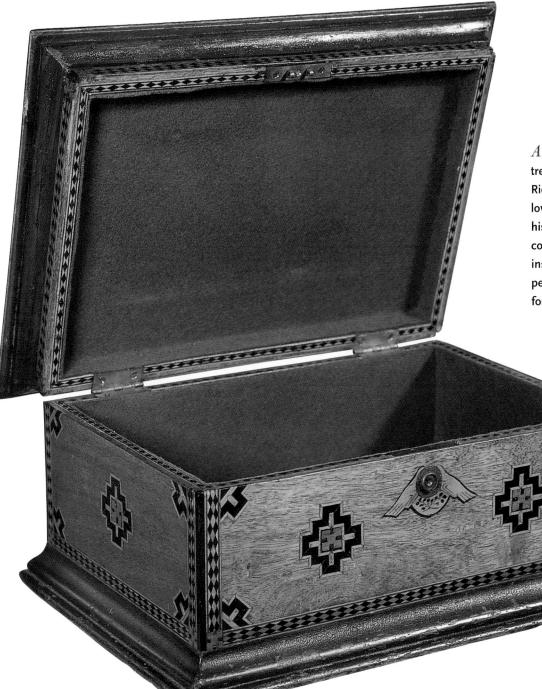

*A perfect place* for personal treasure, this chest owned by Richard Hatch once held the love letters his father wrote to his mother when they were courting. The heavy felt lining inside the chest makes a perfectly padded enclosure for such treasures.

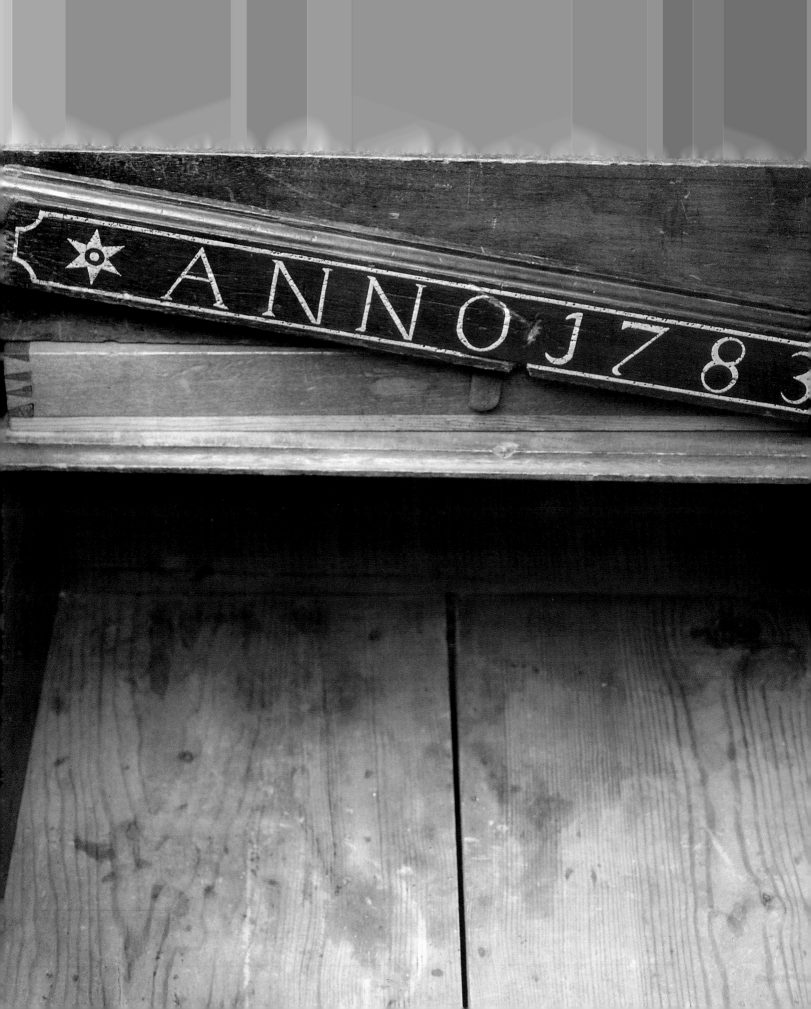

# Bridal Chests

## *Where the Future Is Stored*

SINCE LATE MEDIEVAL TIMES at least, it has been customary in many Western countries for a woman to gather her trousseau—clothing, linens, plates, and other household goods—in anticipation of marriage. The bridal chest is the receptacle she has used to store these things. For centuries, while women were denied by law the right to own property, the bridal chest and its contents were often the only things a woman owned. When she did marry, the chest went with her to her new home. As a woman filled her bridal chest, often sewing and weaving many of the items in it herself, she would have thought ahead to the time when she and her chest would be delivered to an unknown future.

Some of the oldest and most elaborately decorated wedding chests were Italian cassoni. These were enormous, lidded chests made in the 15th and 16th centuries. Deeply carved and brightened with gilding, they were also often decorated with finely painted scenes from mythology or the Bible. Made by some of the finest craftsmen of the Italian Renaissance, cassoni were symbols not only of a wedding but also of great wealth and often of the joining of two powerful families.

*A tradition* of long standing, the practice of making a special chest to store a bride's trousseau or a young married couple's belongings is common across many cultures. The photos shown here are details of American bridal chests built two centuries apart.

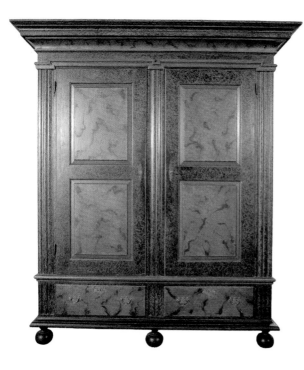

*Not exactly minimalist* when it came to decoration, Italian artisans of the Renaissance created bridal cassoni like this one covered with gilded deep-relief carving and featuring scenes painted by fine artists. This cassone from 1460–65 has paintings attributed to Apollonio di Giovanni.

In the Netherlands and in Dutch settlements in America, a large, free-standing two-door wardrobe, or kast, with shelves inside was often used to house a woman's trousseau. The Dutch were famously fastidious housekeepers who would carefully stack their freshly washed and ironed linens and tablecloths in the kast.

In Germany, a similar two-door cabinet called a schrank was used to hold bridal linens. Like most bridal chests, both the schrank and the kast were designed with moving in mind. For these large, unwieldy cabinets, portability was accomplished by constructing them with removable pegs so the parts could be easily disassembled.

Immigrants to America brought various traditions with them from Europe, and in the New World some distinctive new forms of the bridal chest arose. Scandinavian immigrants to America, many of whom settled in the northern Midwest, brought with them the custom of making brightly

*Enormous but easily movable,* Kendl Monn's contemporary kast, like the 18th-century originals on which it is based, can quickly be taken apart. Kasts and their near relatives, schranks, were often used as bridal chests.

painted chests for prospective brides. As bridal chests were in most cultures, the Scandinavian bridal chest was a gift from the bride's parents. In America, where many settlers had to learn at least the rudiments of woodworking, among other crafts, to get by, these chests were often made by a woman's father or fiance. On most Scandinavian bridal chests, the bride's initials and her intended wedding date were worked into the painted design.

Hadley chests, a distinctly American form of bridal chest with English roots, were made in the late 1600s and early 1700s in central Massachusetts. Hadleys were embellished with stylized low-relief carving, sometimes painted or stained in solid colors, that spread all over the front surface of the chests. Similar carved and painted chests were prevalent throughout New England.

In Pennsylvania, meanwhile, German settlers were developing their own eye-catching style of dowry chest, extending a tradition brought across the Atlantic from Switzerland and Germany. With patterns derived from classical architecture and folk art, they applied their flair for vibrant decorative painting to a sturdy form of a dovetailed six-board lidded chest.

The bridal chest tradition crossed economic as well as cultural boundaries and was found in all levels of society. Workmanship in the chests varies widely, as do materials, joinery, and the level of decoration. Across most of these variations, however, one feature is constant: On the front of most bridal chests you will find either painted, carved, or inlaid the name or initials of the bride and sometimes the groom and often the date of their wedding. Whether the bridal chest was elaborate or humble, large or small, it was built to hold not just a woman's trousseau but also her hopes and dreams for the future.

*The painted dowry chest* reached an apex in the hands of Pennsylvania German craftsmen, who applied vibrant designs to sturdily built chests.

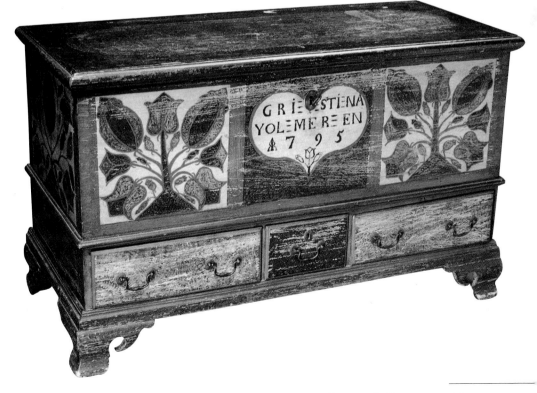

# Mary Burt's
# 18th-century bridal chest

*An American classic,* the Mary Burt chest is one of a group of related chests made in the Connecticut River Valley and now referred to loosely as Hadley chests. Burt's was made in Northampton, Massachusetts, in 1710.

WHEN SHE WAS 15, MARY BURT RECEIVED a bridal chest. The year was 1710, and the gift was both typical and unusual. It was typical because the custom of giving a young woman a chest in which to collect her trousseau was widespread and centuries old. It was unusual because the chest she received happened to be a Hadley.

Hadley chests, named for the small Massachusetts town on the Connecticut River where some of them were made, are paneled chests distinguished by a stylized form of low-relief carving that spreads over the

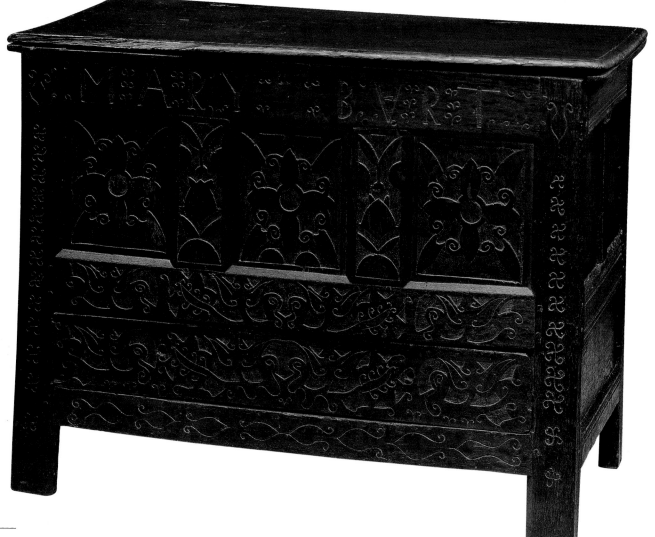

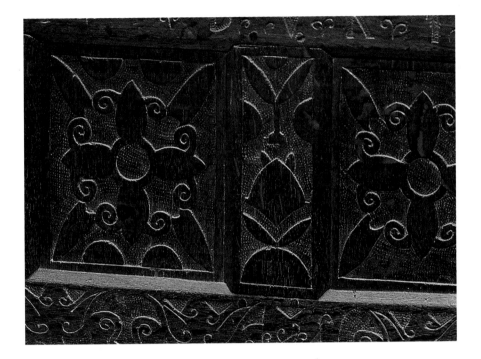

*Vibrant, shallow-relief carving* was characteristic of many chests made in southern New England at the time Mary Burt's chest was built. American craftsmen developed a stylized version of a tulip-and-vine motif that originated in Europe.

*Pilgrim furniture* in the age of e-mail. This frame-and-panel chest and others like it are the product of the cabinetmaker's shop at Plimoth Plantation, a museum of Pilgrim life in Plymouth, Massachusetts, an hour's drive from Boston. A living history musuem, Plimoth Plantation re-creates daily life as it was lived in 1627. Peter Follansbee (see the photos on p. 20) built this chest using construction techniques from the decade after the Mayflower landed in Plymouth.

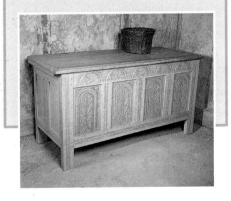

front surface. Hadleys were made in the Connecticut River Valley from 1690 to 1725. In the 20th century, they became coveted for their vibrant peasant-style carving and their value soared.

Most Hadleys that survive have one or two drawers below the lidded well at the top of the chest. The chests always bear a name or, more commonly, a set of initials carved into the top rail or center panel.

Like many American chests of the era, Hadleys were made in the joined or frame-and-panel style derived directly from English examples. The decoration on Hadleys was derived from tulip-and-vine motifs common on much furniture of the time in America and Europe. But the carved decoration on Hadleys was unusual for being so stylized and so exuberant— instead of being contained sedately within the panels, the carving covered nearly every inch of the front of the chest.

Six years after receiving her chest, Mary Burt married Preserved Marshall of Framingham, Connecticut. Her chest was passed down by her descendents from mother to daughter for nearly three centuries before it joined the collection of the Daughters of the American Revolution Museum in Washington, D.C.

# Sulfur inlay:
# An intriguing craft revived

*Simple tools for sulfur inlay.* **Sulfur is melted and then poured into a slot in the wood. The sulfur expands slightly as it cools, locking it in place. When the sulfur solidifies, it has the consistency of hard wax. The excess can be easily removed using a chisel and scraper.**

THE GERMAN IMMIGRANTS WHO SETTLED IN and around Lancaster County, Pennsylvania, earned lasting renown as furniture makers. Their work was both expertly made and strikingly decorated. The painted chests they made are especially prized. But for about a half century—from 1765 to about 1820—a few Pennsylvania-German cabinetmakers practiced another decorative technique that is equally impressive but far less well known.

It is sulfur inlay—the technique of using molten sulfur to decorate furniture. This walnut dowry chest bears an extremely fine example of the practice. Dated 1783, the chest has been traced to Mrs. Deitrich of Ephrata, Pennsylvania, who received it when she was 17.

After the Smithsonian acquired the chest in 1976, the inlay was chemically analyzed, and what had previously been thought to be a mixture of white lead and beeswax was found to be sulfur. Air bubbles in the inlay indicated that the sulfur was melted and then poured into channels carved into the wood. The hardened sulfur was scraped flush with the surrounding wood to form the intricate patterns seen on the chest.

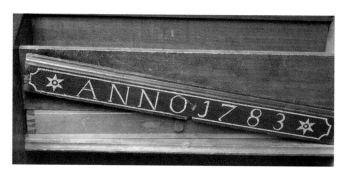

*The date board hides a secret* **drawer that is tucked under the till in the Deitrich chest.**

*Pennsylvania Germans* found a fine use for sulfur when they developed the technique of melting it and using it for decorative inlay. Their flair for embellishment is evident in this chest, built in 1783.

*A few contemporary craftsmen* have revived the art of sulfur inlay. One of them is Mike Siemsen, a furniture maker in Minnesota who specializes in 18th-century reproductions. One of Mike's clients saw the Dietrich chest on display in the Smithsonian and asked Mike if he would make a replica of it. Mike happily agreed, and while he was at it, he also made one for his newborn son, Arlo.

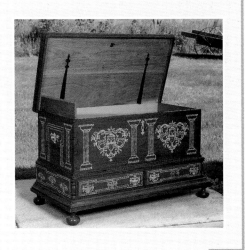

# Precision woodworking in the 18th century

BUILT THE YEAR BEFORE GEORGE WASHINGTON WAS FIRST ELECTED president, this walnut bridal chest offers evidence of the outstanding craftsmanship and resources the new nation's furniture makers could lavish even on an unpretentious piece.

The joinery in the chest is especially fine. With tails spaced barely more than a saw-kerf apart, the dovetails represent a substantial investment of time and skill. Although craftsmen these days can save time by using routers to cut some dovetails, they have found no shortcut to a set like these—because these dovetails are so tightly spaced, they would still have to be cut by hand.

The sides of the chest feature another specialty of the time: wood harvested from virgin forests. The walnut planks for the front and sides of the chest are at least 20 in. wide and flawless. Today, after two more centuries of logging, a walnut plank of that width is a rarity.

Although structurally this chest is not far removed from the simplest six-board chest, it bears the influence of exposure to higher-style furniture in its scrolled bracket feet and in the moldings at its lid and base.

The chest was a gift from 24-year-old Abraham Kage to his new wife, Anna Neff of Shenandoah County, Virginia, in 1788. The straw-colored decoration around the lock was done with sulfur inlay, a technique that was developed in Kage's native Lancaster County, Pennsylvania.

*Tightly spaced dovetails* on each corner give this chest a refined yet robust appearance. A mere saw-kerf apart, these dovetails are spaced too closely to be cut with a router.

*Fine lines of straw-colored sulfur inlay* make a handsome contrast with the honeyed walnut of this bridal chest.

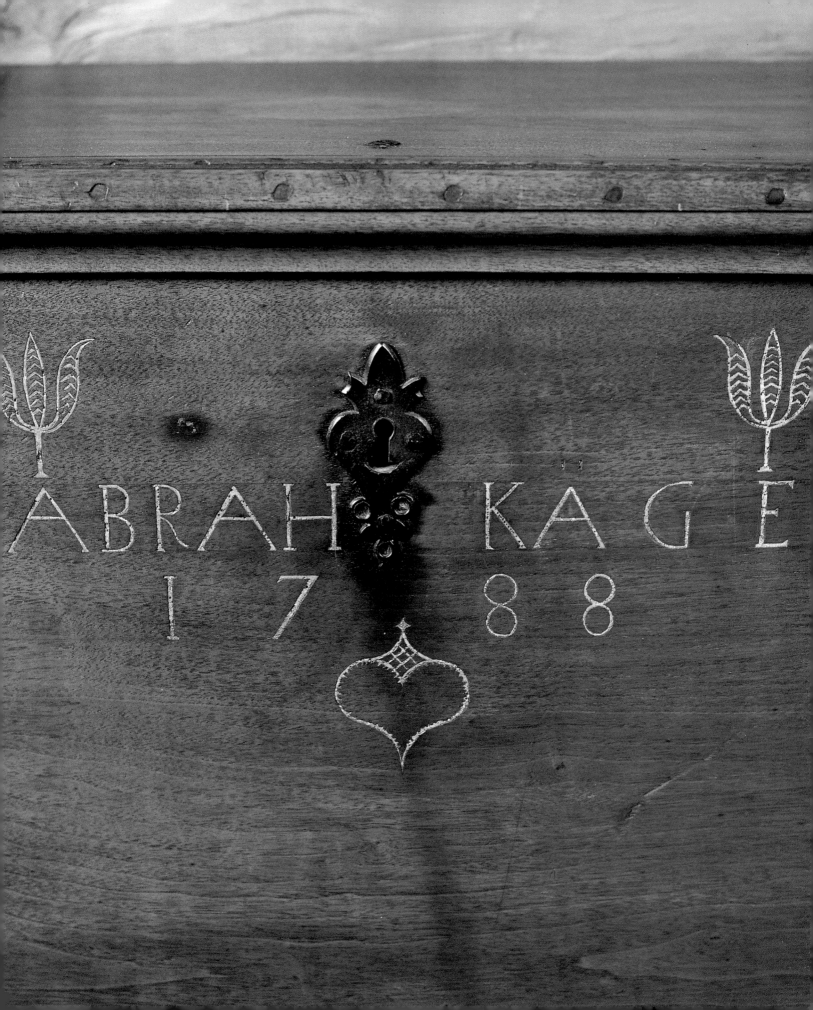

# Fashioning a hope chest
# for an old-fashioned girl

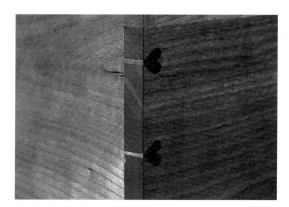

*An expression of a father's love,* **this variation on the handcut dovetail is both functional and beautiful.**

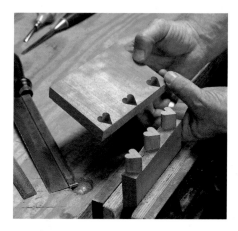

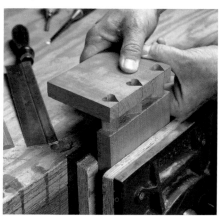

IT WAS 1993 WHEN Jim Fontenot built his daughter Amy's hope chest. She was 20 and going to college. She was a '90s girl—but in her case, it was more like the 1890s. Sure, she had tried rock climbing and river rafting, but she was just as comfortable in an old-fashioned long dress and a bonnet as she was in rock-climbing gear.

Amy loved Victorian clothing, architecture, furniture, and fabrics. And she embraced at least one old custom, as well: By the time her father got the idea to build her a hope chest, Amy had already begun collecting her trousseau, articles for her future life as a married woman. She had the quilt her mother made for her, some special linens, an apron Amy had woven by hand, and some doilies she had crocheted. She collected all of these things but had no good place to store them—no hope chest. That is until her father's arrived.

As he designed the chest, Jim reviewed a number of ways to cut dovetails, since creative woodworkers have dreamed up dozens of variations on the basic dovetail joint over the centuries. In an old issue of *Fine Woodworking* magazine, Jim found just the thing: lovetails, a heart-shaped version of the dovetail. Lovetails perfectly matched the project and the love this father feels toward his daughter.

Now that she's married, Amy lives with her husband (and her hope chest) in a Victorian-era village near Atlanta.

*A lot of hand-fitting* **with chisels and files is required in making these heart-shaped dovetails, or lovetails. The tails are fashioned first using a drill and a thin-bladed backsaw. The pins are then marked from the tails. The pins are roughed out with a backsaw, rounded with a chisel, and refined with files for a tight fit.**

*Heart-shaped dovetails* **and a carving of dogwood blossoms distinguish this hope chest made by Jim Fontenot for his daughter, Amy. No matter how far away she moves, the carving will remind Amy of her family's Atlanta home.**

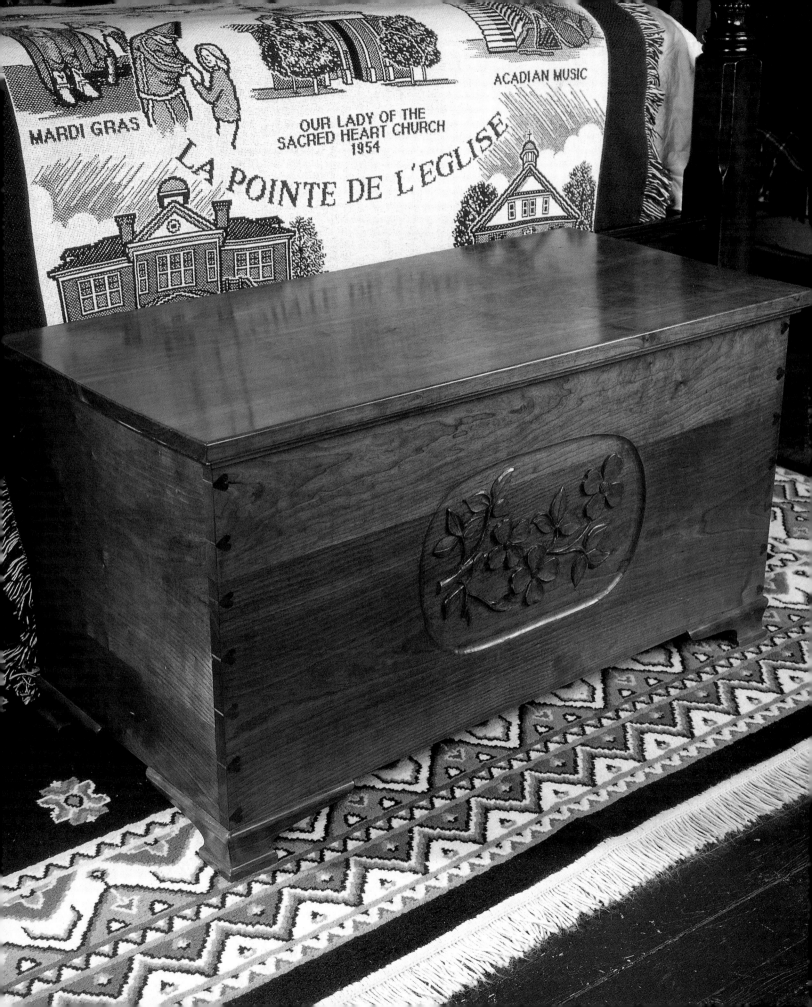

# A factory-made cedar chest

A little chest with a big impact, this 12-in.-long box is one of millions of miniature cedar chests the Lane Company has given away to high school girls in hopes of stimulating sales of full-sized chests. The extremely successful promotional campaign, begun in 1930, has helped Lane prosper and keep the hope chest tradition alive.

W HEN DON WALSH FIRST MET MARYANN ROZANSKI, she was 15 and he was 17. Right then and there, Don knew he had found the girl he would marry. Long before they were even engaged, he bought her a hope chest.

He got the idea one day when the two of them were wandering through a furniture store and Maryann admired a particular chest made of solid aromatic cedar. The chest Maryann was attracted to was something of an American classic. It was made by the Lane Company of Altavista, Virginia, a company that has been manufacturing cedar chests since 1912 and selling them by the millions across the country. Although factory made, Lane chests feature a special hidden corner joint—a locking miter that slides together—that provides great strength and security.

When Maryann saw the Lane chest, Don was a Coast Guard Academy cadet. He had a cash allowance of about $35 per month, which made the $200 price tag on the chest seem nearly out of reach. But with months of saving, Don got the sum together and bought the chest in February 1969.

Getting the money for the chest wasn't Don's last hurdle. When he got the chest out to his small convertible, Don discovered that it was too big to fit inside. So in the bitter cold of a Connecticut winter and with snow falling, he found himself driving the 12 miles to Maryann's house with the top down.

Since that frosty inaugural ride, the chest has traveled with Don and Maryann on countless moves across the globe—most of them during Don's 20-year career in the Coast Guard but several more moves after that. All of the miters are still tight, the lock still works perfectly, and they have even managed to keep track of the key. The lid, when opened, releases the wonderful aroma of cedar, still fresh after 30 years.

## A SLIDING LOCK-MITER JOINT

The outside corner looks like a conventional miter.

The joint interlocks and must be slid into place.

A sliding miter joint offers the clean look of a mitered outside corner with the strength of a mechanically interlocking joint. The Lane Company has used this joint for decades.

*Applying production techniques* to an old idea, the Lane Company has made millions of hope chests in its Altavista, Virginia, factory since it was established in 1912.

# Two fathers-in-law make a chest for their shared son and daughter

*With roots in Texas and California,* this walnut bow-front chest was the product of an unusual collaboration between two far-flung fathers-in-law.

"KEN, WE HAVE TO CONFER." With these words, spoken across a crowded living room, John B. Stokes initiated a most unusual collaboration. John B. thought his future daughter-in-law, Jenna, needed a hope chest. When he first met Jenna's father, Ken Cowell, a professional woodworker, and saw the way he'd furnished his house with many fine pieces he'd made, John B. had an idea. The two men withdrew to Ken's shop to discuss it.

He proposed that the two fathers work together on a hope chest. If Ken would provide his shop and his expertise, John B., who lives on a farm in Texas, would fell a walnut tree, cut it into planks, dry it, and haul enough boards to Ken's shop in California to make the hope chest. (As it turned out, John B. felled an aromatic cedar tree, too, and the wood from that was used inside the chest.)

Since the gift was to be a surprise, all the planning and the work had to be done secretly. The men juggled vacations and cross-country travel on the quiet. Ken did the designing and some preliminary work in preparation for making the piece, but for the most part he waited until John B. arrived before starting construction. They set aside the two weeks prior to their Christmas deadline to build the chest.

Two weeks might have been a comfortable amount of time to build a simpler chest, but the design Ken produced for the chest, with its double-curved bow front, required some of the most technically difficult cabinetry. To produce the curves in the front rails, panel, and drawer front, the two fathers used bent lamination. They built curved bending forms and then sliced some of the walnut into pieces thin enough to conform easily to the curves. They then glued a stack of these thin pieces on the bending form. When the glue dried, they had the curved parts they needed.

A year and a half went by from the initial meeting of the minds between John B. and Ken to the deadline day. They finished just in time. How close was it? Let's just say that if lacquer weren't a finish that dries virtually on contact, the chest would have been a little sticky on Christmas morning.

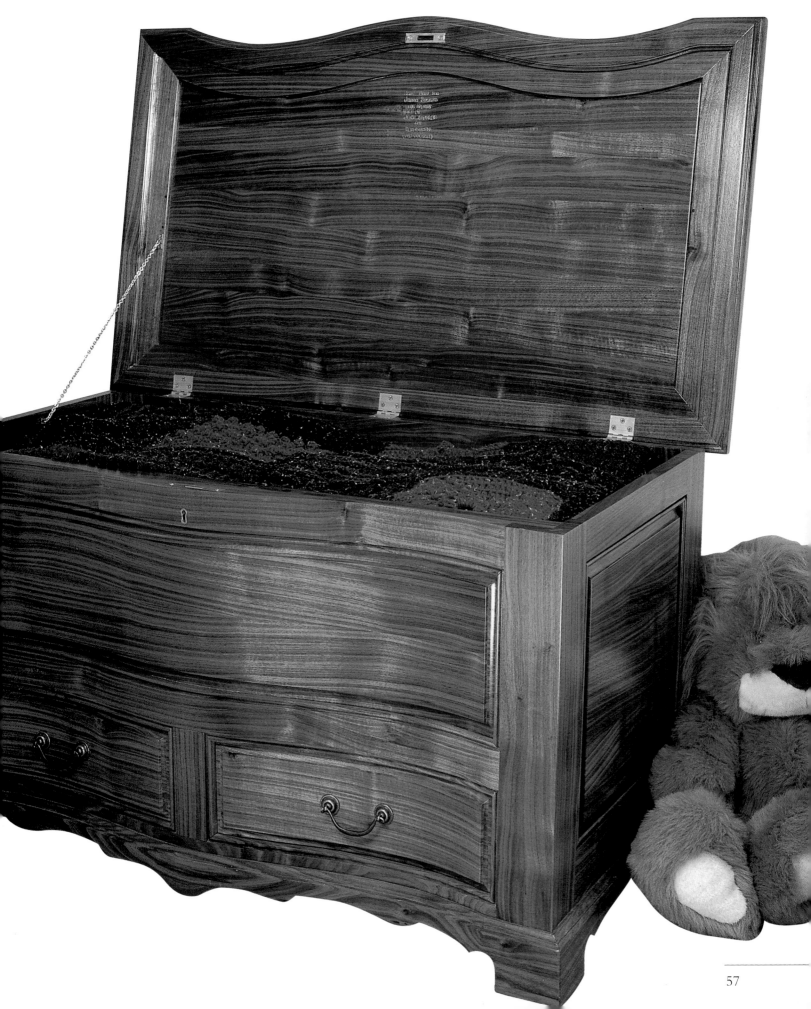

# Tricking the eyes
# with tumbling blocks

*Precision is paramount* in cutting the blocks for the chest's surface. If the angles are off even slightly, accumulating error soon destroys the pattern.

THE SURFACE OF KERRY MEDINA'S HOPE CHEST is three-dimensional. Or is it? With blocks that appear, depending on where you stand and what your eye focuses on, to be sticking inward or outward and going up or going down, it is hard to tell. Look at them long enough and the blocks even seem to flip in and out.

Kerry made the pattern by cutting solid wood of three species—walnut, oak, and maple—into diamond-shaped blocks. Then he glued the ¾-in.-thick blocks onto a backing board of plywood. The different colors of the three kinds of wood create effects of light and shadow, and the grain on the pieces contributes to the illusion of depth in the composition.

Making a pattern with thick wood blocks glued down to another surface is termed parquetry, as in a parquet floor. Parquetry is distinct from marquetry, which involves making a pattern by gluing down thin pieces of wood, or veneers. For Kerry, precision in cutting out the blocks was of primary importance. Had the angles been off even a fraction or the sizes of the blocks varied at all, the errors would have accumulated and ruined the pattern.

Kerry's mysterious parquetry invites comparison with the tricky pictures of the Dutch artist M. C. Escher. Many of Escher's drawings show images the mind knows are impossible—but the eye isn't so sure. One drawing, "Ascending and Descending," done in 1960, shows figures on staircases going up, down, and in the same direction continuously. Kerry took the Escher inspiration one step further, rotating a few of the blocks at random, so they don't conform with the general pattern. Just as the eye finds a point of reference, it's tricked again. The only way to solve the mystery is to walk up to the chest and touch it—what you will feel is a perfectly smooth, flat surface.

*Hard to figure and hard to make,* the oak, walnut, and maple blocks that form the surface of this chest create a compelling illusion of depth.

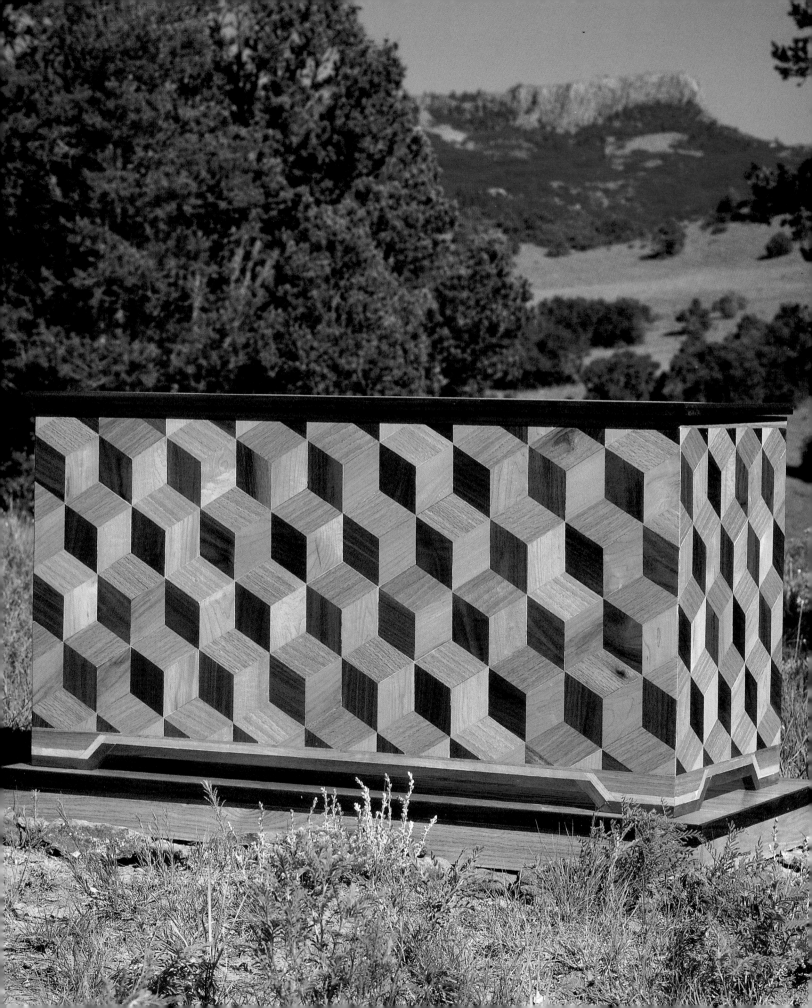

# A hope chest full of hiding places

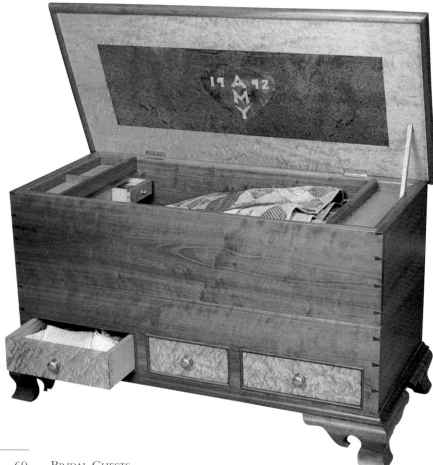

**One more** secret spot in a chest replete with them, this shallow hiding place is created by a false drawer bottom (the drawer shown here is upside down). Thomas Miller built nine secret compartments into this hope chest.

Tom Miller used to spend time checking people into the boards; now he's more likely to be found smoothing boards with a plane. A former professional hockey player with the New York Islanders and Detroit Red Wings, Tom now operates a custom woodworking shop in the barn beside his 1862 stone farmhouse in Ontario.

Right from the beginning of his woodworking business, Tom built a secret compartment into nearly every piece of furniture he made; it became a kind of signature for him. His younger daughter, Amy, always tried to find the hiding places and she usually succeeded.

When Amy turned 19, Tom built her a hope chest. Considering that the chest has a host of hand-cut dovetails, three beaded main drawers, a removable bank of five small drawers inside, and is made from a variety of woods that are difficult to work, it is no surprise that Tom put some 250 hours of labor into the chest. And considering that the chest was for Amy, it is no surprise that it would have to have a secret compartment. Well, it has more than one—nine, in fact. Amy eventually found six of them and Tom showed her the rest. To be sure none of them ever get lost, Tom thinks he might need to draw a map.

*A gift from father to daughter*, this beautifully hand-dovetailed hope chest, made by Thomas Miller for his daughter Amy, continues a centuries-long tradition of hope chests made by family members. The chest is made of cherry with bird's-eye maple drawer fronts.

# Epoxy dots on an effervescent hope chest

**M**ake something fun and original. Those were Greg Zall's instructions when he received the commission to build this hope chest. His answer was to create a functional chest with a straightforward shape but with an effervescent pattern of black bubbles fizzing up from its black base onto its maple sides.

Greg lives in northern California but received the commission through Pritam & Eames, a gallery in East Hampton, New York, where he sometimes shows his work. The first challenge was to get a transcontinental commission off the ground. It took several weeks of phone calls, letters, faxes, drawings, and samples sent back and forth across the country before he and his clients agreed on the design. In the course of these conversations, Greg built prototypes and made up samples of wood, inlay, and finishes. Once the chest was fully designed and drawn, he began what he called "the easy part," actually building it.

To build the body and lid of the chest, Greg used maple with pronounced figure called quilted or fiddleback, which is traditionally used in making stringed instruments. Wood with good fiddleback figure has an iridescent quality and the surface appears deeply corrugated when in fact it is perfectly smooth. To make the dots on his hope chest, Greg used a somewhat less traditional material: epoxy. After considering other options, he concluded that filling holes with black glue instead of inlay would be far simpler. Like the chest itself, the contrast is original and fun.

*Black dots on the maple box* **create the playful effect of effervescent bubbles. The dots are made of black epoxy; the base is ebonized mahogany.**

*A cross-country commission* **led San Francisco furniture maker Greg Zall to make this hope chest. The lid's upswept ends lend it an Oriental flavor.**

# Tool Chests

## *The Craftsman's Calling Card*

A N 18TH-CENTURY journeyman cabinetmaker walks into a furniture shop to apply for a job. He sets down the tool chest he made as an experienced apprentice. It is a stout but humble box, painted a drab color and covered with nicks and scuffs. Then he opens the lid, revealing rows of neatly kept and beautifully sharpened tools. Inside the lid and on the drawer fronts are displays of banding and marquetry in exotic veneers, and all the carefully fitted drawers and dividers demonstrate a sure command of joinery and detail. From a single glance into the chest, it is clear this journeyman is organized, efficient, respectful of his tools, and well versed in their use. On that basis, the job is his.

There may often have been more to such a job interview than a look at the applicant's tool chest, but then as now, a craftsman's tool chest was a clear reflection of his abilities and inclinations. When a chest is made by its user, it amounts to a self-portrait. This marks out tool chests from most other types of chests and makes them nearly as various as the people who build them.

The traditional European-style cabinetmaker's chest is an example of a design that remained constant for centuries as it was handed down from

*Every craftsman* is a collector of tools, and every tool chest is a showcase. Some are simple, some high-flown, but every one is a reflection of its maker.

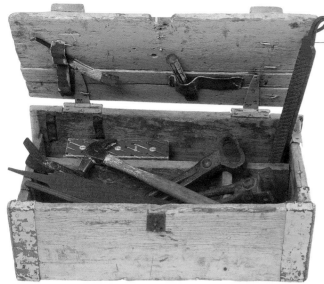

*Humble yet highly efficient,* **this rough chest was made to hold tools for shoeing horses.**

*The classic cabinetmaker's tool chest* **was built to hold all his hand tools. Such chests typically had a rough, blandly painted exterior and a finely detailed and finished interior.**

master to apprentice. Built to house a cabinetmaker's entire complement of hand tools, it was a low and heavy lidded box that sat on the floor. Inside, a sophisticated arrangement of wells and sliding trays and tills with drawers provided organized storage for tools ranging in size from try planes and bowsaws to tweezers and finger planes.

These chests did their job admirably, but by the end of the 19th century the rise of mechanization had made the chests and many of the hand tools they were designed to hold—not to mention the craftsmen who used them—virtually obsolete.

With the proliferation of machines for mass production, a new class of craftsman was born—the machinist, a metalworker skilled in making parts for machines. With the new trade came a new kind of chest. The machinist's chest, designed to hold smaller tools and fewer of them, was typically about one-fourth the size of the journeyman's chest. Instead of sitting on the floor, it was generally placed on the workbench or on a table nearby. Since a machinist's tools were small and made of metal, most of the storage was in shallow drawers lined with felt. The very joinery of the machinist's chest expressed the passing of highly skilled work in wood. Factory made, machinist's chests replaced traditional dovetails and mortise-and-tenon joints with tongue-and-groove and dado joints, which are more easily accomplished by machine.

The traditional cabinetmaker's chest and the machinist's chest are but two of the scores of shapes that tool chests take. Unlike blanket chests, for example, which tend to conform to a basically cofferlike overall shape, tool chests can be wall-mounted, built-in, tabletop, or portable, and they can sit on the floor with a lid or on a stand with doors and drawers.

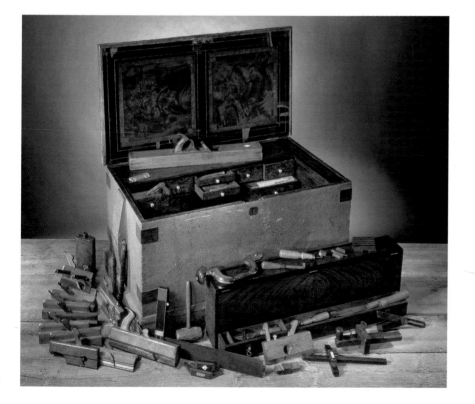

Across all these variations, one essential requirement drives their design: excellent organization. They need maximum storage with unimpeded access. For storing half a dozen blankets, an undivided box is perfect, but try putting 400 small tools in the same box and it becomes clear that classifying your tools and separating them for storage by type, shape, and frequency of use is the first requisite of tool-chest planning. In this department, one tool chest stands above the rest: the one left behind by piano maker H. O. Studley. Exercising a rare genius for spatial organization, Studley nestled the many tools of his exacting trade in an arrangement that is both elegant and extraordinarily dense.

But not everyone needs hundreds of tools close at hand or is willing to spend 30 years perfecting a toolbox. The rancher who nailed together the simple lidded box shown in the top photo on the facing page created a chest with no pretensions to elegance but one that would have served its purpose—shoeing horses—perfectly well. Despite its roughness, it is carefully considered, with dividers in the box and metal straps on the lid providing the means to keep the ferrier's tools organized, separated, and close at hand.

The tool chest has one last function. Many craftsmen go through life making lovely objects for others, either selling their pieces or giving them away. A craftsman's tool chest may keep him from being entirely empty-handed when it comes to his own work; it is one thing he might actually keep.

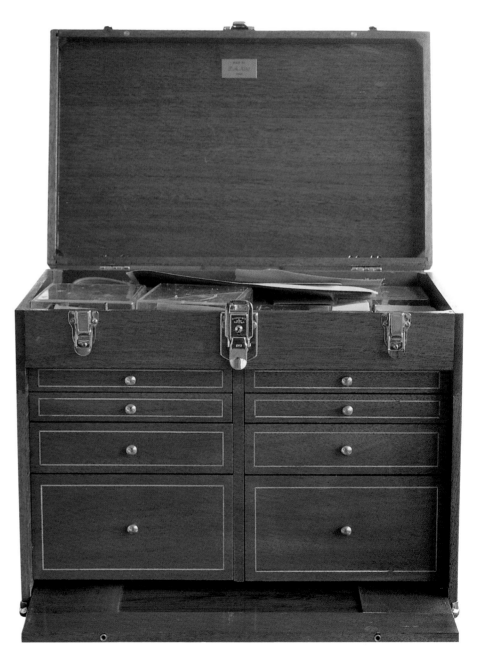

*Made for machinists,* this type of tool chest provided shallow, felt-lined drawers for the small tools of their trade. The machinist's chest, which generally sat on a table or benchtop, marked a departure from the much larger floor chests used by cabinetmakers.

# The peerless tool chest of H. O. Studley

*Almost lost among the tools* **but no longer obscure to history, the name of the maker, H. O. Studley, and his Massachusetts hometown of Quincy are engraved on small plates just above his brace.**

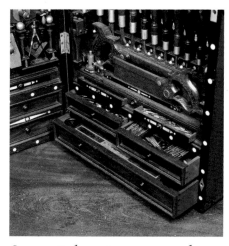

*Scraps of ebony, ivory, rosewood,* **and mother-of-pearl left over from his work as a piano maker gave Studley raw material for his tool chest and many of the tools it contains.**

MASSACHUSETTS PIANO MAKER HENRY STUDLEY built his magnificent tool chest over the course of a 30-year career at the Poole Piano Company. The chest lived on the wall near his workbench, and he worked on it regularly, making changes and adding new tools as he acquired them. Using ebony, mother-of-pearl, ivory, rosewood, and mahogany—all materials used in the manufacture of pianos—he refined the chest to the point that now, some 75 years after his death, it remains in a class of its own.

Considering how many tools it holds, the famous chest is really quite small; when closed, it is just 9 in. deep, 39 in. high, and just more than a foot and a half wide. Yet it houses so many tools—some 300—so densely packed that three strong men strain to lift it.

For every tool, Studley fashioned a holder to keep it in place and to showcase it. Miniature wrenches, handmade saws, and some still unidentified piano-making tools each have intricate inlaid holders. Tiny clasps rotate out of the way so a tool can be removed. In places the clearances are so tight that the tools nearly touch. The chest, which hangs on ledgers secured to a wall, folds closed like a book. And as the chest is closed, tools protruding from the left side nestle into spaces between tools on the right side. Amazingly, despite being so densely packed, the tools are all easily accessible.

*Planning is paramount* **if you want to follow in Studley's footsteps. Murray Kernaghan, a Canadian woodworker, spent the better part of a Manitoba winter studying photos, making drawings, even corresponding with curators to learn as much as he could about the chest. By the time he was finished building his simplified Studley, it had consumed some 350 hours, much of that time devoted to planning.**

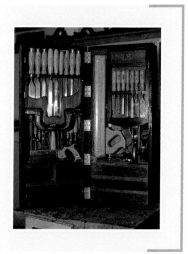

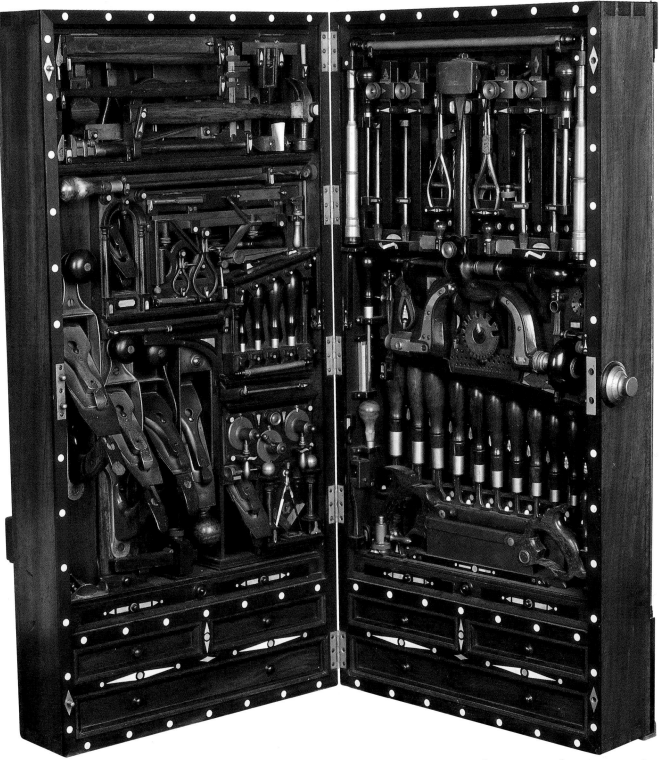

Studley was well into his 80s before he retired from the piano company. Before he died in 1925, Studley gave the tool chest to a friend. That man's grandson, Peter Hardwick, loaned the chest to the Smithsonian in the late 1980s and later sold it to a private collector in the Midwest. The current owner loans the chest to the Smithsonian National Museum of American History in Washington, D.C. from time to time.

*Packing more tools per square foot* than seems physically possible, piano maker Henry Studley's unrivaled tool chest also manages to be beautiful in the process. The chest stands as perhaps the most exquisite example of 19th-century tool-chest craftsmanship.

# A traditional tool chest
# with a twist—and a history

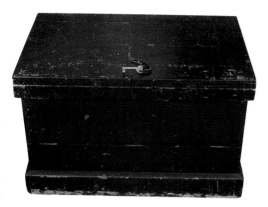

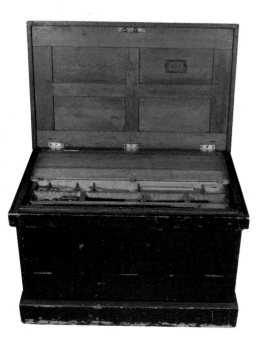

*A simple exterior* belies the rich array of tool-filled compartments within. The 19th-century painted pine chest holds some 400 tools, many of them marked with their owner's name, J. Hilton.

WHEN A CONNECTICUT PATTERNMAKER NAMED J. HILTON built this chest for his tools sometime in the mid-1800s, he followed the style that had been traditional for cabinet-makers' and joiners' chests for centuries: a basic lidded box about 3 ft. long, 2 ft. high, and 2 ft. wide made of heavy planks and reinforced with skirt boards around the bottom and the lid.

Such boxes were made to hold and organize hundreds of tools (this one holds more than 400), which was done efficiently by using a system of lidded trays and tills with drawers. The trays and tills slid back and forth on waxed runners to afford access to the storage wells for larger tools at the bottom of the chest. But with so many tools in such a tight space and accessible only from above, getting at the tool you wanted was not always simple. Hilton's one major departure from tradition addressed this short-coming. In Hilton's chest, the entire front section folds out, providing direct access to the 12 drawers in the chest and to several layers of trays in the hinged front section.

Hilton's tool chest, with its full array of molding planes and other specialty tools, is an expression of hand-tool woodworking in full flower. But that flowering had finished for good by the 1920s, when Hilton's grandson, who inherited the chest, traded it with all its tools for a car. After spending the next 70 years undisturbed in an attic, the chest was bought recently at an estate sale by Ken Newell, a tool collector in Maryland.

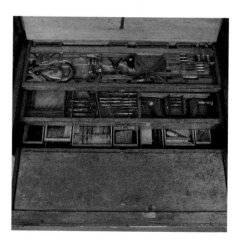

*French-fitted tools* lie snugly in re-cesses cut precisely to their outline. A higher evolution of painted outlines on a wall of hanging tools, French-fitted com-partments make it simpler to return every tool to its intended spot and raise a visual alarm when any tools are missing.

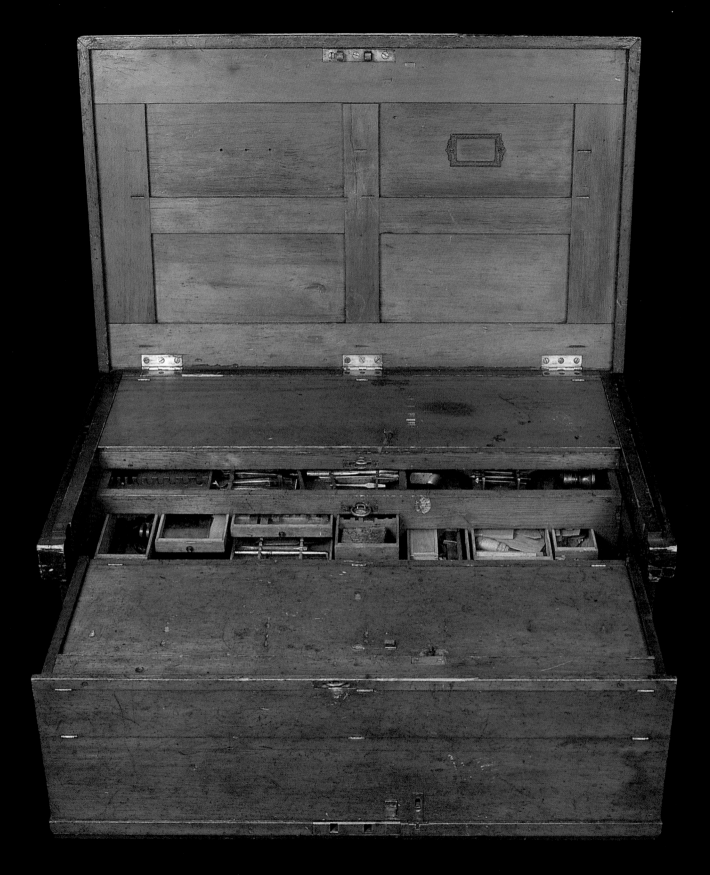

*A twist on history,* the front section of this chest was made to swing forward on hinges, providing better access to the drawer till behind it. Otherwise, the chest is modeled on a traditional cabinetmaker's chest.

# Two approaches to the portable chest

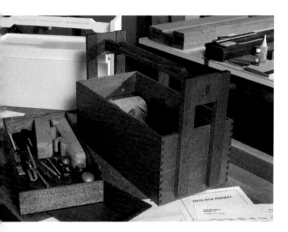

*A prototype paves the way* for a smooth transit from first sketches to a finished piece. California woodworker John Barbee made full-scale drawings from his initial sketches and then built a full-scale mockup in foamboard.

## A SLIDING TOP

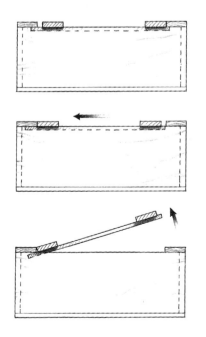

CARL SWENSSON, A HIGHLY REGARDED PRACTITIONER AND teacher of Japanese woodworking in Baltimore, does most of his woodworking in his basement shop. But when he teaches or does an installation, he carries his tools in this simple, sturdy chest. With its inset ends it is easy to pick up, and it stacks securely on other boxes of the same type. The sliding lid locks in place with a push but can be lifted right off the box.

The modest tool chest is a favorite teaching project for him. In the course of making one, a student learns the fundamentals of Japanese joinery and hand-tool techniques. Carl takes this one with him as a sample when he goes to class. The little chest holds nearly all the tools it takes to build another just like it.

Carl has his students make the chest from a single plank of wood. He shows them how to use a Japanese ripsaw to resaw a portion of the board for the thin lid and bottom of the chest. He has them plane all of the parts flat and smooth with wooden Japanese handplanes and hand-cut the through mortises with a mallet and chisel.

When John Barbee built his portable tool chest, he left nothing to chance. He knew just the tools he wanted it to hold, and he didn't want to find when the chest was finished that a tool or two would have to stay behind. To make sure the tools would all fit easily and that the loaded chest would be well balanced, he built the box twice. Before building the finished piece in mahogany, he made a full-scale prototype.

Prototyping, a common practice in industry, is gaining popularity among craftsmen building one-of-a-kind pieces, who value the chance to evaluate the proportions and detailing of a piece before building the real thing. The trick is to find materials for the prototype that can be shaped and joined very quickly. For the prototype of his toolbox, John used foamboard, which can be cut with a razor knife and joined with brads.

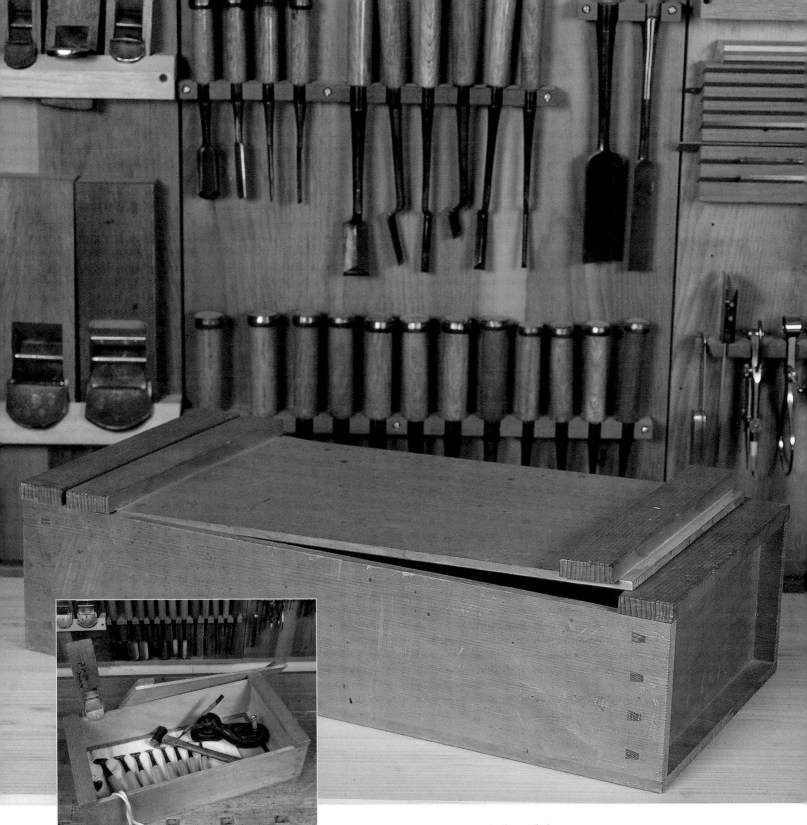

*Tools of a teacher's trade* nestle in Japanese woodworker Carl Swensson's portable tool chest. He uses the chest as a project to teach the rudiments of Japanese woodworking.

*A clever lid* gives this simple, light box an elegant utility. Pushed toward one end, the lid locks in place; pushed toward the other, it can be lifted free.

# Sometimes a chest is made in jest

*For the fun of it,* **Bruce Zeitlin decorated his walnut tool chest with imagery from Roman architecture and mythology. The woman carved at the keystone holds carving tools and a tool chest.**

IT IS TRUE THAT BRUCE ZEITLIN NEEDED A MORE CONVENIENT PLACE to store his tools—they were wrapped up in leather tool rolls—but the real reason he made his over-the-top tool chest was the sheer fun of it.

His walnut chest, with its elaborately carved doors and pediment-invoking imagery of classical antiquity, has the heft of public sculpture. Yet it is destined to remain on a rough workbench instead of a marble plinth. This irony delights Bruce, a computer programmer who proudly refers to himself as an amateur carver—a person, he explains, who carves wood not for profit or practicality but for the pure enjoyment of practicing the craft.

Bruce's folly dependably elicits just the response he'd hoped. When people visit his shop and see the chest, they think he's slightly cracked—talented but slightly cracked, which is just the way he wants it.

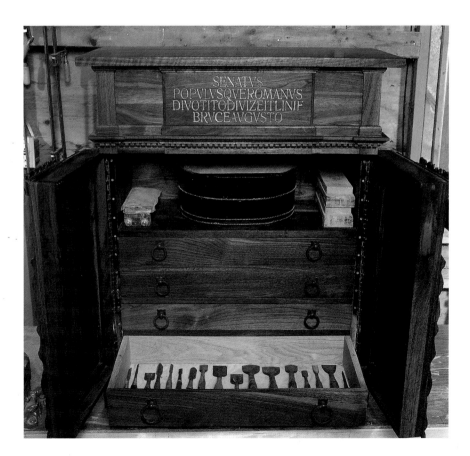

*Japan meets Rome* **in this classically inspired chest built to house custom-made Japanese hand tools. Zeitlin started out imagining a simple box that would be portable and easy to make. Some months later, he wound up with something that is anything but. The trumped-up Latin quote reads, "The senate and people of Rome dedicate this to Alexander, son of Bruce Zeitlin."**

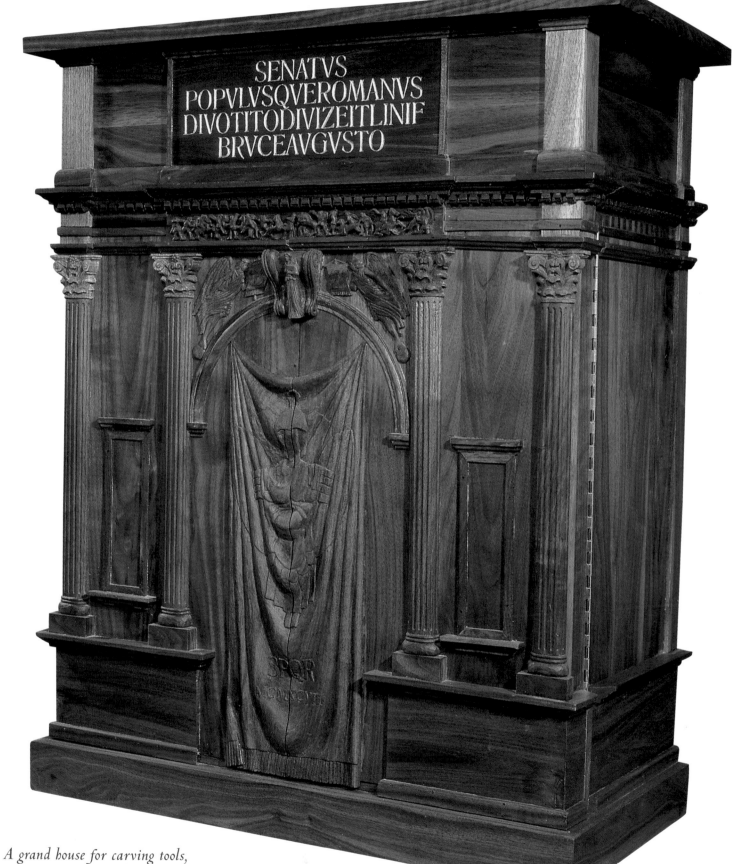

SENATVS
POPVLVSQVEROMANVS
DIVOTITODIVIZEITLINIF
BRVCEAVGVSTO

*A grand house for carving tools,*
this richly carved tool chest was Zeitlin's way of express-
ing his love of the craft of carving. The faint figure carved
in the curtain is evidence of his skill.

# A chest for heirloom tools that is portable—in a pinch

*Slide back the false bottom* and you gain access to the well of larger tools below. The 12-drawer till slides front and back on waxed runners to make access easier. The till can also be lifted right out of the chest if necessary.

CHARLESTON, SOUTH CAROLINA, IS HURRICANE COUNTRY. Architect John Wilson and his wife, Lynne, know they may be faced with evacuation in the face of a huge storm some day. With that extremity in mind, John set out to build a chest that would hold their collection of old woodworking tools (some that John had bought over the years and others that once belonged to Lynne's great-grandfather) and could be moved quickly in the face of a hurricane.

John wanted to make a chest that would honor their family history, too. The tools passed down from Lynne's great-grandfather, George McQuilkin, included chisels, some calipers, a large drawknife, and a couple of handsaws. In a very conscious way, John brought the past into the present by hand-cutting the dovetails in the corners of this new chest using the old chisels. The design of John's chest also owes something to family history. John based the design partly on a sea chest once owned by both McQuilkin and his son, George McQuilkin Jr., and later inherited by Lynne (see the top photo on the facing page).

He built the entire chest (except for the white-oak drawers) from a single plank of mahogany 22 in. wide and some 14 ft. long. He looked a long time before turning up a plank with enough width and figure to suit his chest.

As to portability, well, with its load of tools the chest is awfully heavy. But if four people are each willing to grab a handle, they should be able to get it to the truck before the storm hits.

*Retrieved from the attic* of her parents' home, this chest, which once belonged to Lynne McQuilkin-Wilson's great-grandfather, has become a centerpiece in her home. It also provided Lynne's husband, John, with design inspiration as he planned to build the chest to hold their collection of tools, some of which were passed down from the same great-grandfather.

*Never meant* for the wood-shop, this chest was designed to stand in the living room and store a collection of old tools rather than to be a working toolbox. Its stately proportions and careful detailing, clear-finished mahogany, and exposed joinery combine to give it the feeling of fine furniture.

# H. Gerstner & Sons (daughters, really), maker of fine tool chests

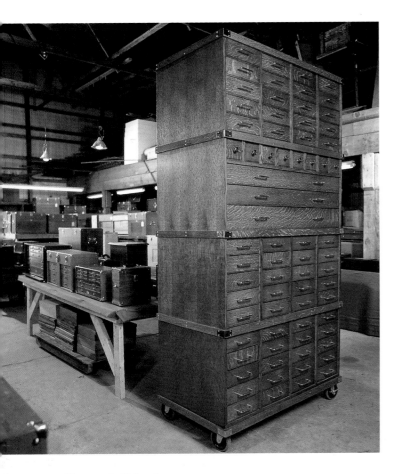

*Chests of all kinds* stream from the Gerstner factory in Cincinnati. In addition to many standard models, the company makes custom chests. The large chest shown in the foreground, made in four stacking sections, was designed to hold parts and tools for a Florida gunsmith.

THE WRIGHT BROTHERS WERE WORKING ON their first airplane when Harry Gerstner made his first tool chest. Gerstner was a 21-year-old journeyman patternmaker in Dayton, Ohio, earning 10 cents an hour—good money at the time—and spending his nights building his tool chest. When the chest was finished, a co-worker admired it and asked if Harry would make him one just like it. Harry agreed and with that sale Harry became a tool-chest manufacturer.

These days, H. Gerstner & Sons makes some 4,000 chests each year. In addition to the machinist's tool chests for which it is widely known, the company also builds humidors, sportsman's chests, and makeup cases. And it will also make custom chests to a customer's specifications.

The Model 52, seen in the photo on the facing page, is Gerstner's largest-selling tool chest. It has 10 drawers and a 3-in.-deep top compartment long enough for a 2-ft. level or scale. The tall, narrow drawer in the center is sized to hold the bible of the trade, the *Machinist's Handbook*. The chest will fit nicely on a benchtop and house a fairly good-sized collection of tools. When Harry Gerstner sold that first chest to his co-worker, he charged $5—a week's wages. The Model 52, available since at least 1934, costs approximately $750 today—still roughly a week's wages for a journeyman.

Gerstner named his company H. Gerstner & Sons hoping that one day he would bring his yet unborn sons into the business. He and his wife, Emma, never did have any sons. They did have three daughters, and today third- and fourth-generation family members run the company.

*In demand since 1934,* the Model 52 machinist's chest remains H. Gerstner & Sons' biggest seller. The chest's shallow drawers, sized for machinist's tools, are all hand-fit and lined with felt. Most models have a locking front cover that tucks out of the way in a slot below the bottom drawer.

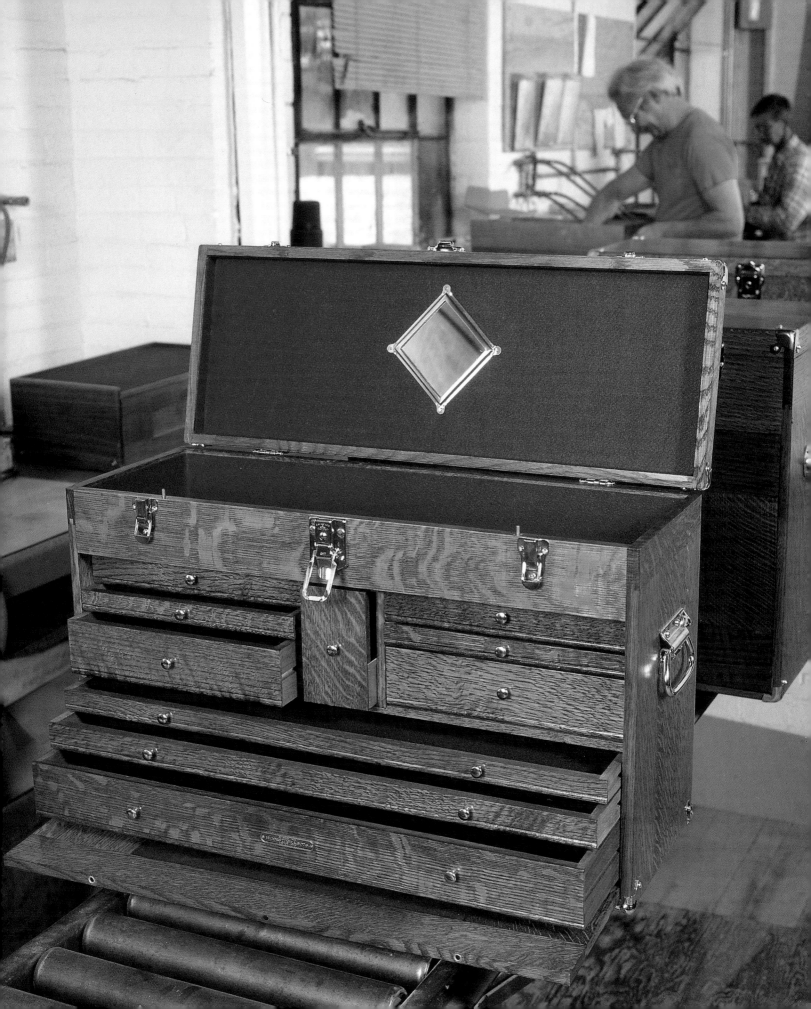

# A machine-made chest
# for a master of hand tools

**Decorative yet as strong** as a dovetail, the cove-and-pin joints locking this chest together at the corners were made entirely by machine.

## A COVE-AND-PIN JOINT

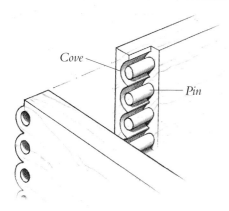

Cove

Pin

HENRY RADO WAS A METALSMITH in the late 1800s. He worked his art in precious metals, producing jewelry, silverware, and other decorative metalwork at Tiffany & Co. of New York. The tool chests he left behind contain more than 700 of the files, gravers, chasing punches, hammers, and chisels he used to coax metal into beautiful shapes and patterns.

Rado's oak and walnut tool chest, now part of the Smithsonian collection, is an example of the work that was produced as newer machinery came along to mechanize the woodworking industry. The unusual corner joint that still holds the chest together so well was vogue in the 1880s and '90s. Called a circular dovetail, or cove and pin, the joint could be fabricated entirely by machine.

In the last decades of the 19th century, factories mass-produced thousands of drawers and chests using the Wisconsin Dovetailing Machine to cut the circular corner joints. A hollow drill, something like a core drill or a plug cutter, formed the pins. It drilled down into the end grain of the piece, shaping the pin and the circular recess. This was repeated along the width of the board at regular intervals. The tails were formed by first drilling holes to accept the pins, then making the scalloped cuts along the ends of the tails, the most demanding part of the joint.

It is ironic that Rado, who made his living working metal entirely by hand, chose to store his hundreds of tools in a chest made entirely by machine.

*A jeweler's tools* were housed in this chest. Henry Rado, an artisan in metal at Tiffany & Co., used this tool chest and left it filled with tools of the metalsmith's trade—more than 700 files, gravers, chasing punches, hammers, and chisels.

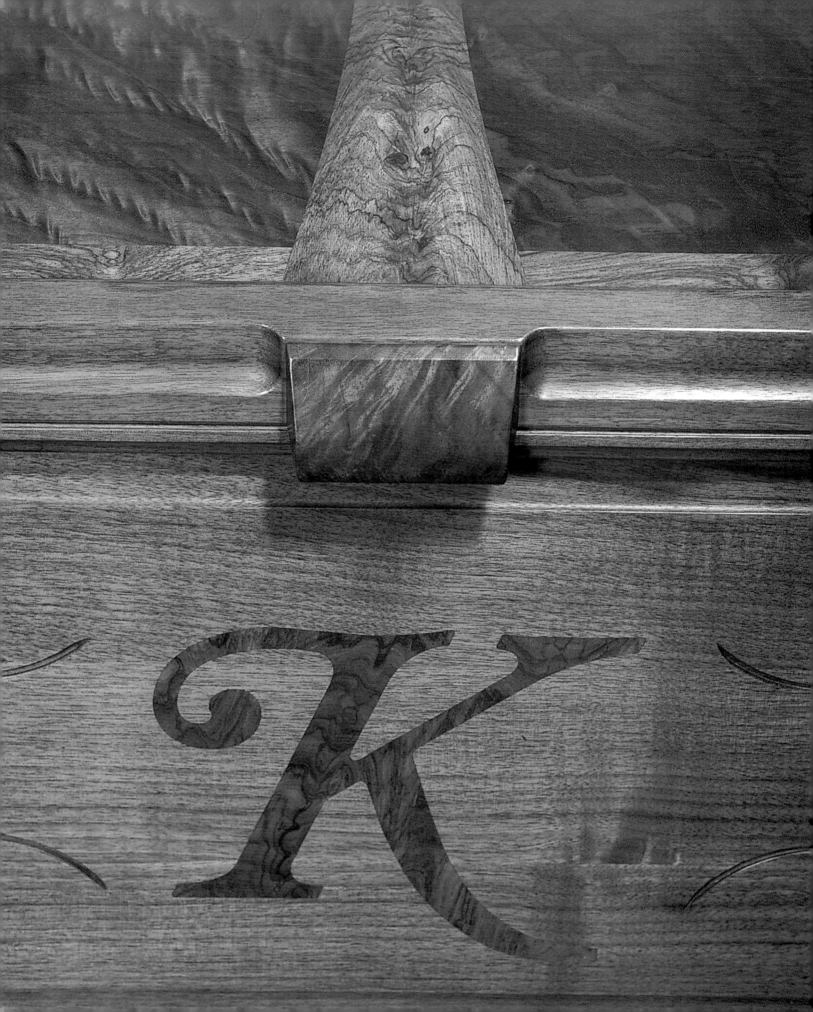

# Blanket Chests

## *Warmth in a Large Box*

O PENING A BLANKET CHEST CAN become something of a ritual. When the lid is raised, the fragrance of cedar, wool, and linens wafts up, and those sweaters and heavy blankets that have gone unseen all summer get pulled out—it's fall again.

The blanket chest is as old as any known form of furniture, yet it retains its usefulness today. As civilizations have come and gone, furniture forms have evolved, multiplied, and died off. Through it all, the blanket chest has remained remarkably constant.

Chests for linens and blankets were used in classical antiquity; these were lidded wooden boxes a few feet long and about knee high, their interiors one undivided open space. And at the foot of your bed? Quite likely something similar. It's not that all types of chests have stayed the same. There's very little call for a doubloon chest these days or a manuscript chest, a wagon chest, or a chest for everyday clothes or kitchenware. All these forms of the chest have become obsolete. Blanket chests persist because a large, undivided space is still the best place to store bulky, foldable things.

Before closets became common in the 19th century, chests were used for all sorts of household storage. At first, most chests were undivided inside.

*A basic box,* **undivided inside, is typically what's used for storing blankets—a far cry from the elaborate divisions and subdivisions required to store a collection of tools, for instance. But while blanket chests often conform to a standard format, they have been made in a dizzying array of styles.**

But storing small items of daily use in such a space is inefficient at best. So chests were soon fitted with various trays and dividers and altered for special contents. In response to particular needs, the whole form of the chest began to change.

The wardrobe and the chest of drawers both developed from the blanket chest and soon monopolized the business of storing clothing. Hutches and cupboards appeared for kitchenware and food storage, along with secretaries and bookcases for the study and many other specialized cabinets.

Although the function and layout of blanket chests remained constant, their appearance responded to the trends in construction technique and style. They've been dovetailed at the corners, made in frame-and-panel fashion, and put together with nails or screws. More recently, blanket chests have been made with plywood and manmade sheet goods covered with veneer.

Chests to store clothing and blankets have long been made—or lined—with fragrant woods. In the East, camphor was the wood of choice, while in the West, cedar was commonly used. In both cases, the aroma of the wood, which is pleasing to people, is reputed to repel moths and other insects that damage woolens. That there is scant scientific evidence to confirm this has not prevented blanket chest makers from using cedar and camphor as a matter of course.

There is a wide variety of cedars, but the species typically used for lining blanket chests and cedar closets is Eastern redcedar (*Juniperus virginiana*), also known as aromatic cedar and juniper. Eastern redcedar, which grows throughout much of the eastern United States, was once the tree of choice for making pencils, but dwindling supplies forced pencil manufacturers to turn instead to the lofty incense cedar, a native of Oregon and California.

Cedar is so prevalent as a lining in blanket chests and makes its presence known so pungently that people often skip the "blanket" and call these containers "cedar chests." But whatever you choose to call them, the evidence indicates that a big open box is still the best way to store blankets.

*It wasn't always wood* that protected blankets. Although a cedar lining has lately become synonymous with the blanket chest, this copper chest would handle the job equally well.

*Drawers made a blanket* chest more useful. They made the lidded well easier to reach into and provided easily accessible storage below. This simple, 19th-century New England chest is similar in appearance to many Shaker chests.

*The blanket chest continues to evolve.* This cushion-topped chest made by Berkeley Mills has sliding doors instead of a lid. Because the piece doubles as a bench, it is convenient not to have to lift the top to reach the contents.

# Beauty in utility

THE NOTION THAT SOMETHING SIMPLY BUILT is inherently beautiful shines through in Shaker work. Although most of the Shakers are gone, their lasting gift of furniture design lives on.

The Shakers would be nearly forgotten by now as a fervent Christian sect if it were not for their furniture. Throughout the 19th century as furniture attracted more and more ornament, the Shakers aimed the other way, paring their pieces down to the bare bones. Their designs were to be first functional, then beautiful. Exposed joinery, drawers beautifully graduated in size, and chairs reduced to their simplest elements all characterize the Shakers' far-reaching influence on furniture design.

The Shakers, who valued self-sufficiency, supported themselves in part by making furniture for sale. Their beautifully unadorned and utilitarian designs appealed to a broad market at the time and they still do. Many Shaker designs and variants of them are being produced by craftsmen today.

This original blanket chest was built at the Union Village Shaker Community in Warren County, Ohio. Exemplifying the Shakers' notion that beauty and purpose are closely tied, the dovetailed walnut chest is completely functional with little decoration. Carefully considered proportions and fine craftsmanship give the chest its stature. The relatively fancy scalloped base is perhaps a concession to the worldly market.

It is sometimes forgotten that the Shakers not only embraced the latest manufacturing technologies but also improved on them. For example, Tabitha Babbitt of the Harvard, Massachusetts, community did nothing less than revolutionize woodworking in 1810 by dreaming up the circular saw, offering yet another gift to furniture makers.

*The ultimate joint for chest corners,* **the hand-cut dovetail is highly prized for its beauty, simplicity, and strength.**

*Pure forms characterize Shaker furniture.* **The case of this blanket chest from a Shaker community in Ohio displays a straightforwardness common in Shaker work, but the more lighthearted scalloped base is somewhat atypical.**

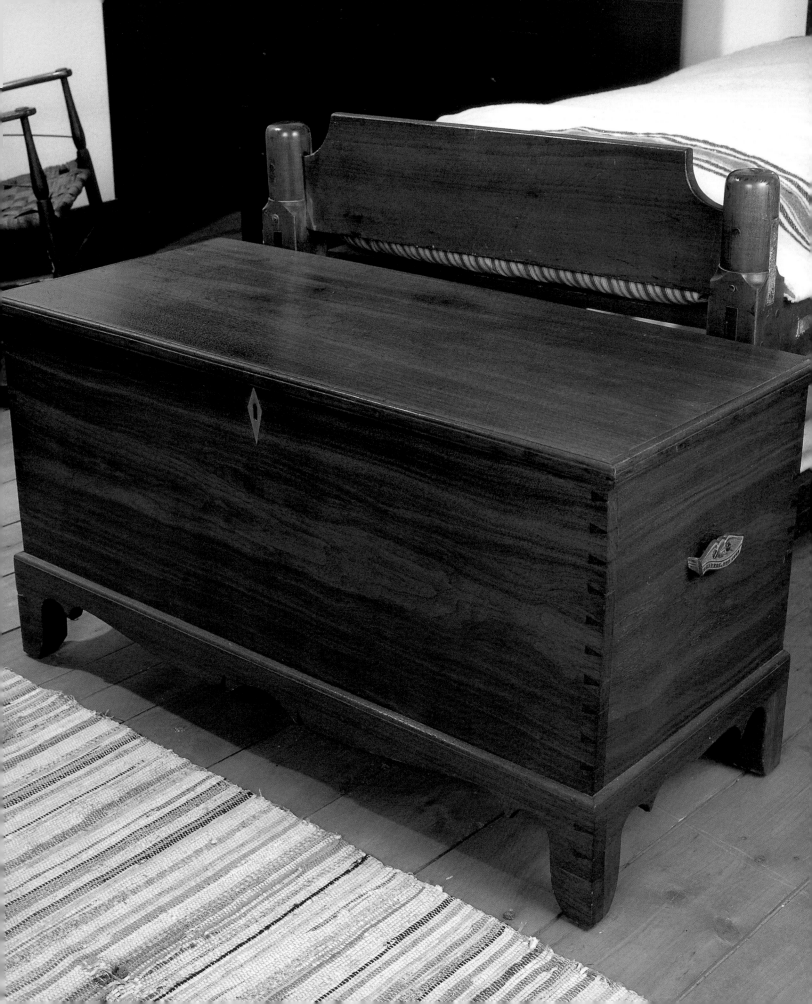

# A carved chest by Jean Clemens, daughter of Mark Twain

*Father and daughter* were quite close, and Jean Clemens' early death left Mark Twain bereft. This photo was taken in 1909, the year Jean died.

*Mark Twain* kept his daughter's chest and her carving tools after her death at age 29. Jean Clemens' work now stands beneath a portrait of her father in the Mark Twain House, a museum in Hartford, Connecticut.

WHEN YOU CONJURE UP IMAGES OF AMERICANS in the latter part of the 19th century, you think of steamships and horse-drawn carriages. You see gentlemen in waistcoats and top hats. The ladies are in hoop skirts, perhaps sewing by the fireside. Certainly the ladies are not in a woodshop carving chests. Or are they?

Around the turn of the 20th century, the Arts and Crafts movement was gaining a broad popularity. Preaching the honesty of craft, it inspired the middle and upper classes to work with their hands. Many young men and women began to dabble in clay, fabric, glass, wood, and metal. Few of them did this for a living—the modern hobby was being born.

Jean Clemens, Mark Twain's daughter, took up woodworking and carved several chests when she was in her 20s. Clemens was no doubt affected by the upsurge in interest in crafts, but for her carving was more than a casual hobby. That's clear from the high quality of her work but also from her history. She had epilepsy, a disease much feared and misunderstood a hundred years ago. The treatment at the time required long stays in sanitariums, and Clemens spent much of her life isolated in that way. It is thought that she took up carving as a form of occupational therapy, possibly prescribed by a doctor.

The family traveled as far as Sweden seeking a cure for her affliction, and between stays at sanitariums she lived at home. When she died on Christmas Eve, 1909, at the age of 29, it broke her father's heart. Shortly after her death, he wrote, "I know now what the soldier feels when a bullet crashes through his heart." He kept the chests she had carved and the tools she used to carve them for the rest of his life.

*Heartfelt carving* of a high caliber graces a blanket chest and tool box by Mark Twain's daughter, Jean Clemens. Afflicted with epilepsy, Clemens did much of her carving while isolated for treatment.

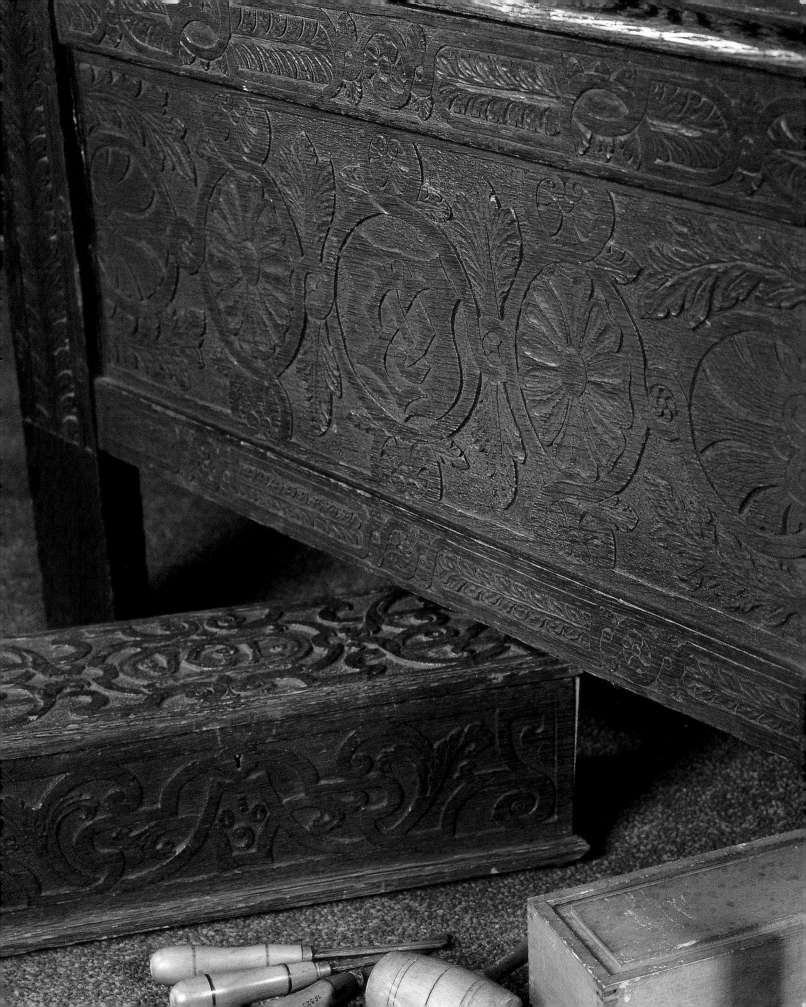

# A blanket chest for the man who brought furniture to the masses

S TARK, SOLID, AND SLIGHTLY MEDIEVAL, this oak blanket chest built in Gustav Stickley's Craftsman Workshops for use in his own home embodies the values that launched the Arts and Crafts movement. Stirred first in England by the writings of critic John Ruskin and the furnishings of William Morris and his circle, the movement strove to revive a world of honest craftsmanship. Rough, humble medieval furniture provided an inspiration for Morris and others, offering a vivid counterpoint to Victorian ornamentation.

Stickley was among the first American furniture designers to adopt the straightforward style. He produced a line of oak furniture made with thick, heavy timbers and ornamented, if at all, with rugged wrought iron or hammered copper hardware. In the process, Stickley became one of the chief proponents of Arts and Crafts, and his magazine, *The Craftsman*, gave its name to his particularly solid strand of the style.

The ray-streaked quartersawn oak used in this chest is a signature of Stickley's furniture, as is the very restrained detailing: Just simple curved corbels flanking each panel elevate the woodwork in this chest from the purely utilitarian.

*Arts and Crafts* started in England, where this ruggedly attractive chest was made in the 1890s by Sidney Barnsley. Gustav Stickley admired the honesty, simplicity, and hand-cut exposed joinery of English Arts and Crafts designs and adapted the ideas in America. The philosophy behind the Arts and Crafts movement was imported from England along with the aesthetic.

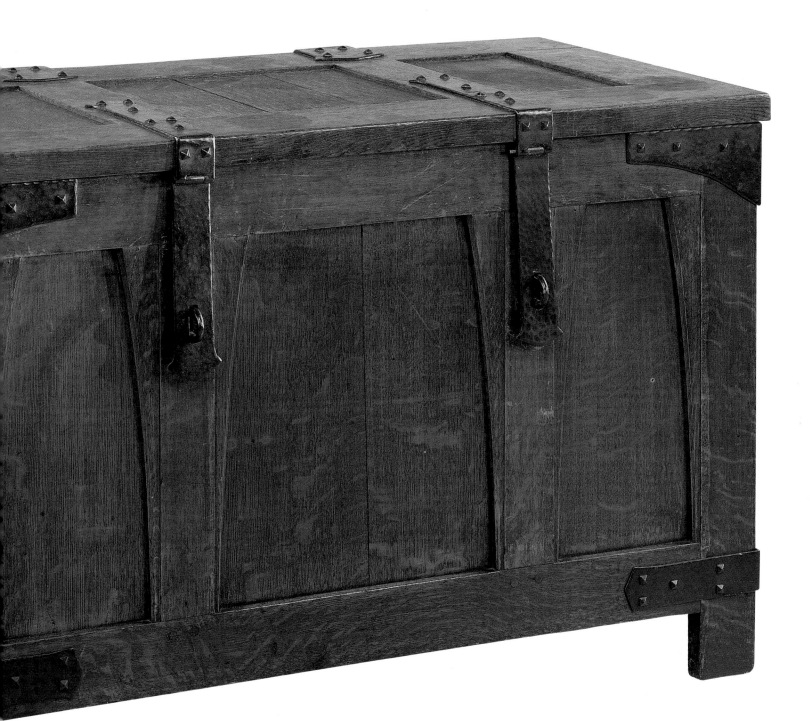

Somewhat paradoxically, Stickley's furniture, which had such a strong influence in a movement founded on the sanctity of handwork and the individual craftsman, was itself mass produced. And in a second twist, these factory-made pieces, consigned to the attic if not the trash heap for much of the 20th century, are now collected avidly and priced as though they had been made as individual works of craft.

*Medieval massiveness* in the timbers and the ironwork gives Gustav Stickley's furniture a powerful bearing. Early Arts and Crafts furniture makers in England were inspired by the forthrightness of medieval woodwork and the honesty of handcraft. Stickley's Craftsman furniture translated the style for an American clientele.

# An exploration of Arts and Crafts style

ARTS AND CRAFTS, THE PARED-DOWN FURNITURE STYLE that had its heyday in the decades just before and after the turn of the 20th century, was a reaction against the excessive ornament of the Victorian era. Despite being simple and shorn of decoration, however, the best of Arts and Crafts furniture used proportion and careful detailing to create pieces with a strong presence. These subtleties are part of what attracted aerospace engineer Paul Babcock to the style. Paul built this blanket chest, inspired by a Gustav Stickley chest, while he was taking a woodworking class at Cerritos College in Norwalk, California.

Paul wanted to build his chest with plain, wide quartersawn oak planks, but he wanted to give the piece some texture. He did it by joining boards that differed slightly in thickness. To keep the lid from looking like one flat slab, for instance, Paul built it with planks of three different thicknesses. The end boards are thickest and the center panel is thinnest. The boards are flush on the underside of the lid, but the three thicknesses create stepped elevations on the top of the lid. The joinery was tricky, but it paid off by creating the visual interest he was seeking. It was exactly the sort of keen detail Paul always appreciated in Arts and Crafts furniture.

## QUARTERSAWN OAK

*Quartersawing generally produces extremely straight and regular grain.*

*Ray fleck*

*The face of a quartersawn board is cut along the radius of the tree trunk.*

*Medullary rays*

*Growth rings*

*In oak trees, the medullary cells, which radiate from the center, are large and produce oak's distinctive ray fleck.*

*Adopting the Stickley style,* **Paul Babcock built his blanket chest with only the subtlest of decoration. To create visual texture with shadow lines, he used planks of various thicknesses. And in keeping with Stickley's practice, he used beautifully quartersawn white oak to build his piece.**

# Nana's lucky carved chest

An heirloom with a tale to tell, **Cliff** Trimble's blanket chest was made in his grandfather's furniture factory in Arkansas and carved by his grandmother on the eve of World War II. Trimble treasures it for its lost-and-found history and for the way it links him to his grandparents and his youth.

CLIFF TRIMBLE REMEMBERS SITTING on his Nana's lucky wooden chest when he was a little boy and listening as his grandparents told him its story.

Cliff's grandfather had the chest made especially for Nana in the furniture factory he managed. Some years later, on the eve of World War II, Nana volunteered as a medical aide at the VA hospital in Long Beach, California. While she was there, she heard about a woodcarving class being offered at the naval shipyard nearby. She had always planned to do some carving on her blanket chest, so this seemed the perfect opportunity to try. She made good progress that fall of 1941, carving a border of leaves and flowers on the lid. But on December 8, the day after the bombings at Pearl Harbor, classes were canceled and all civilians were barred from the facilities. In the turmoil of the following years, Nana gave up the chest for lost.

But out of the blue, years after the war, a Navy clerk telephoned her, wondering if she would like to come and pick up a certain wooden chest with flowers carved on the lid. It had been carefully stored in a warehouse during the war.

When Cliff's grandfather passed away and Nana began giving furniture to various family members, Cliff asked her if he could have the chest. Why, Nana wondered, would he want that old thing? When he recounted the story, detail by detail, his grandmother smiled and said, "Of course, you're welcome to it." These days, when Cliff sees the chest in his living room, he remembers his grandparents telling its story some 50 years ago.

# A small museum for quilts

A CLOSED BLANKET CHEST MAY BE HARD TO BEAT for blanket storage, but for purposes of display, it is not the best. Or so it seemed until Ernie Conover, a woodworking teacher and author in Ohio, built this glass-sided chest for his wife, Susan. Susan is a fiber artist who makes quilts and other textiles, often using yarn spun from the wool of llamas she and her husband raise.

Ernie built the frame of the chest with curly cherry and used tempered glass for the panels. Tempered glass is stronger than ordinary glass, and if it breaks, it shatters into thousands of tiny pieces instead of the large, sharp shards of ordinary glass. Ernie had the sheets of glass for his chest cut to size and beveled on their edges before having them tempered. In thermal tempering, glass is heated nearly to its melting point, then quickly cooled. All cutting and beveling must be done prior to tempering because once the glass is tempered, it is too hard and brittle to cut.

Ernie designed his chest with large sheets of glass because he wanted the chest to be like a museum display of Susan's fiber art. He wanted the figured cherry-and-glass chest to fade into the background, leaving the quilts at center stage.

*Look at the quilts, not the chest.* **This is what Ernie Conover hopes visitors will do when they see the chest he designed and made for his wife's needlework. The glass panels were tempered to prevent a dangerous accident.**

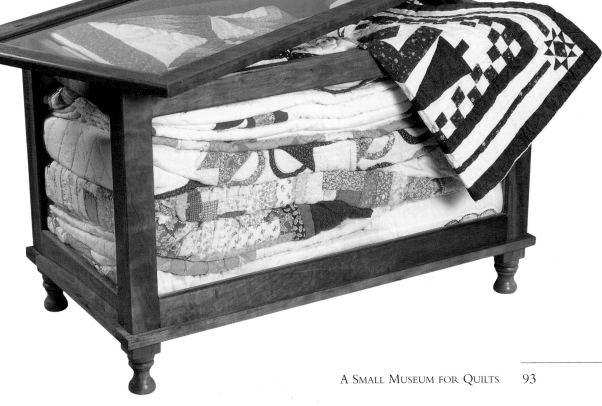

# A simple-looking chest
# is anything but

F OR HIS FINAL PROJECT AS A WOODWORKING STUDENT, Ted Wong wanted to make something challenging. He was studying at the College of the Redwoods, a small school with a big reputation tucked away in the town of Fort Bragg on the rugged California coast north of San Francisco. The school is the home of James Krenov, one of this country's premier woodworkers and woodworking instructors.

Ask someone who has been through the woodworking program at the College of the Redwoods to summarize the experience and you typically get more than a summary. There is no handy pigeonhole in which to place the program or James Krenov, nor is there any easy way to describe the process by which he teaches his particular philosophy of woodworking.

Ted's blanket chest, with its bowed front and back and its handsomely spaced and impeccably executed dovetails, is deceptively difficult but he rose to the challenge. The chest is not a typical piece for the College of the Redwoods program, where many students follow their venerable teacher's lead and build cabinets on a slender scale. But Ted's work shows a level of care in the composition and precision in the execution that should certainly make his mentor proud.

Ted spent two years at the school and emerged with skills strong enough to land him his own job as a teacher of woodworking and furniture making in the architecture department at Miami University in Ohio.

*Shallow curves* like the ones on the front, back, and lid of Ted Wong's chest can mean deep water during construction. The chest's gracefully graduated dovetails only increase the difficulty.

*An outstanding education* is reflected in Wong's mahogany chest. Built as the culmination of a two-year stint studying under James Krenov, the chest is Wong's attempt to stretch his skills as a craftsman without appearing to do so. Deceptively simple looking, the curved top of this chest is a challenge to build.

# Another challenge successfully met

*Wood from the family farm* provided Jim Kollath's chest with its magnificent figure and color. He selected a walnut tree and cut it into planks himself using a 50-year-old saw his dad built. Kollath covered the lid with figured walnut veneer and inlaid an initial "K" cut from rose-wood veneer.

TOOLING ENGINEER JIM KOLLATH LIKES MACHINES. He likes to run them and he likes to build them. For his woodworking, he built himself a surface planer, a 12-in. jointer, and the lathe he used to turn the handles on this chest. But this runs in the family. Each fall for 50 years, the saw Jim's dad built by hand has sawed trees from the family dairy farm into planks. When Jim decided to build this blanket chest, he selected a black walnut tree on the property, felled it, and sliced it into lumber with his dad's saw.

Having inherited his father's self-reliant streak, Jim relishes a challenge. The biggest challenge in building this chest was the curved top. It was the first time he had ever tried a bent lamination, the technique in which thin, flexible layers of wood or plywood are bent over a curved form and then glued so they retain the shape. Jim made a sandwich with three layers of thin plywood on the inside and sheets of walnut veneer on the outside. Much to his amazement, it worked beautifully. Now, if only he could build a machine to do this for him.... ⌗

*Producing polished work on the first try,* Kollath built the domed lid for his blanket chest using bent lamination, a technique he'd never before attempted. By gluing thin layers of wood over a curved form, he was able to get the lid to curve just the way he wanted.

# Carving a Southwest-style chest affords time for reflection

*Blending European and Hispanic* sources, Jim Wiley created a powerful design for the large rosette on the end panels of his chest. Like many carvers, he prefers to work with basswood, whose homogeneous grain is easy to carve, holds detail very well, and presents no pattern of its own to compete with the carving.

FOR MOST WOODWORKERS, IT'S ENOUGH TO BUILD a very nice piece of furniture. For Jim Wiley, though, building a blanket chest with raised panels and mortise-and-tenon joints is only the beginning. Jim still has the chip carving to do. But for him that's the fun part.

Jim's carving career started in the mid-1980s, when his sister said she wanted a carved gate. Although he had never had a day's instruction in carving, he enjoyed that project. He began reading books on carving and learning by trial and error, so that by 1992 carving had become his career.

To make a chest like this one, Jim first cuts and dry-fits all the pieces of the chest, then he takes the whole chest apart, carefully numbering each piece. He draws the intricate carving patterns on the panels, rails, and stiles. If he doesn't like a pattern, he sands off the pencil lines, just like erasing a chalkboard. Once he is satisfied with the designs, he begins to carve. He saves the large, relief-carved panels for last because they are the most enjoyable.

Chip carving is one of the simplest forms of carving. All you really need is a sharp knife—and a good deal of patience. The technique consists of cutting inverted pyramids, or chips, from the surface of the wood. From a series of these simple chips, complex patterns develop. As each chip pops out of the wood, Jim watches the design emerge as if in slow motion.

*As easy as 1, 2, 3*—after a while, that is. In chip carving, the carver makes three incisions with a knife to remove each pyramid-shaped chip from the surface of the wood. The repetition of these relatively simple actions eventually creates complex patterns.

*Chip carving* on a grand scale gives Wiley plenty of time to think. In his Taos, New Mexico, shop he applies his meditative craft to furniture designed in the Southwest style. Before beginning to carve, Wiley cut all the joints and dry-assembled the chest. Then he disassembled it to do the carving.

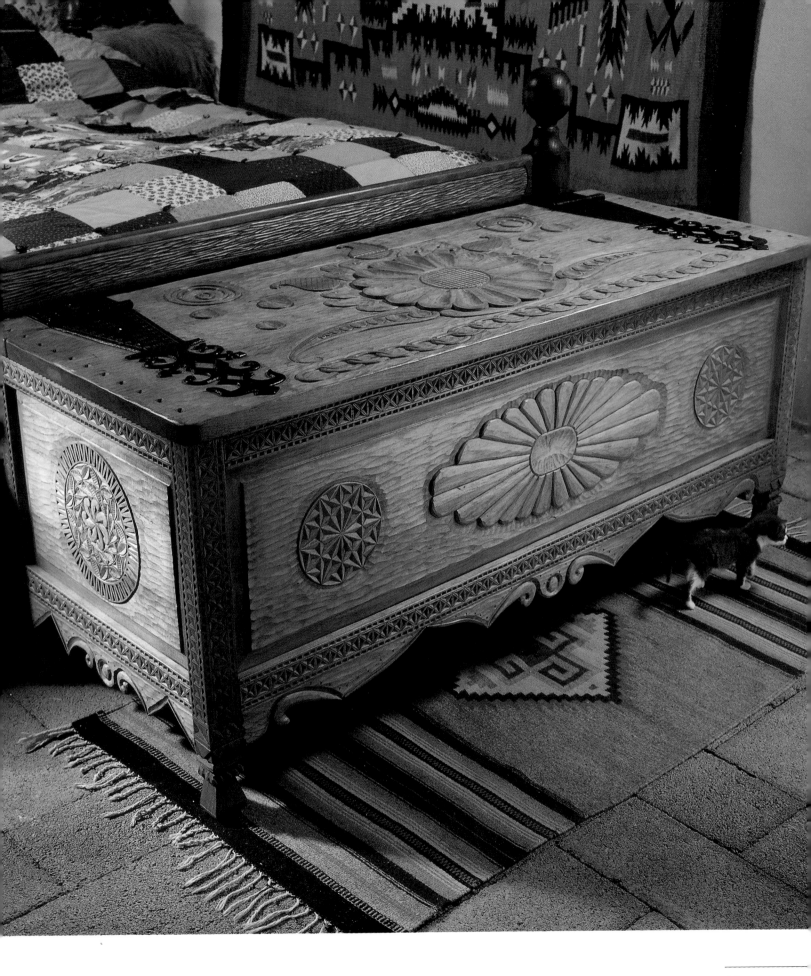

# The great gift of recycled goods

I N THE MID-1970S, UTAH BUILDER LYMAN EVERETT salvaged a truck-
load of dirty, roughsawn planks from an old apartment building under
renovation. The lumber was ugly on the outside, but he could see that
it was clear pine on the inside—very valuable wood then and even
more so today. He didn't know exactly what he would do with the lum-
ber, but it was just too good to throw away or burn. It would be
20 years before he discovered the right use for it.

When his daughter was about to be married in 1995,
Lyman decided to build something for the new couple.
He wanted his daughter to have a chest in which she
could store family heirlooms.

Lyman pulled the old, blackened planks from his
lumber rack and milled off the dirty outer layer to
reveal fresh-smelling, beautifully figured clear pine
inside. These boards would do just fine to make a chest. He used
the pine to build an exterior frame that he filled in with redwood
panels, then he lined the interior with aromatic cedar.

If Lyman wondered at all about whether he'd made the right
decision in using that wood he'd been saving for so long, he found
the answer in his daughter's thank-you note, in which she called the
chest "the nicest gift I ever got."

*The range of color in the redwood*
Lyman Everett used for the paneling in
the chest might have caused a problem.
He turned a potential problem into an
advantage by defining the joints between
the pieces so they would read as indi-
vidual planks.

*Some materials have to wait* a
while before they find their proper use.
Everett had a stash of recycled clear
pine for two decades before he used it to
build the framework of this blanket chest for
his daughter. Once he milled off the dirty outside
layer, Everett found the wood inside was fresh
and fragrant.

# An indulgence in creative freedom

WHEN PROFESSIONAL STUDIO FURNITURE MAKER Jeni Sue Wilburn set out to make this blanket chest as a gift, it was, in her words, "a welcome indulgence in creative freedom." Without a client looking over her shoulder, she could use what materials suited her, apply any proportions she thought looked nice, and add or omit details at her whim. Best of all, she had no deadline.

Freed from the normal pressures of work, Jeni Sue happily skipped the usual estimate of labor before she began and didn't keep track of time as she worked. She also dispensed with elaborate drawings, proceeding to construction with just a rough sketch and improvising the details along the way.

Selecting the materials was part of the pleasure. Jeni Sue wanted the chest to be a composition in contrasting woods, so she used walnut posts and rails to frame lively panels of book-matched bird's-eye maple. For the lid, she found a pretty plank of walnut burl and added breadboard ends made of Honduran mahogany.

Of all the ways this project differed from paying jobs, perhaps the most satisfying came last: Because she made it as a gift for her partner, the chest never left the house. "The craftsperson brings a piece of furniture into being," Jeni Sue says, "but rarely gets to see how it matures and takes on a life of its own as years of use go by."

*Creating a composition in contrasts,* Jeni Sue Wilburn paired a walnut-burl lid with bird's-eye maple panels. The mahogany breadboard end on the lid adds another contrast and keeps the lid from warping.

*With an eye to the East,* Wilburn incorporated detailing that lightens her handsome blanket chest and gives it an Asian feeling. The slight stylistic twist is found both in the breadboard ends, which rise from the lid's main panel, and in the top and bottom rails with their curved detail at either end.

# A former forester finds pleasure in the wood

I't's hard to imagine how someone who spent 12 years working as a forester and wildlife biologist could get closer to trees. Jeff Dilks, of Washington state, did it by taking up woodworking as a hobby.

Much of Jeff's satisfaction in furniture making comes from the wood itself. For this frame-and-panel chest, he chose quartersawn cherry for the rails and stiles and bird's-eye maple for the panels. He picked pieces of bird's-eye that contained both heartwood and sapwood because he likes the contrast in colors they provide.

Largely self-taught, Jeff takes design inspiration from the California Arts and Crafts designers Charles and Henry Greene. Their Asian-tinged style is reflected in his use of decorative ebony pegs, in the bridle joints at the corners of the lid, and in the stepped profile, or cloud lift, worked into the lower rails.

Jeff made this blanket chest as a present for his wife, Kelli, and says he appreciates the freedom and the pleasure of making things to give away. When you make something as a gift, he says, you not only give the object but also something of yourself as well.

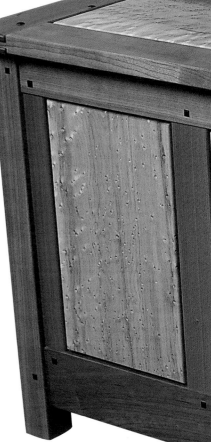

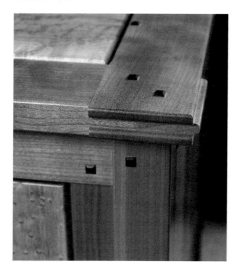

*Proud ebony pegs* and articulated bridle joints give the lid a dash of Arts and Crafts aesthetic. Jeff Dilks is fond of Greene and Greene furniture, which also inspired the detailing of the chest's bottom rail.

*Seeking a balance* between simplicity and ornamentation, Dilks built his chest with a formal arrangement of frames and panels and then created areas of detail at the corners of the lid and on the bottom rail.

# A deceptively simple chest—until you look beneath its skin

**Sweet and simple,** the sweeping lines of Richard Dunham's anigre and cherry chest give no hint of the complex work required to produce them.

## VENEERING USING A VACUUM BAG

*Everything goes in the bag—the curved bending form and the sandwich of plies and veneer. The air is then sucked out of the bag using a vacuum pump, forcing the wood to conform to the bending form.*

Now a professional wood-worker, Richard Dunham is a former lighting and set designer for Broadway shows, a technical director for opera, and was involved with special effects for ballet and films. Tired of living in New York and longing to return to his New England roots, he moved with his wife back to Maine where he grew up.

Richard's woodworking is a bit like his lifestyle: simple on the surface but the product of much thought and work. The simple lines of his blanket chest belie the complexity of the design and the construction.

The curved panels that comprise the chest were made from thin layers of plywood clamped over a curved mold. On the inside of the panel, Richard glued aromatic cedar veneer. On the outside, he glued anigre veneer, a light-colored, plain-grained wood from Africa whose extremely curly figure shimmers in the light.

The clamping was done using a vacuum bag. Once he had spread glue on the layers of plywood and veneer, he placed them on the mold and put the entire assembly into a heavy plastic bag and withdrew the air using a

*Thin plies bend easily.* **To make the curved sides of his chest, Dunham made a bent lamination, a technique in which a stack of thin, flexible sheets of wood are covered with glue and bent to shape. Here, samples of the interior plies are stacked with a sheet of cedar veneer and a sheet of anigre.**

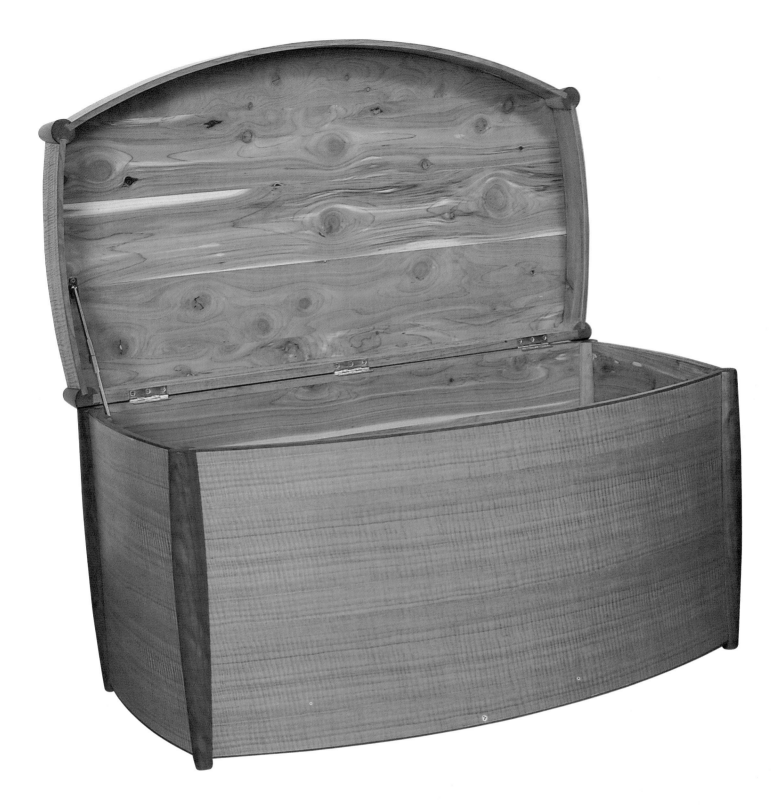

vacuum pump. Atmospheric pressure provided the clamping force, holding the pieces tight to the curved form while the glue set.

Like his old career in theater, Richard's new one often involves a fair amount of work and technology that the public never sees. A well-made chest, like a well-lit scene, looks effortlessly done.

*The cedar inside* **is in the form of veneer. On each of the panels that comprise the chest, Richard Dunham used aromatic cedar veneer for the inside face and anigre veneer for the outside. The corner posts and trim are cherry.**

# Like painting on canvas

CHARLES CASWELL IS A WOODWORKER WITH A PAINTER'S EYE. He makes furniture that is meant to touch people in ways more commonly associated with painting than with woodworking: through texture, color, and harmony.

His canvas in this case is a large blanket chest with six drawers inside. He chose the palette for it carefully. For the framework, he found some old-growth white oak, which was quartersawn at an old, mom-and-pop sawmill in Pennsylvania. For the panels, he cut squares of beautiful oak-burl veneer. For the drawer pulls and other accents, he used ebony. And to cover the drawers, he bought some paper handmade in India that has flower petals pressed into it. Not wanting anything inappropriate to muddy his composition, Charles designed his own hinges and had them custom-made.

The grid pattern of wide frames and small panels that gives the chest its visual strength was inspired by an old, Indonesian chest he saw in a store window. When it came time to fill in the frames, he cut many more squares of oak-burl veneer than he needed and spent a good long time composing—sorting, rotating, and flipping them this way and that until each square had a visual harmony with the whole.

*An artist's eye for materials* **and pattern gives Charles Caswell's gridded blanket chest its distinctive appearance. Trained as a painter, he carefully composed the squares of oak-burl veneer that fill the panels of his chest.**

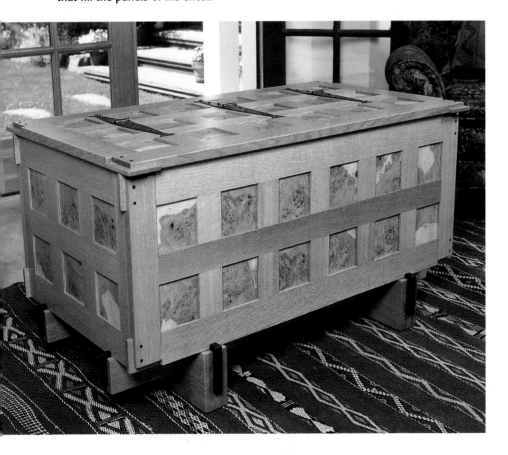

*Flower petals are pressed* in the paper that covers and lines the chest's six drawers. The paper, handmade in India, represents another of Caswell's careful decisions regarding materials.

# Sea Chests

## *All a Sailor Had in the World*

THE CHEST A MAN TOOK ABOARD SHIP in the days of sail was a reflection of his quarters on board. For the majority, that would be a communal space—often the forecastle—crowded with cramped bunks and devoid of any storage or seating. The chests that ordinary sailors took from ship to ship were similarly humble. The captain's quarters, on the other hand, even on a rough vessel like a whaling ship, could be quite impressive, with an upholstered couch, a wide bed, and plenty of built-in storage. The captain's chests often reflected the disparity. He might have a liquor chest with hand-blown glass decanters and glasses; a chart chest; or a cleverly made desktop writing chest. The captain's special chests might be veneered with exotic woods and lined with decorated paper or fabric.

The simple design of an ordinary seaman's chest was derived from blanket chests of domestic use and consisted of a single, undivided compartment often fitted with a small, lidded till at one end. Seamen's chests never got very fancy, but over the years their design was sometimes adapted to their environment by the sloping of the front and back, which provided the chest with a wider base and more stability in rough weather.

*Whether rough* or fine, made of painted pine or polished mahogany, sea chests were made to take abuse, and they took it.

A seaman's chest was used to store his clothes and perhaps a few possessions: a Bible or other book, a knife, a blanket. It also served as seating, as evidenced by its dimensions—the standard height of a sea chest is around 17 in., the same as the standard height of a chair seat. One distinctive feature of a sea chest's design is its handles. In place of metal bail-style handles, most sea chests have a becket at each end, which is a short loop of line passed through a wooden cleat.

The construction of a typical seaman's chest is rough but sturdy. With few exceptions, they are of the six-board variety— wide planks form the four sides, the lid, and the bottom, the cheapest way to build a box. They were typically made of pine, which was inexpensive and available in wide planks. But no corners were cut when it came to joinery. Because of the battering these chests would have to take at sea, even the roughest of them were joined with stout dovetails, rarely simply nailed together as were some utility chests made for domestic use. The bottoms of standard sea chests, however, were almost always nailed on. A skirtboard around the base of the chest reinforced the attachment of the bottom and hid the joint between the bottom and the sides while also protecting it from damage.

Decoration on these chests was minimal. Very few are carved or elaborately painted. Sailors did decorate their chests with intricate knotwork, however. In idle hours a sailor might sit on deck and make a fringe of delicate knotwork to be tacked to the edge of his chest's lid, or he might use bits of sail canvas to make a new set of beckets with a sophisticated woven pattern.

*A captain's chest* often combined storage for clothes or blankets with a fall-front writing desk. This English example from the 19th century was made in two stacking units so it would be easier to transport.

*The stout chest of a sailor* was typically dovetailed at the corners and reinforced with skirtboards. Sailors often decorated their chests with fine knotwork and braiding, as seen on the fringe and handles of this chest.

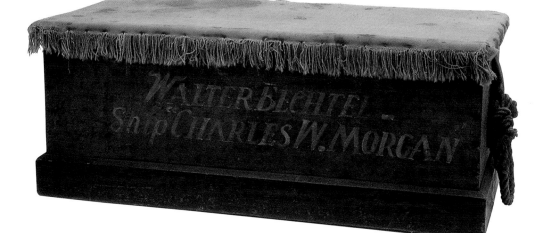

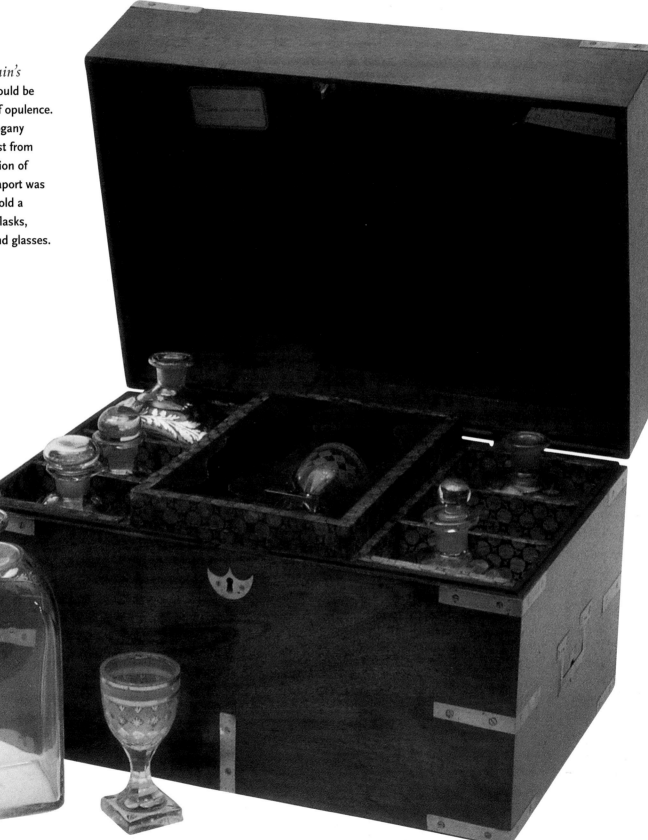

*The captain's* quarters could be an oasis of opulence. This mahogany liquor chest from the collection of Mystic Seaport was made to hold a captain's flasks, carafes, and glasses.

# Oil-blackened and built to take abuse

*Marks of a ship's mechanic* **hard at work cover the tills and interior of this mahogany chest. Trays lift out to provide access to more tools stored below.**

OWNED ORIGINALLY by a mechanic who tended the engine of a fishing boat, this stoutly built chest still bears the grime of his trade. The blackened tool tills and the nicks and scratches all over the chest attest to hard use, and the crescent scars below the hasp where a lock used to hang bear witness to the rolling of the ship.

Compared with a cabinetmaker, a ship's mechanic typically has a relatively small kit of tools. But they are heavy and the chest for them needs to be portable. So compared with a cabinetmaker's chest, this one is modest in size—2 ft. long, 1 ft. high, and 1 ft. wide—but it is powerfully built, with hand-cut dovetails at the corners and with skirtboards protecting the lid and the base.

Having spent its working life belowdecks on a boat that fished out of the port of Richmond, California, the mahogany chest is in a comfortable retirement now, serving as a coffee table for Judith Hanson at her home in Martinez, California. When Judith found this chest, she was indulging in her Sunday pastime of hunting for antiques. Because her husband, Lee, likes to make furniture, she has developed an eye for joinery and other details. She was impressed by the hand-cut dovetails on this chest and the original hardware, so when she heard the story of its past she knew she had found a keeper.

*It takes a tough box* to withstand the abuse a sea chest is subjected to. Nothing strengthens a chest like dovetail joints and well-fitted skirtboards. This chest served half a century at sea before retiring to the living room.

# Not bad for a 15-year-old

Dr. King Heiple began working wood in 1937 when he was 10 years old. His carving career started five years later when his aunt gave him a set of six Millers Falls carving tools for Christmas. Eager to learn how to use the tools, he decided to build a chest and decorate it with carvings.

A trip to the library turned up a photograph of a sea chest with dragons carved in deep relief. It seemed to him just the right project to break in his Christmas present. Figuring he might need some help with the chest, he signed up for the high school woodshop class. When he showed the veteran shop teacher the chest he intended to build as his first foray into carving, the man simply shook his head. King did not take the hint.

He built the mahogany chest in the school shop and then took it home to do the carving. With books on carving propped open while he worked, he fearlessly tackled the most difficult carving first—the dragons on the front of the chest. It took him a year of

*Some sea chests never leave shore.* **King Heiple built this chest from a photo of a sea chest. Having spent 60 years serving as a blanket chest at the foot of Heiple's bed, the chest has yet to make its maiden voyage.**

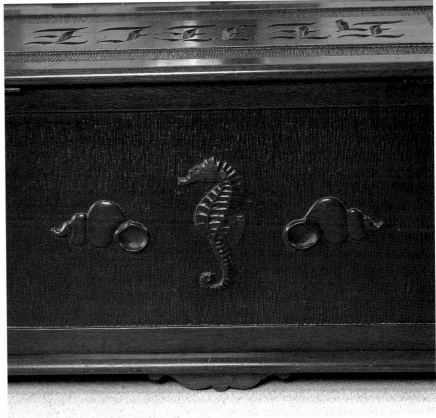

*The chest served as an apprenticeship* in carving for King Heiple, who made it when he was 15 and carved it with his first set of carving chisels. This sort of deep-relief carving, in which the entire background is removed, is normally not for beginners.

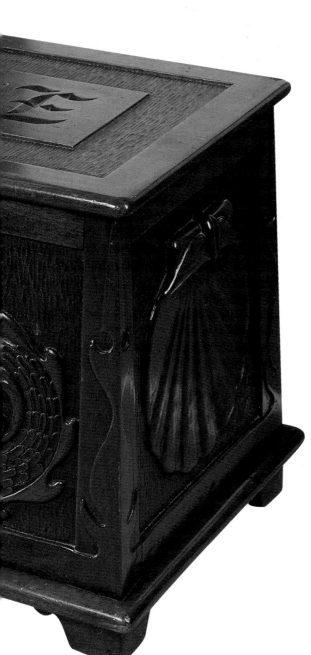

carving to work his way around the chest and over the lid, where he carved his name in old English script. By the end of that year, he'd improved so much as a carver that he decided he'd better do those dragon carvings over again.

King, now retired as an orthopedic surgeon and professor of medicine, continues to enjoy woodworking, specializing in carving and hand-cut joinery. He still has that original set of six small carving tools, along with about 100 others he's acquired over the years. He uses his old sea chest to store blankets at the foot of his bed, just as he has for nearly 60 years. He says of the chest, "It is not quite an antique and not quite an heirloom, but I have hopes that eventually it will become both."

# Built to sail in a clipper ship, this chest traveled overland

JOHN F. PIKE WAS ONE OF THE LAST of the clipper-ship captains. In the 1850s and '60s, Pike guided the sleek, swift trading vessels on a route between Boston and Hong Kong. Built for speed and carrying precious cargo, clipper ships had their brief heyday at midcentury, spurred by the China tea trade and the California gold rush.

To keep some of his personal things while on board, Pike used this powerfully built teak chest, which has dovetailed corners and thick, hemp handles. To help chart his course, Pike used the sextant shown sitting on top of the chest in the photo on the facing page.

Since Pike's last voyage, his sea chest has stayed on land and in the family. But it has not stayed put. For a century or so it lived on the New Hampshire farm of some of Pike's descendents. But just after World War II, when a female descendent sold the family farm and followed her son and grandchildren to Washington state, the chest moved with her.

Fifty years later, one of those grandchildren, Bryan Phinney, found the chest in his mother's garage. The well-traveled chest was in sad shape—its lid unhinged and split down the middle, its trim pulled off and lying loose in the chest, its large tray lost, and the whole thing covered with 150 years of dirt. Bryan's mother was inclined to throw it away. But Bryan, a woodworker, repaired and refinished it and built a replacement tray.

*Simple and sturdy,* **this chest once owned by the captain of a clipper ship bears the hallmarks of a traditional sea chest: six-board construction, dovetailed corners, and rope handles.**

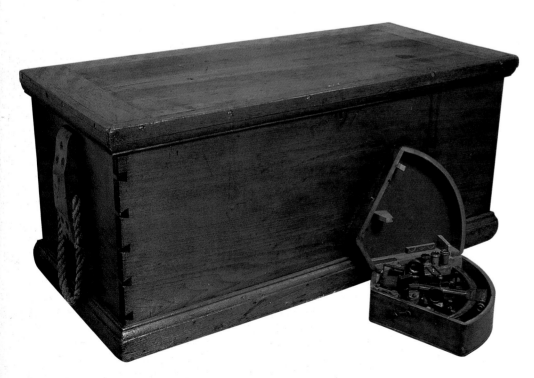

*Rescued by a distant relative* of the
original owner, the chest was recently
restored. It was cleaned up, refinished,
and fitted with a replacement tray. The
original case for Captain Pike's sextant
has kept it safe for a century and a half.

# Camphor chests: imported by the thousand, collected by the dozen

*Flush corner brackets* and fine camphor wood identify the better Chinese chests, which are still affordable and widely available. For the avid collector, these chests can provide, as the characters on one chest say, "a thousand happinesses."

CULLEN WILDER, AN OTHERWISE NORMAL civil engineer from Washington state, has a passion for Chinese camphor-wood sea chests. He has collected more than 50, keeping three dozen or so and distributing the rest among his three daughters and other relatives and friends. His passion was piqued 25 years ago by a Chinese chest his wife inherited from her grandmother, who used it as luggage when she and her husband emigrated from Ireland to America in the mid-1800s.

What was a Chinese chest doing in Ireland in the first place? And why are similar old Chinese chests so plentiful in the San Francisco Bay area, where Cullen has purchased most of his collection in antique stores and flea markets?

It is because such chests were a staple of the China trade in the 18th and 19th centuries. European and American ships were a constant presence in Chinese ports, and in addition to the most prized cargo—tea—the ships would fill their holds with Chinese furniture, porcelain, paintings, silks, and embroidery. Thousands of camphor-wood chests also made their way back to the West in these ships. Often, the chests were used as containers for more precious cargo and then emptied and sold separately when they reached their destination. Similar chests made elsewhere in Southeast Asia came back on ships plying the spice routes.

The chests were strong and simple, bound at the corners with brass brackets and made of camphor wood. Camphor, the Chinese equivalent of cedar, has an enduring fragrance that appeals to people but not, apparently, to insects.

The best Chinese camphor chests, Cullen reports, are joined with hidden dovetails and have brass brackets that are carefully mortised in so they lie flush with the surrounding wood. The lids of the finer chests, made from planks chosen for strong figure, form an almost airtight seal with the chest when closed. Even the less finely detailed chests, with plainer wood and brackets simply attached to the surface, are still soundly made, having through-dovetails at the corners and good craftsmanship throughout.

*One chest collector's bounty* stands stacked in his backyard. Cullen Wilder collects Chinese camphor chests, which were used as packing boxes in the China trade and then were sold separately once they were emptied.

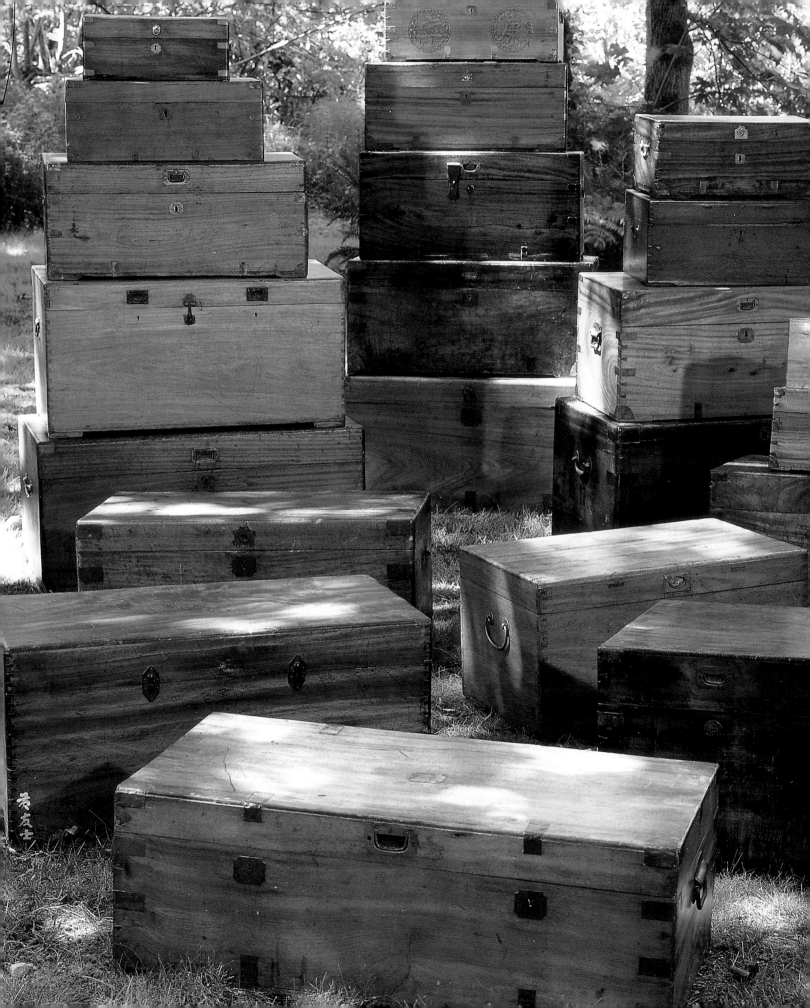

# A Chinese sea chest built for keeps

*No trespassing* is the clear message this chest sends. Equipped with a massive hasp riveted in place, heavy strap hinges, and 1¼-in.-thick sides, the chest was plainly intended to fend off anyone curious about its contents.

W HEN LUI VENATOR FOUND THIS CHEST, it had been abandoned for years in the old Whampoa shipyard in Hong Kong. Covered with decades of grime, the chest looked to him "as if it had been sitting in the mud at the bottom of the bay for 50 years." The shipyard was being cleared for a building project, and Lui had bought some leftover lumber and plywood at auction. As he walked around inspecting the lumber, he noticed the chest and asked about it. He was told it had come off a ship but that the sailor who owned it never came back for it.

It's a heavily built brute made with solid planks of camphor wood more than 1 in. thick. The planks are joined with tightly fitting dovetails. Massive iron strap hinges and a powerful lock hasp are clinched with heavy rivets to the top, front, and back of the chest. As Lui says, any lock you put on it would be the weakest part of this chest. The treasures the chest was designed to keep safe from intruders must have been valuable indeed.

Inside, the chest has an ancient coat of black finish, one so thick and so tough it defied all Lui's attempts to strip it. If it defied Lui, however, it can't defy the camphor wood itself, whose fragrance still wafts up whenever the chest is opened.

An American lawyer now living in California, Lui has lived some 30 years in Asia—with stints in China, Vietnam, and Indonesia as well as Hong Kong, where he lived for 17 years. In his travels, he and his wife have collected a range of fine Asian furniture, but only one chest quite as powerful and mysterious as this one.

*An elegant brute with an uncertain history,* this solid camphor-wood chest was found abandoned in a Hong Kong shipyard. Camphor wood is as prized in Asia as cedar is in the United States and for the same reason: its fresh scent.

# A family history

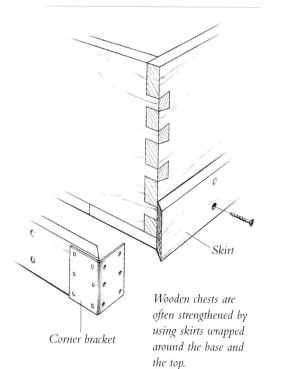

Corner bracket

*Wooden chests are often strengthened by using skirts wrapped around the base and the top.*

Skirt

S OME FAMILIES HAVE SALTWATER IN THEIR VEINS—a love of the sea and sailing get passed down from generation to generation. Jane Butson Webster's family is one of those. Her great-grandfather owned a shipyard in Cornwall, England; his son, Jane's grandfather, left England and settled in Noank, Connecticut, where he started a shipyard of his own. And Jane's great-uncle Butson, her grandfather's brother, was a sailor who worked on trading ships that traveled a triangle between England, Australia, and the United States.

The family proclivity didn't skip Jane's generation. She and her husband, John Webster, live in the historic port town of Mystic, Connecticut, less than two miles from her grandfather's old boatyard. And John, no stranger to the sea, teaches boatbuilding to children at Mystic Seaport museum.

Jane inherited a chest that is an emblem of her family's connection to the sea. She believes that her great-uncle Butson used the chest on his Australian voyages. A traditional skirted chest with brass-bound corners and with sides joined by large dovetails, it is sturdy but not highly refined—a chest more suited to a sailor than a captain.

**Building a link to the past,** John Webster admired the old chest and being an avid woodworker decided to build a near replica of it as a Christmas gift for his daughter. It was his way of making sure the family's connection to the sea doesn't skip a generation. He departed from the original in using cherry to build it and in omitting brass corner brackets.

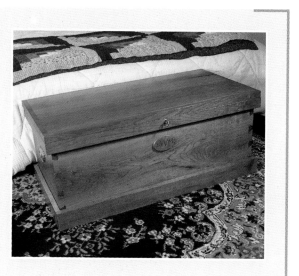

One of the reasons the chest survived so well is that it has skirtboards wrapping its top and bottom. Skirtboards not only protect a chest from damage due to impact but also provide critical reinforcement of the joint between the bottom and the sides. If the bottom of a chest is held on only with nails driven up through the bottom and into the sides, the joint will be weak. Nails driven horizontally through the skirtboard into the bottom secure the joint.

*A simple chest* **for an ordinary seaman, this belonged to a sailor who traveled the world in trading ships in the 19th century. Made using pine and oak construction and brass bound corners, the chest survived thousands of nautical miles.**

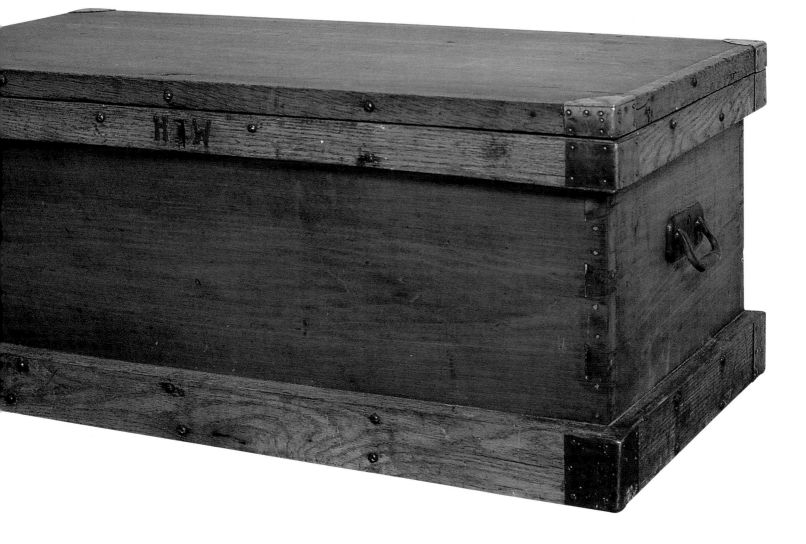

# Dual-purpose chests above decks and below

*Designed as both seating and storage,* this pine and mahogany chest sits at the end of the dining table down below.

## A HINGE GUTTER

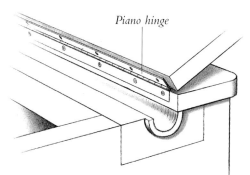

*A gutter drains away any water that seeps through the hinge.*

Piano hinge

*DVENTURESS*, A 100-FT. SCHOONER SAILING OUT of Port Townsend, Washington, has chests on deck and down below. Built in 1913, *Adventuress* served as a San Francisco pilot ship and an Arctic explorer before arriving in the Seattle area in 1951. Designated a National Historic Landmark, *Adventuress* now serves as a floating classroom, giving thousands of schoolchildren a taste of life at sea while they learn about the Puget Sound's vulnerable ecology.

Co-skipper, sail maker, and shipwright Wayne Chimenti hand-crafted the chests that sit on *Adventuress'* deck. He built them not only to last a long time and keep their contents dry but also to be stout enough to withstand pounding waves in the process. Built to hold life preservers, scrub brushes and buckets, blocks, spare line, and other items needed on deck, they also serve as benches.

Wayne built the chests with planks of solid mahogany 1¼ in. thick. He dovetailed the corners and reinforced the joints with stainless-steel screws. He devised an ingenious gutter system to drain water away from the hinge area.

Down below, in *Adventuress'* cozy main cabin, is another chest that offers both storage and seating. Built by students at the nearby Wooden Boat School in Port Townsend, this pine and mahogany chest provides storage for bedding and other belowdecks gear, but it also serves as seating for the dining table. Made just the right height and length for the table, it has a smooth, rounded top that makes it quite a comfortable perch. In the nautical tradition, the sides of the chest taper—so the chest is wider at the bottom than the top—to improve stability in rough weather.

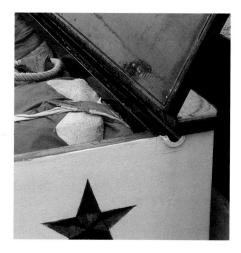

ADULT
LIFE PRESERVERS

*Built to take a beating* from rain, sun,
and seawater, this long mahogany deck
box is both dovetailed and screwed.
Like any woodwork on deck, it needed
varnish or paint. This chest got a bit
of both finishes.

# A rolltop desk in miniature

**A** SEA CAPTAIN'S PERFORMANCE OFTEN DEPENDS as much on his ability to handle paperwork as it does on his ability to handle a ship. Reports must be filed, correspondence must be written, the ship's log must be meticulously kept. A ship's purser, too, is kept busy with a pen, tallying accounts, allotting funds, and keeping inventories of supplies from spars to ship's biscuits. How better to accomplish all this paperwork than with a small writing chest, one in which pen and ink can be placed, paper can be kept dry, and the ship's books can be stored under lock and key?

This portable ship's desk from the collection of Connecticut's Mystic Seaport museum dates from the mid-19th century. Although the design has an English flavor, the chest was probably made in China, museum curators believe, based on its camphor-wood construction and some calligraphy on the bottom of the drawer. The little chest has a sliding tambour lid—the same type of lid you see on a typical rolltop desk. Tambours are made from thin slats of wood glued to heavy canvas. The slats give the lid stiffness and the canvas acts as a hinge so the tambour can bend to follow a curved track.

*All a captain needed* for correspondence, reports, and recordkeeping was a small folding desk like this handsome example in camphor wood.

*An extremely ingenious device,* the camphor-wood chest has a drawer that serves as storage but also supports the hinged writing surface. Opening the drawer also pulls open the tambour lid, revealing cubbyholes for pens, paper, inkwells, and other stationery items.

As you open the drawer to this chest, the tambour automatically retracts, revealing a bank of pigeonhole compartments. With the drawer fully extended, you flip open the hinged writing surface. When the last biscuit has been accounted for, you fold the upper pigeonholes downward, fold up the writing surface, and, lastly, slide in the drawer. The chest is only 19 in. wide by 15 in. deep when closed, so it fits easily on nearly any tabletop.

# A sea chest with a hull for a lid

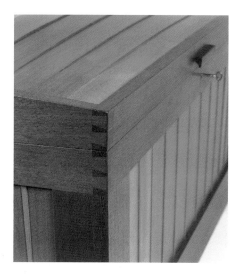

*A cabinetmaker* as well as a boatbuilder, Hjorth-Westh used hand-cut dovetails to join the frames of his chest. The entire lid weighs a mere 5 lb.

*Lapstrake planking* makes an elegant boat. Ejler Hjorth-Westh learned boatbuilding before furniture making. He built this lapstrake dory and uses it in his summer occupation as a fisherman off the northern coast of California.

BORN AND RAISED IN DENMARK AND TRAINED there as an elementary school teacher, Ejler Hjorth-Westh came to the United States on vacation in the early '80s and stayed. Settling on the northern California coast, he apprenticed himself to a boatbuilder in a small town. Later, he studied furniture making for two years under James Krenov at the College of the Redwoods. His chest, which marries Ejler's two crafts, was built while he was at the school.

"There are few places where nautical design can merge with furniture better than in a chest," he says. Ejler built the chest's domed lid using lapstrake construction, a technique borrowed directly from Scandinavian boatbuilding.

If you see a wooden boat with very prominent lines running gracefully from one end to the other, you are looking at a lapstrake hull. This construction, so named because the planks, or strakes, overlap, results in a strong, very light, and beautiful hull. Where they overlap, the planks are beveled to fit one another, forming a double thickness that acts to reinforce the hull along its entire length. This allows the planking to be thinner and lighter.

Having built several lapstrake boats, including a fishing dory for himself, Ejler thought it seemed natural to adapt the technique to make a domed lid for his chest. The Douglas-fir slats he used to make it are only ¼ in. thick, yet when flexed and overlapped they form a lid easily strong enough to sit on. And their thinness makes the lid extremely light—it weighs just 5 lb. The whole chest, in fact, with its mahogany frame and Douglas-fir panels, is surprisingly light, weighing just 20 lb.

*Borrowing from boatbuilding,* Ejler Hjorth-Westh used a Scandinavian boatbuilding technique called lapstrake to make the bowed lid of his chest. Lapstrake is the method the Vikings used to build their boats.

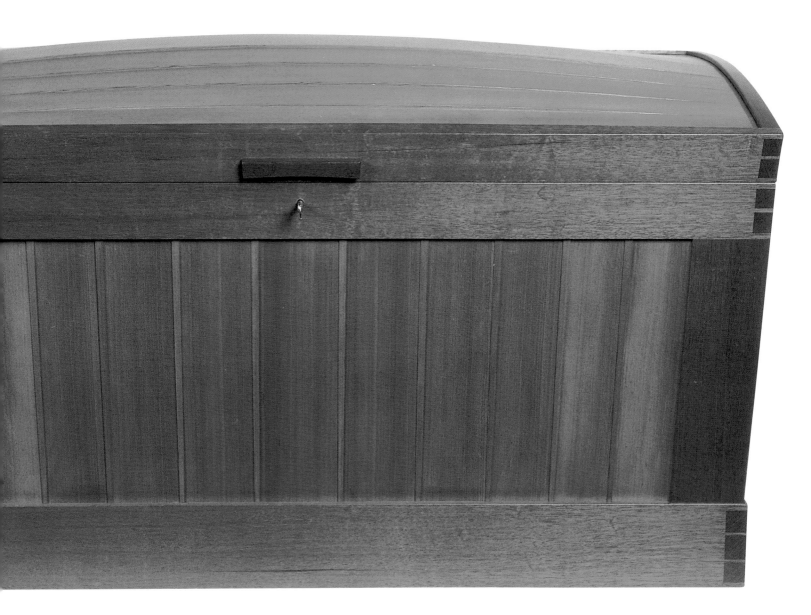

# A captain's chest
# from the glory days of sail

*A simple painting of a schooner* adorns the inside of the lid of Captain Fredrick Champlin's sea chest. It could be a likeness of *Chief*, a coastal schooner Champlin commanded during the Civil War years.

S AILING SHIPS REACHED THEIR PINNACLE in the mid-19th century. In those middle decades, some of the fastest and most beautiful ships ever built sailed the seas, carrying passengers and cargo all over the world.

Fredrick Champlin was lucky enough to be a sea captain in those days. Starting in 1845, at age 28, Champlin commanded coastal sloops and schooners, graceful ships nimble enough to contend with the headwinds and tricky currents of coastal sailing. The sloops were single-masted ships with fore and aft rigging that allowed them to sail very close to the wind, a great speed advantage when sailing into the wind. Schooners were two-masted ships also well adapted to coastal sailing.

One of the chests Champlin took with him on his journeys up and down the Atlantic seaboard is this small one, just more than 2 ft. long and quite light. Although larger chests certainly did the heavier work, it is this type of chest—thin-sided, lightweight, often with a domed lid, and sometimes painted—that has come to be called a sea chest in the antiques trade. Given its size and light-duty construction, it is likely that Champlin used this small chest for holding rolled charts rather than clothing or blankets. As captain, he would have had his own cabin, which would most likely have been outfitted with built-in storage for his clothes.

It is thought that the painting on the underside of the lid of Champlin's chart chest may be of the 82-ft. schooner *Chief*. Champlin skippered a number of ships, but he was *Chief's* owner and skipper for 11 years, sailing her throughout the Civil War years and selling her in 1867, when *Chief* would have been 30 years old and her master would have turned 50. With more than a decade at her helm, he would have known her intimately and probably enjoyed having a remembrance of her when his days at sea were over.

*Battered by long, hard use,* this sea chest was simply made but still up to the task of protecting its contents. The battens across the top were meant to keep the solid-wood lid from warping.

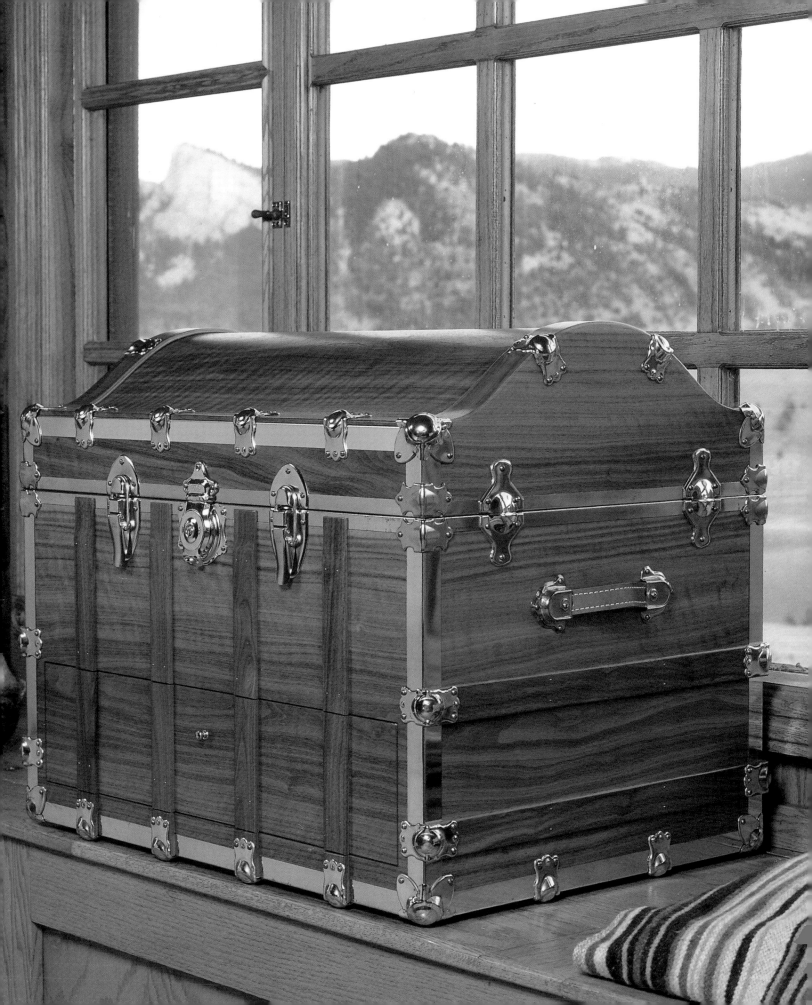

# Chests for

# Travel

## *Carrying the Vagabond's Possessions*

A CHEST FOR TRAVEL INVARIABLY lives a double life. There is the life it was designed and built for—crossing the ocean in the hold of a ship, crossing the country in a Pullman car, or crossing town in the bed of a wagon. And then there is the afterlife—the typically much longer but less arduous years of service holding board games and family photos in the attic, blankets in the bedroom, or cocktails at the end of the couch.

In the years before airplane, bus, and automobile travel put such a premium on cargo space, chests for travel were typically wooden boxes large enough to carry clothes and supplies for several months. They were built solidly enough to withstand the rigors of rough roads and seas and heavy enough to require two adults to move them. All these qualities made them as valuable after the voyage as they had been on it. In the United States, land of immigrants, most families have such chests in their houses—or at least in their history.

For all but the wealthiest immigrants, a new life was built from the contents of a chest or two. It would have taken an armada of ships to hold all the pieces of furniture reputed to have been brought to America on the Mayflower, but the likely truth is that the Pilgrims brought little if any fur-

*Before suitcases* **became common-place and passengers began carrying their own bags, people packed their belongings in chests when they traveled. The advent of automobile and airplane travel put a premium on baggage space.**

*A bedstead for a bushwhacker,* **this folding cot-in-a-suitcase was custom designed by Louis Vuitton for the explorer Pierre Savorgnan de Brazza for an expedition to the source of the Congo in 1876.**

niture. And the same was true of most of the millions of immigrants who followed. But most families had at least one chest for their belongings. In many cases, the chests were quickly made to make the trip. In others, the chests had been in the family already, pieces of household furniture that suddenly saw use as large pieces of luggage. Once the immigrants had arrived in America, their travel chests became their first furniture in the new land.

Travel chests that doubled as seats and tables are at least as old as medieval times. When a feudal lord and his retinue moved from one house to another—which they did with some frequency—they left large furniture and built-ins behind in the shuttered house and took the precious tapestries and fabrics then used to brighten their walls and furniture with them, packed in wooden chests. The chests were built for travel, with heavy handles for hand carrying and domed tops to shed rain. Such chests were sometimes covered in leather for added protection against the weather. Upon arrival in the next house, the chests were emptied and then used as seats and tables.

Until the arrival of lighter luggage toward the end of the 19th century, chests for travel didn't stray all that far from those medieval chests. Travel chests could take many specialized shapes, but the standard chest was a dovetailed box of heavy boards reinforced at the corners with thick metal

brackets. Most were foursquare but some, such as those used by sailors and those made in Norway and Sweden, had tapered sides and quite a few had domed lids. In later centuries, the doming of the lids had less to do with shedding water, presumably, than with preventing other chests and cargo from being stacked on top. Thin slats of wood were sometimes attached to the top and bottom surfaces of a trunk to facilitate sliding and to prevent damage to the chest, a detail that was adopted by luggage makers when they began building leather trunks.

These days, we put a few things in a bag and head to the airport. Our bags are perfectly suited to modern travel—tough, lightweight, and often fitted with casters. But what have we got when we get home? Something that begs to be put away in deep storage. It's hard to imagine our grandchildren polishing up our vinyl suitcases and soft-sided collapsible carry-ons for use in the living room. The old-fashioned travel chest was storage that didn't need to be stored once the trip was over. It was as useful at home as at sea, still valuable as furniture after its life as luggage.

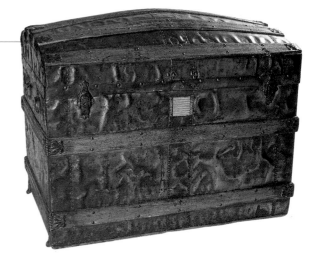

*A domed lid denotes travel.* Medieval chests were made with domed lids to shed water; later, steamer trunks like this metal-covered French one were given domed lids to prevent other luggage from being stacked atop them.

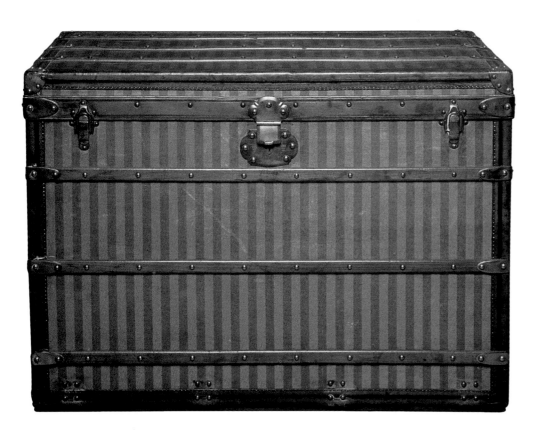

*Lightweight and made for* stacking. Louis Vuitton pioneered a new sort of travel chest in the 1850s when he began making flat-topped, canvas-covered trunks. He made the trunks of poplar to minimize their weight.

# Dower chests make the trip across the sea

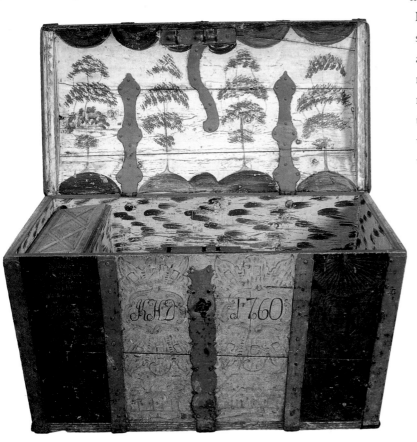

*Made for a marriage but* **used for a voyage, this sponge-painted Scandinavian chest represents thousands of other dower chests that were pressed into service as travel chests during the great migration of Norwegians and Swedes to America.**

**T**HE INSCRIPTIONS ON THE FRONT AND BACK of Bob Bell's Scandinavian chest tell the two sides of its story.

The first half of its story is explained on the front, where there is a set of initials and a date—hallmarks of a dower chest. Thousands of chests like this one began life in Norway and Sweden, where they were built as dower chests (for women) or family chests (for men). The tradition of dower chests was extremely strong, and many Scandinavian households of the 18th and 19th centuries, lacking other storage furniture and closets, would use a number of such chests to store linens, blankets, clothing, and other household goods.

Typically dome-topped and tapered so they widen toward the top, most Scandinavian chests were made of pine or spruce. Normally dovetailed at the corners, they were also strengthened with handsomely forged iron strapping and sometimes studded with rows of round-headed nails. Nearly all of these chests were painted. Most commonly, the painting on Norwegian chests was in a tradition of floral designs called rosemailing, a technique that was applied to the interiors of houses and churches as well as to furniture. A smaller number of Norwegian chests were decorated, as this one was, with sponge-painted designs.

The second half of this chest's story is revealed on the back. There, a name and address are painted in flowing script: Engelret Engelretson, Minesota [sic], North America. Like thousands of other Scandinavian dowry chests, this one

*Bright scenes inside* **and artful hardware are typical of Norwegian chests. The sponge painting outside is less common.**

was built in the old country and brought to the New World when its owners emigrated.

The settlers who brought it could hardly have found a better container for the trip. Like many other emigrants, the owners of this chest would have discovered that their dower chest, so roomy and so stoutly built, was perfectly suited to serve as luggage for the long voyage across the Atlantic and the rough wagon trip to the northern Midwest.

After being brought to America, some such chests were cherished as mementos of the homeland, but many others were relegated to service as storage boxes for feed or firewood. This chest evidently escaped such harsh duty. When Tennesseean Bob Bell bought it at an auction, he found that it was still in pristine condition—ready for another voyage if need be.

*A new address on an old chest* was a common sight, as immigrants used family heirlooms for luggage. Tapered sides and a domed lid are characteristic of Scandinavian dower and family chests.

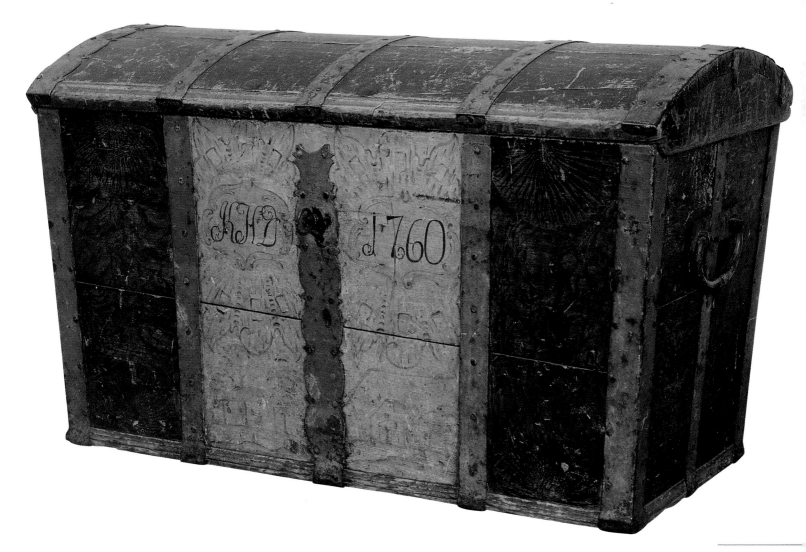

# Reimagining the '49er chest

*A self-taught smith,* **Dennis Cooney made his own hardware for the chest using nothing more than a hammer, a propane torch, and a pair of pliers.**

ENNIS COONEY DECIDED ONE DAY TO BUILD A CHEST like the ones used by the early travelers to California—the people who joined the gold rush of 1849. There was one small difficulty: He had no idea what those chests looked like. But being a California history buff, he did know something about the conditions of travel in those days, about the people who joined the rush, and about the routes they traveled to stake their claims.

In the span of five or six years, the California gold rush brought some 200,000 people streaming into a territory that had been relatively unpopulated. From the East Coast there were three main routes to California—two by ship and one by land—and no shortcuts. If you went by sea, you could sail down one side of South America and up the other to get there or you could sail to Panama, slog across the isthmus to the Pacific, and then wait for another ship to take you north to California. Most travelers, however, went overland, some on horseback, others in wagons, and still others on foot.

Dennis figured a '49er chest would have been nothing fancy. It would have been inexpensive and quickly made. It was a rush, after all. But the chest would have to be strong enough to absorb thousands of miles of jostling and bumping in the hold of a ship or on the bed of a wagon.

For speed, Dennis dispensed with dovetails, making a rudimentary board chest joined at the corners with butt joints and screws. For strength, he reinforced the corners with simple iron brackets that he forged himself. The brackets serve to hide the screws as well as to reinforce the corners.

Sometime after building his chest, Dennis came across a genuine '49er chest in a museum in Monterey. He was tickled to find that the real thing looked an awful lot like the hypothetical '49er chest he'd created.

*Wide planks and a vivid imagination* combine in this mahogany chest made by Cooney. Without ever having seen an original one, Cooney designed a chest he thought might have been used by someone racing westward during the gold rush of 1849.

# A civilized chest for the nostalgic traveler

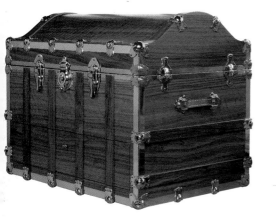

*A chest of dreams,* **this contemporary piece is not a reproduction. It was made by Don Rawlings to evoke the romantic era of rail and ocean travel at the end of the 19th century.**

IN THE EARLY 1970S, AT AGE 38, DON RAWLINGS made a romantic leap of faith. He left the structured world of banking, where he was a senior trust officer at Bank One in Ohio, for an uncharted future as a woodworker in the West. He wound up in a small town 50 miles outside Cody, Wyoming, where he has a view into Yellowstone National Park and snow as early as September. These days, he and his wife and their two sons work together producing furniture and chests with a western flavor.

This trunk, which they have named Grand Voyager, certainly evokes the days of grand voyages—by train across the continent, by ship across the ocean, by paddlewheel steamer down the Mississippi. And that's just as Don would have it. He designed the chest not to reproduce any particular historic chest or style but to conjure up a romantic vision of long-distance travel in the last decades of the 19th century.

The chest has enough compartments to organize even the most unorganized traveler. A large drawer in the lower section of the chest provides easy access to space that is hard to reach in a deep chest without drawers. The upper portion has a removable tote tray that nestles into the lid and other lift-out boxes in three layers, providing compartmentalized storage in every inch of the chest. Even the lid itself has two storage compartments.

Don made the chest of hardwood plywood and then veneered it inside and out. The interior is veneered with olive wood. The fingerjoined trays are made of hardwood, then veneered. The largest tray, with its handle and curved sides, is veneered with rosewood, while the other trays are olive. Outside, the chest is sheathed in black walnut veneer, protected by slats of solid black walnut and bound with brass-plated steel hardware.

Looking at the camel-back lid, the brass hardware, the walnut and rosewood veneer, and the leather handles, it's enough to make a person forsake airplanes and luggage on little wheels for good and embrace a more civilized mode of transport at a more stately pace.

*Rugged, lush, and practical,* **Rawlings's chest is bound with brass-plated steel hardware, sheathed in black walnut veneer, and filled with cleverly designed compartments and trays for maximum access.**

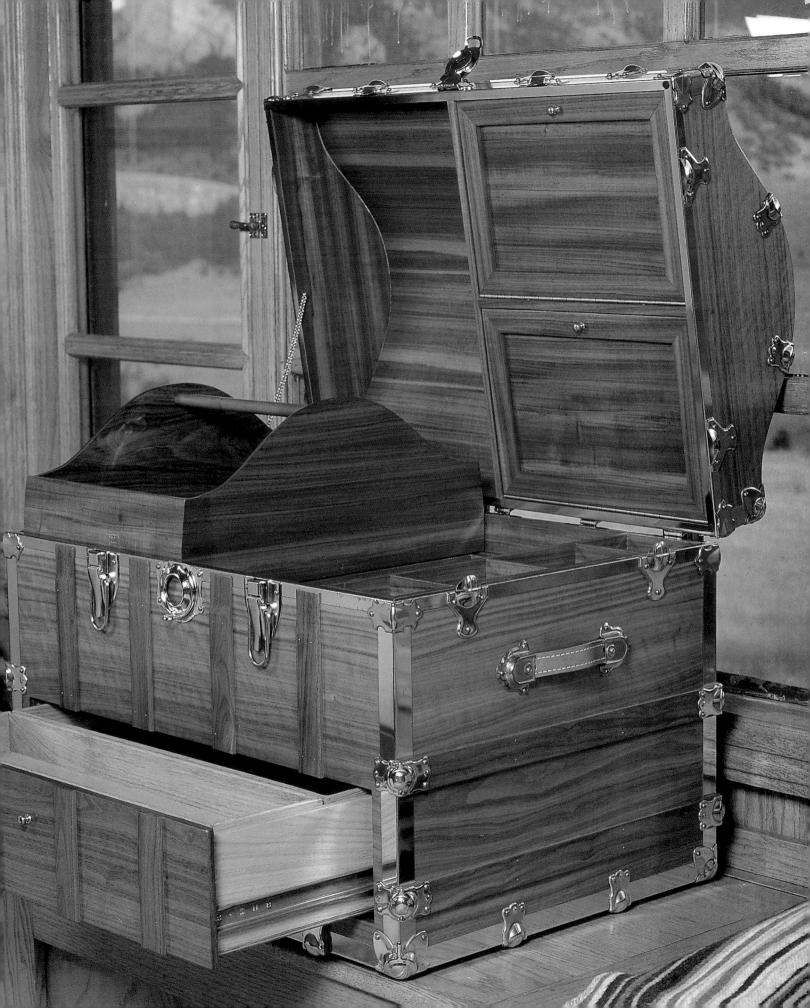

# A suitable chest for
# the greatest show on Earth

*Plastered with circus posters,* the interior of the chest is a reflection of the life it led serving a bandleader in the G. F. Bailey circus. The posters, or heralds, were handed out to announce the impending arrival of the circus.

THE SIGHTS, SOUNDS, AND SMELLS OF THE TRAVELING CIRCUS combined to make it an event like nothing else in the life of rural America during the late 1800s. In a time before even silent movies or radio, let alone television, any evidence of the outside world was sure to rivet a town's attention. Arriving by train or wagon, the circus made a majestic procession: performers in costume, brightly painted cars or wagons piled high with luggage and equipment, striped tents, spangled costumes, and a parade of exotic acts and animals.

Waterman Brown's trunk, with its hourglass profile, studded elephant-hide exterior, lion's head locks and medallions, and iron wheels, was clearly designed to make its mark in such a procession. Brown was a circus musician—leader of the string band, in fact—in the G. F. Bailey Circus in 1861. Elaborate as his trunk may seem today, Brown may not have considered it particularly flamboyant. After all, this was a man who spent part of his workday riding in what fliers for the Bailey Circus called "the Massive Golden Band Chariot, an enormous gilded wagon drawn by a team of elephants."

Brown's magnificent traveling chest probably held his instruments and his costumes in addition to the more personal items such as the books on exotic animals found inside one of the compartments. In surprisingly good shape given its age, the trunk has some small nicks and dings in the exterior, which indicate a lot of handling but handling done very carefully.

The entire interior is papered with circus posters and handbills dating from the late 1800s, and the drawers still have debris from years on the road. Even after 100 years when the lid on Brown's giant chest opens, a pleasant, earthy smell wafts up. It is organic, sweet, and spicy— the smell of railroad boxcars, straw, musty sleeping cars, and dirt floors covered with sawdust. It's the smell of the circus.

*Made to be paraded,* Waterman Brown's circus chest from the 1860s is arresting for its great size, its hourglass shape, its solid brass, lion's head hardware, and its handsome wood and metal strapping.

# Thomas Jefferson's 18th-century version of a laptop

W HEN THOMAS JEFFERSON TRAVELED TO PHILADELPHIA in 1776 to attend the Second Continental Congress, he boarded with a well-known local cabinetmaker, Benjamin Randolph. While staying with Randolph, the 33-year-old Jefferson designed a small writing chest and Randolph built it for him. That summer, Jefferson drafted the Declaration of Independence on his new writing desk.

After that impressive initiation, the little laptop chest continued to see quite a lot of action for the next 50 years. It went everywhere with Jefferson, including to the White House for his two terms as president and to Paris for his six-year stint there. In the winter of 1826, Jefferson's last, he passed the chest on to his grandson-in-law, Joseph Coolidge of Boston, who kept it all his life. Coolidge's heirs donated it to the United States in 1880.

The extraordinary little desk is evidence of Jefferson's ability to invent the obvious. Compact and light enough to rest comfortably on your lap, with a folding writing surface that could

*Replicating a piece of history,* I made this copy of Thomas Jefferson's traveling desk. Working from photographs and some rough dimensions, I began the project by producing full-scale working drawings.

I decided to make the desk's writing leaves out of plywood to solve the warping problems that plague the original. By gluing strips of mahogany around the perimeter and then veneering over them, I gave the leaves the appearance of the solid-wood leaves of the original desk. To make the simulation perfect, I used strips of end grain on two ends. I found that even using modern materials and machines, the little desk proved quite a challenge to build.

be propped at various angles and a drawer with
space for paper and ink and quills, it was a desk that
could turn any room, any carriage, practically any place at all,
into a comfortable place to write.

These days, the desk rests in an alcove on the first floor of the
Smithsonian's National Museum of American History. Museum-goers can
be forgiven for overlooking the little desk, surrounded as it is by eye-catching
artifacts like ceremonial swords and first ladies' dresses. But there it sits, a
treasure for the more observant.

*A traveling desk for a*
**prolific writer. Thomas
Jefferson designed this clever
portable writing desk and
used it when he drafted the
Declaration of Independence.
He carried it with him for the
rest of his life, using it for his
voluminous writings and
correspondence.**

# A portable library for the Minnesota Woodworkers Guild

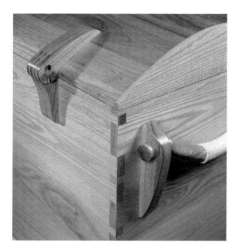

*Fresh details distinguish the chest.*
The coopered lid opens on shopmade finger hinges, the dovetails at the corners of the ash chest are intriguingly spaced, and the heavy-duty carved handles, also of ash, are wrapped with sail maker's twine.

IT WAS EMBARRASSING. When the Minnesota Woodworkers Guild held its monthly meetings, which were hosted each month at a different member's shop, the club's papers, records, and instructional videos were brought along in an old cardboard box. Accomplished woodworkers living out of a cardboard box? Something had to be done. Guild members Rich Gotz and Willis Bowman were designated to rectify the situation.

The plan was simple, as plans often are at first. The two would build a modest-sized wooden chest for the club paraphernalia and give it a proper lid and handles. Then the committee got involved. Soon the chest was redesigned, enlarged enough to carry a wide range of woodworking books and a collection of catalogs.

Rich and Willis built the chest to the new design, working together on occasional evenings over a two-year period. And they did the club proud, building an impressive ash chest joined with decorative dovetails. They fitted the chest with strong, sculpted handles and wooden finger hinges, capped it with a coopered lid, and topped it off with an oval medallion of an open book deftly carved in butternut. At last, a receptacle to suit the group.

There was only one problem: When the chest was finally loaded up with all the reading materials and videos, it was far too heavy to lug around to all the meetings. These days, the chest rests at Rich's house. And the club's gear travels from meeting to meeting in a couple of cardboard boxes.

*An open book* in butternut serves to mark the construction date and signify the use of the guild's chest.

*Designed to transport books and videos* about woodworking, this chest is itself a virtuoso demonstration of the woodworker's art. It was made for the Minnesota Woodworkers Guild by two guild members, Rich Gotz and Willis Bowman.

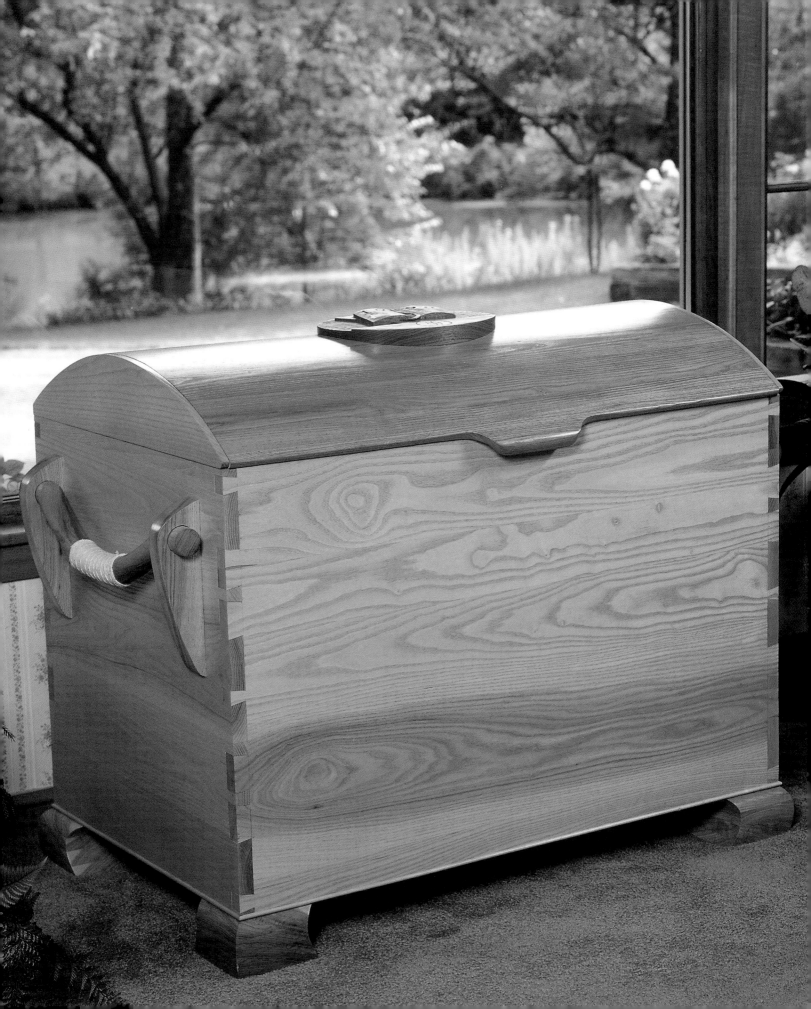

# Learning whatever it takes to make a chest

*A jeweler's touch* **is evident in the chest's latch, which Linda Schmitz designed and made herself. Unhappy with the hardware she found commercially available, she signed up for a course in metalsmithing to make her own.**

## COOPERED PANEL

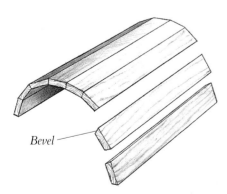

*Bevel*

*In a coopered panel, the angle of the bevels and the width of the planks determine the radius of the panel.*

THERE ARE THE MEEK AMONG US, AND THEN there are people like Linda Schmitz. When it comes to making things, Linda is not intimidated by inexperience.

Woodworking is a demanding craft, and it behooves the beginner to start slowly. Many woodworkers spend years working from detailed plans and only gradually increase the difficulty of the projects they tackle. This did not appeal to Linda. She decided that her first big piece of furniture would be a chest with double-curved sides and a domed lid.

To improve her skills, Linda, who lives in Prescott, Arizona, attended woodworking classes at Yavapai College. In her second semester there, she presented her instructor, Dick Marcusen, with the idea for this chest project. To put it mildly, Dick thought it was a pretty ambitious project for the second semester. Undaunted, Linda plowed ahead.

To make the double-curved sides of the chest, she used coopering, a woodworking technique derived from the one used by barrel makers, or coopers, in which a curved panel is created by gluing a group of narrow planks edge to edge. The edges of the planks are beveled before glue-up so that when assembled they form a curve.

Instead of making the four sides one at a time in four separate glue-ups, Linda simplified her project somewhat by gluing up 10-ft.-long planks into one long double-curved panel. When the glue had cured, she crosscut the piece into four panels, then joined them to make the chest. Linda also coopered the lid, laying out the strips so that their grain patterns alternated, creating a design something like an Indian blanket.

Linda's pioneering didn't end with the woodwork. When she looked for hardware to use on the chest, she couldn't find anything she liked, so she signed up for a jewelry-making course. In the first class, she made the brass latch, the hinges, and the handles for her new chest. So much for inexperience.

*Undaunted by the craft's* steep learning curve, Linda Schmitz built this challengingly curvy chest in one of her first forays into cabinetmaking. Its curved sides and lid are coopered—made like a barrel—and patterned after a chest she once used for overseas travel.

# A traveling equestrian tack chest

*A range of trays nestle inside,* holding the gear required for grooming and saddling a horse. The tops of some trays are trimmed with diamond-inlay banding.

MANDY KARNAUSKAS DISCOVERED horseback riding when she was eight years old and began spending every afternoon and weekend at the stable. Before long she had accumulated an array of equestrian gear ranging from saddle pads to braiding tools.

When Mandy's father, Bob, a winter woodworker, saw that her cheaply made plywood tack box was falling apart, he decided to build her a proper chest to replace it. When he took her to competitions, he and Mandy would look at other riders' tack boxes, both commercially made and home built, noting the features Mandy liked and those she didn't. Then the two of them sat down with a sketchpad and worked out the configuration for the chest Bob would build.

For smaller items, they designed removable trays and boxes custom sized to their contents. The scissors, combs, and yarn Mandy uses for braiding the horse's mane, for instance, have their own open tray with a decorative padauk handle. And the chest's lid has compartments for holding leg wraps and saddle pads.

Bob built the chest over the course of a long Wisconsin winter. He made the sides of the chest from planks of solid cherry and dovetailed them at the corners. For the lid and the bottom of the chest, he used cherry plywood, which provides strength and rigidity without posing any problems of expansion and contraction. Because the chest would be moved so often, Bob fitted it with heavy, solid-brass handles that make it comfortable to carry. And although function was at the core of his design, Bob didn't neglect a little decoration: He trimmed a few of the small boxes inside with snazzy geometric banding. After years of hard use, the chest is holding up well even in the harsh environment of a Wisconsin horse barn.

*A riding chest made for travel,* this tack box was designed to carry all the gear Mandy Karnauskus needs when she and her horse compete in equestrian events. She collaborated with her father on the design and he built it.

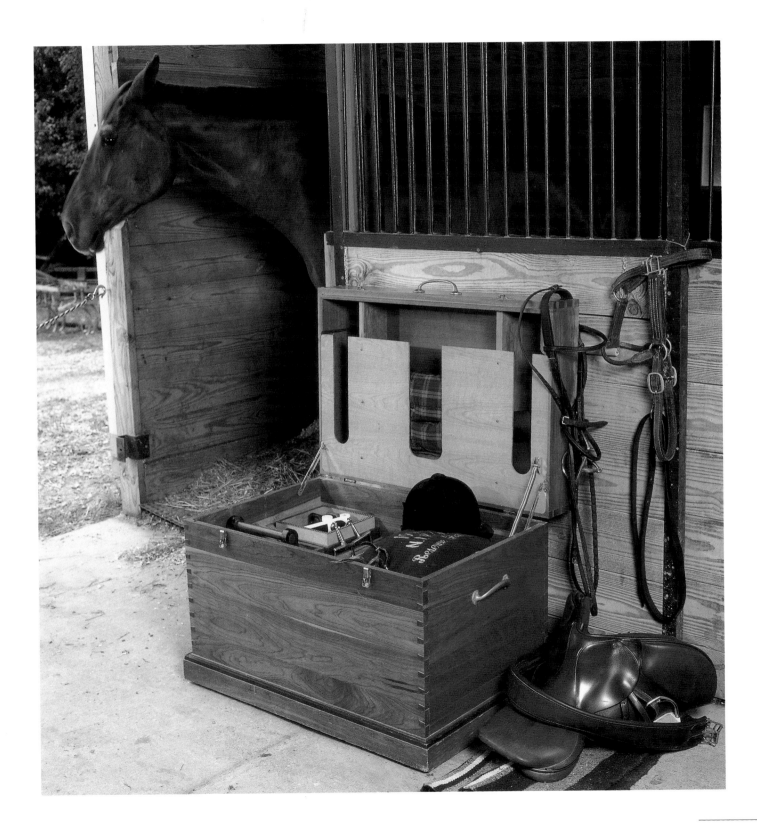

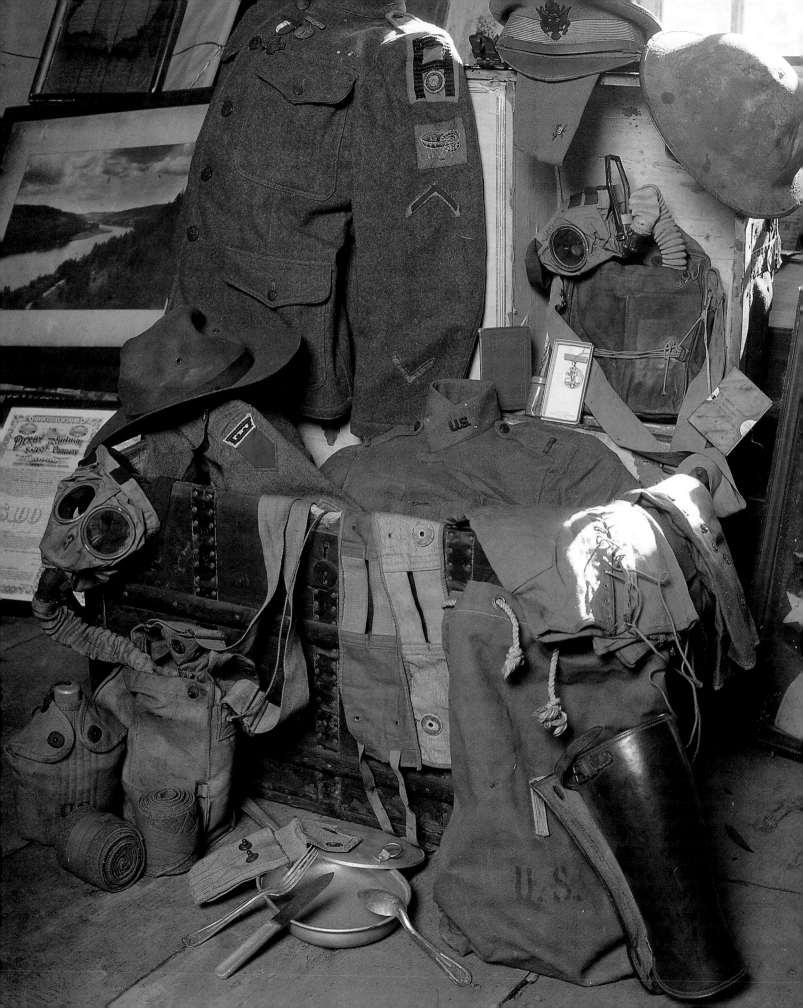

# Chests for War

*Furniture behind the Fighting*

Some military chests and crates tell explicitly of battle—those made to carry all sorts of weapons, ammunition, and equipment. But the chests in this chapter tell the other side of the soldier's story. They suggest the daily life behind the battle, where clothes were washed and folded, where meals were cooked and drinks were shared, where an officer wrote out his orders, and where a chaplain composed his letters of condolence.

Military chests are a type of traveling chest but constructed with the grim reality of war in mind. They are built as strong as sea chests and are similarly unadorned on the outside, bearing only their owners' names and ranks. They tend to be flat-sided and flat-topped, making them easy to stack and store on wagons and trucks and in the holds of ships.

When an army or navy is on the move, the common soldier or sailor typically travels without a chest. Instead, he makes do with a pack or a duffel bag. In more settled conditions, when his unit is in a fully equipped camp for the long term, a soldier might have a plain chest at the foot of his bed. The wooden variety of past centuries gave way in the 1900s to the pressboard or metal footlocker with its familiar metal-capped corners and

*War means gear* **and lots of it. The range of chests used by soldiers is wide, from clothing trunks and footlockers to writing desks and clothes hampers.**

*Pretty far gone but not forsaken,* this chest now holding garden tools once served Major General John F. O'Ryan in World War I. O'Ryan's cheaply manufactured chest probably never housed anything of great value; it most likely held tack for O'Ryan's horse. It may be in poor shape, but Strother Purdy won't part with it—the general was his beloved grandfather.

round-hasp lock. Inside were kept—neatly folded, of course—spare bedding, clothes, toilet articles, and perhaps a book or two.

Officers generally fared far better. Depending upon their ranks, they might have quite a variety of luggage along, even in combat. One chest in this chapter, part of the luggage of an officer, is marked #20, suggesting that this officer, like many others, was not inclined to travel light.

As a matter of tradition, officers purchase their own gear, from uniforms and weapons to chests and luggage. Just as with uniforms, there are standard styles and types of military chests, although they are made by private provisioners who serve the military trade.

During Napoleon's campaigns, to take the sting out of the long years away from home, officers began taking more and more furniture and household equipment with them. In response, furniture makers devised all sorts of cleverly collapsible pieces—dining tables that could seat 20 yet fold up to the size of a card table, beds that folded out of suitcase-sized boxes, chairs that could be folded flat—and campaign furniture was born.

English colonial officers serving in India, Africa, and other far-flung posts eagerly adopted the practice, so English furniture makers obliged by making more designs that put the elegance and comfort of home in a small package.

One of the most enduring designs in this style was the campaign chest. Combining the functions of a trunk, a bureau, and a writing desk, the campaign chest provided portable storage for clothes and other personal gear as well as a portable office to sort out the mounds of paperwork required to organize and maintain armies and colonial governments.

The campaign chest was typically a four-drawer dresser in which the top drawer had a fall front that served as a writing surface and inside were small drawers and cubbies for stationery. The other three drawers were used for clothing or other belongings. For portability, the chests were made in two units of two drawers each. One was stacked atop the other when in use and lifted off to be carried separately when the time came to decamp.

Campaign chests were often beautifully made, but everything about their design took into account the rough and constant handling they would receive. Simple and rectilinear in overall shape, they had very little molding

or other external ornament that could be damaged or dislodged in transit. The chests were made to be their own packing cases. Their feet were generally short and sturdy and often removable. The cases were bound at the corners, and edges with brass brackets were inlaid flush to the surface of the wood. The brass drawer pulls, too, hung flush with the face of the case when not pulled forward for use. The only departure from this rule of flushness was with the handles used to carry the chests; they were generally quite robust to ensure safe, comfortable handling.

Campaign chests are a rare example of military furniture that has crossed over into civilian use. With their spare, functional design, campaign chests have a strong appeal to the modern eye. But appealing to the eye is the last thing most military chests set out to do. Most military chests, expressing the harsh conditions of their use, are solid and unspectacular, quick to pack up and easy to carry.

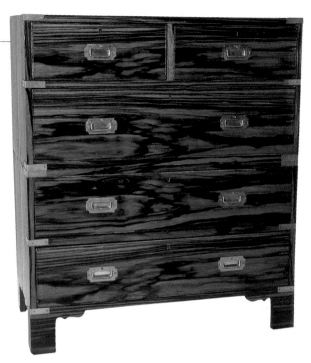

*Chest for a warrior's wardrobe.*
Made in two stacking units for portability and given a squared-off shape, no moldings at all, and fitted with brass brackets at the corners, this English chest typifies the campaign style.

*The handles fall flush* in campaign furniture. Because the pieces were meant to be moved often, they were made with as little protruding hardware and molding as possible. Elegance was not always overlooked, however, as this chest's calamander wood and solid-brass hardware attest.

# George Washington's mess chest: Mount Vernon on the move

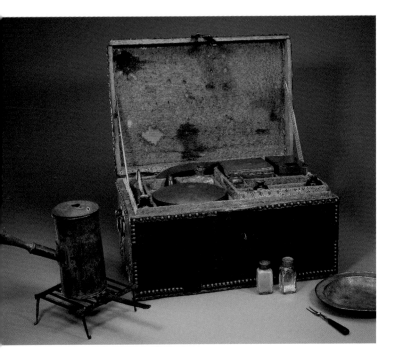

*For meals in the field* during the Revolutionary War, General George Washington used this modest mess chest. For compact storage, the cooking pot has a removable handle and the gridiron it sits on has folding legs.

MOUNT VERNON IS AN IDYLLIC SPOT. Former home of George Washington and now a museum, the stately house sits on a high knoll on the Virginia side of the Potomac River 15 miles south of Washington, D.C. In summer, visitors relax in comfortable chairs on the shady veranda overlooking acres of manicured lawn sloping gently down toward the river. Taking in the peaceful view of the river and the Maryland hills beyond, visitors want to stay all afternoon. If people are reluctant to leave Mount Vernon after only a brief visit, one can only imagine how Washington must have felt about leaving it to lead an army into war.

This compact mess chest from the collection of the Smithsonian Institution illustrates the shift in Washington's circumstances from gentleman farmer to leader of the undersupplied Continental army during the Revolutionary War. Washington would have used the chest when the army was on the move; when the army was more settled and had time to set up a formal mess, this chest would have remained in storage.

Like other officers, Washington purchased his own equipment. Although he was a wealthy man, his mess chest indicates that he wasn't extravagant; it is a modest if perfectly serviceable example of this type of chest. Cleverly nested inside along with dishes and platters made of tin-plated sheet iron are cooking pots with removable handles, glass bottles, salt and pepper shakers, two nesting tin boxes, some utensils, and a gridiron with folding legs. There is also a tinderbox containing materials for starting campfires—a reminder that matches would not be available for another generation.

On the occasions when the chest was used, Washington must have felt a long way from Mount Vernon. One envisions him in the dead of winter, hunched over a campfire, deep in thought, not having been home in several years, and clutching a cup for warmth, perhaps using the chest as a table or a seat. The small mess chest embodies the spirit of all the men like Washington whose willingness to make personal sacrifices helped realize the dream of a new nation.

# A chaplain's desk: the link between the fighters and their families

FEW FIELD DESKS WOULD HAVE BEEN AS WELL USED or widely traveled as this one. It belonged to the Rev. Charles W. Freeland, who was a chaplain in the U.S. Army for some 30 years. For much of his career, Freeland served under General John Pershing. Freeland and the desk followed Pershing to the Philippines after the Spanish-American War; to Texas in 1916, where Pershing led a punitive raid against the Mexican revolutionary Pancho Villa; and to France during World War I, where Pershing was commander of the American forces.

A military chaplain tends to the personal as well as the spiritual needs of soldiers and their families. Working outside the normal channels of the military's chain of command, chaplains often manage to pull just the right strings to help military men and their families in times of need. When all else fails, you contact the chaplain.

This portable field desk, now part of the Smithsonian collection, must have seen letters by the thousands from wives and mothers, sons and fathers asking for word, for news, and for help. Many more letters, these written by the chaplain, would have contained words of condolence and perhaps a first-hand account of a soldier's last words on earth.

*Key equipment* for a military chaplain, this field desk belonged to the Rev. Charles W. Freeland, who no doubt wrote and received thousands of letters during his service in the army from 1892 to 1922. The leather-covered wood desk enabled him to attend to his correspondence wherever he was stationed.

# Utilitarian precision in the 18th century

*Fine work from colonial times* is evident in the chest's interior, where the partitions are carefully fitted. The work is more impressive considering it was all done with hand tools.

WHEN THE DECLARATION OF INDEPENDENCE WAS SIGNED in 1776, 20-year-old John Francis Hamtramck was already a two-year veteran of the U.S. Army and newly promoted to captain. Hamtramck served the Revolutionary cause well, playing a pivotal role in securing the area around Detroit, Michigan.

Among the gear he took into battle was this large chest, designed to be hung from the side of a Conestoga wagon. Such wagons were the tractor-trailers of their day. Pulled by six horses, they could carry up to seven tons of freight.

Hamtramck's chest is a fine example of the high quality of workmanship often found in even the most utilitarian chests in the late 18th century. The joinery is amazingly precise and strong. The corners of the chest were first dovetailed and then reinforced with screws and iron brackets. Iron hanging straps go clear under the chest and around to the front, supporting it from the bottom.

Inside, all the pieces are beautifully milled—all by hand, of course—and the partitions are fitted together with a level of precision on which modern machinery could not improve. Hamtramck's chest was built to hold up under heavy use, and it has lasted very well.

*Long straps add security* for the rough journeys this chest had to take. The chest was designed to hang from the side of a Conestoga wagon.

*Built to take a beating,* this chest has corners that were first dove-tailed, then reinforced with braces and screws. The chest was used during the Revolutionary War by Captain John Hamtramck.

# Drinking water: a precious commodity for Civil War soldiers

*Military chests are typically spartan,* built to survive constant loading and unloading. The plain exterior of this chest gives no hint of its delicate contents.

THE OLD ADAGE SAYS THAT AN ARMY travels on its stomach. Without food and water, even the best-equipped army can't fight. That was never more true than during the Civil War, when this chest was used by Major General George H. Thomas of the Union army. With tens of thousands of men on the march, finding fresh water was a constant concern. And when an army came to a halt and settled in for a long siege, the problem worsened as the impromptu city of men, livestock, and munitions fouled its own water supply. Fresh water was so valuable that it transcended the conflict at times: The Union and Confederate armies even shared a spring on occasion.

General Thomas's chest would have been used to serve water, or possibly cider, to the general and any guests at his table. With its blown-glass bottles, tin cups, and decanting funnel, the chest represents the relative luxury a general enjoyed even under conditions of war and also speaks of what a precious commodity water was.

The chest itself is remarkable for its fine joinery. Very slender dovetails join its corners. Partitions of carefully milled pine divide the interior, creating spaces just the right size for the glass bottles. The dividers cushion the glass perfectly, protecting their precious contents and keeping them cool.

*A measure of luxury* is available to officers. This chest, with its blown-glass decanters, was used during the Civil War to serve water or cider to General George Thomas and guests at his table.

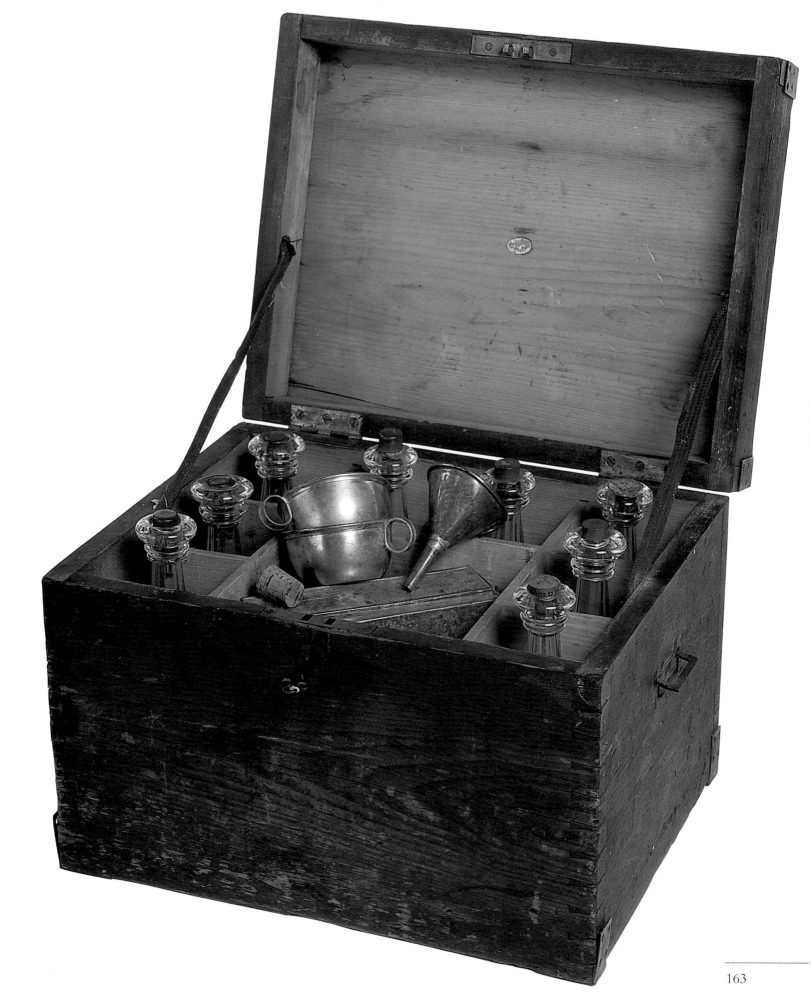

163

# Keeping up with paperwork
# while keeping up with the enemy

ADMINISTERING AN ARMY MEANS MOUNDS OF PAPERWORK. Every military officer needs a place to write, plan strategy, and track the various tasks for which he's responsible. This is hard enough with an office and a proper desk, but it presents a real challenge when the army is on the move and headquarters is under a tarpaulin in the middle of nowhere. For John W. Turner, a major general in the Union army during the Civil War, this portable secretary was the perfect solution. Standard issue at the time, portable desks like this one served to keep paperwork organized while providing space for correspondence. And best of all, a little desk like this could be packed up and loaded aboard a wagon in minutes.

This humble desk has a solid pine carcase, which is dovetailed together. When the hinged door is closed, it keeps the chest's contents in their cubbyholes; when it is opened, its inside face serves as a writing surface. To save the space that projecting knobs would require, the pulls are carved into the faces of the drawers. This way, when the door was closed for transit, it sealed the cubbyholes and kept the drawers shut tight.

Turner, an 1855 graduate of the U.S. Military Academy, held a variety of posts during the Civil War, from artillery commander to commander of subsistence, the man in charge of feeding an army. These were positions that no doubt generated endless paperwork.

*Quick as a wink,* the desk is closed, ready to be packed on a wagon. When the hinged writing surface is upright and locked, it holds the drawers in and seals the cubbies so the contents can't shift in transit.

*For writing letters in the field* and for writing orders and reviewing plans, officers in the Civil War generally carried a portable desk like this one, which belonged to Union General John W. Turner.

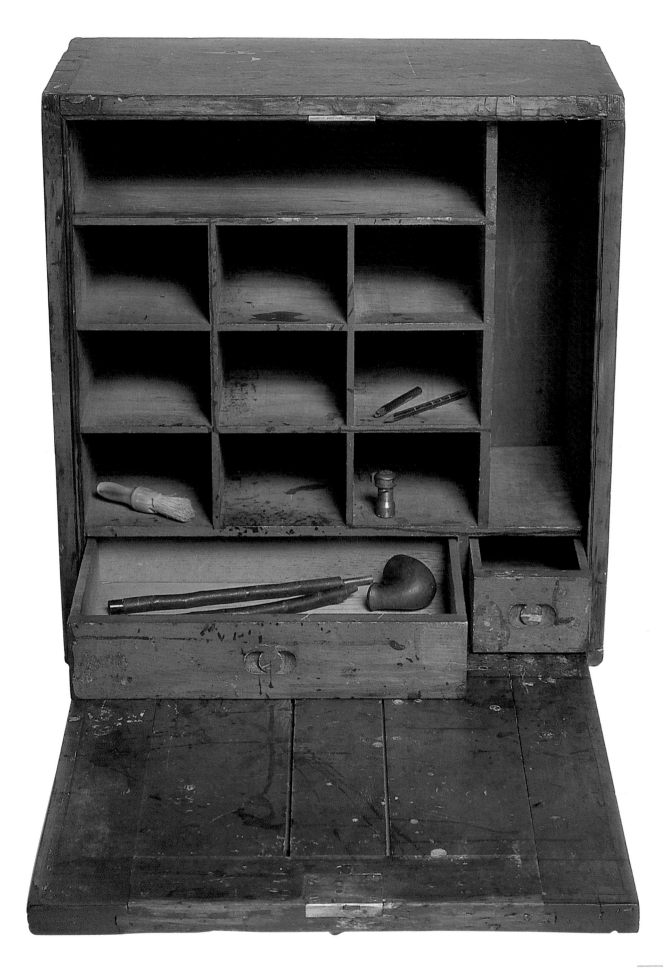

# The long, hard life of a softwood chest

THE HUMBLE WAGON CHEST THAT ACCOMPANIED Confederate Brigadier General Kirby Smith throughout the Civil War is a symbol of endurance. Battered and chipped, rained on, dropped, loaded and unloaded countless times, the chest nevertheless survives.

Nothing about its construction is very sophisticated; it is an example of the most basic style of board chest. The lid is a simple plank affair with cleats fixed to the underside on either end to keep it from cupping. Rabbet joints in the corners of the chest are secured with nails to hold the quartersawn pine boards together. The bottom is nailed on from below rather than held in a groove. The softer parts of the pine's grain have worn away, giving the chest a washboard texture. And the thin iron strapping designed to reinforce the corners of the chest has long since deteriorated. But the old chest is still in one piece.

The chest had plenty of time to take a beating. Smith was the longest-serving Confederate general. In fact, in May 1865, while victorious Union

*Humble and tough,* this roughly made wagon chest has nailed rabbet joints at the corners reinforced with thin, metal brackets. Despite the expedient joinery, the chest survived a long war intact.

*As tough as his wagon* chest, Confederate General Kirby Smith fought on after everyone else on his side had surrendered.

soldiers paraded along Pennsylvania Avenue past the White House, Smith was still fighting. Robert E. Lee had surrendered on April 9, but Smith still had another month of fight in him.

Word of Lee's surrender and the capitulation of the Confederacy spread slowly. It was only after Smith was informed that Jefferson Davis, the president of the Confederacy, had been captured, that he surrendered on May 26, 1865, finally ending the fighting between the two sides.

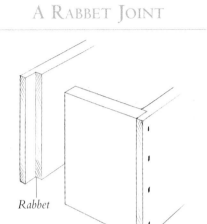

## A RABBET JOINT

*Rabbet*

*It is not your typical heirloom,* but the sturdy, simple wagon chest General Kirby Smith used throughout the Civil War was passed down from his father, a federal judge in the Territory of Florida.

# Mortality and the mundane: a chest and hamper belonging to George Armstrong Custer

*Behind the heroics of war,* **domestic life goes on. This humble clothes hamper belonged to one of the most storied American military figures of the 19th century: George Armstrong Custer.**

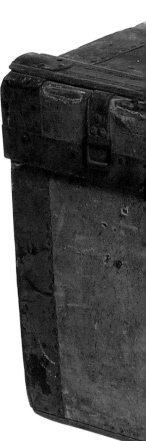

BATTLE MAKES HEROES AND LEGENDS OF MEN, but their belongings tell a humbler story.

A century and a quarter after he and all the men he led impetuously into battle at Little Bighorn were killed, George Armstrong Custer is still vividly remembered. He is remembered as the "boy general" of the Civil War, who squeaked through West Point (graduating last in the class of 1861) but went on to gain fame as a hard-charging leader in Civil War battles. He seemed to delight in battle, but his troops paid dearly for his heroics, suffering casualty rates among the highest recorded in a war of catastrophic losses.

He is remembered for commanding the 7th Cavalry after the war, when he led the campaign against the Plains Indian tribes for close to 10 years. And, of course, he is remembered for the massacre at Little Bighorn.

Custer's flamboyance and vanity are part of the mixture that made him a martyr. A more modest general might not be recalled so vividly, but Custer had an extravagant style of dress, which at one time included black velvet trousers trimmed with gold lace and high boots with gilt spurs. His fringed jacket is one of the most popular exhibits at the Smithsonian History Museum.

These two chests formed a small part of Custer's equipage. The #20 on the cane-and-canvas clothes hamper suggests that Custer carried at least 20 pieces of equipment—he was not a light traveler. And the footlocker no doubt held some of his unusual wardrobe. As we examine these chests, we look in vain for evidence of heroism or hubris. They speak instead of the domestic story behind the valor and vanity of war.

*Forefather of the footlocker,* Custer's canvas-covered wooden clothes chest is of a style that was common in the military in the last third of the 19th century. Famous for his flamboyant dress, Custer would no doubt have carried quite a few clothes chests when he traveled.

# A Civil War powder monkey's reenactment chest

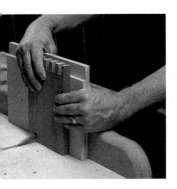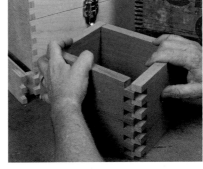

*Just the joint for making a chest,* the box joint, or finger joint, is strong, straightforward to make, and perfectly suited to mechanization. Although box joints can easily be cut with a handsaw and a chisel, box joints made by machine are hard to improve upon. In the photo at left above, they are being cut on a table saw. Box joints have long been used to make massproduced shipping boxes, but with their excellent glue surface and attractive repetition, box joints are excellent for heavy chests as well. Although hidden under the green paint, box joints join the corners of James Perkins' sturdy reenactment chest.

THOUSANDS OF SOLDIERS ARE STILL FIGHTING the Civil War. They shoot at each other across stone walls and chillingly open wheat fields, they charge at each other with fixed bayonets, and they fall down dead. Nearly every weekend somewhere in the United States, Civil War re-creation clubs get dressed up and go back in time.

Each of the participants is required to have authentic reproductions of the equipment used during the war— uniforms, muskets, horse tack, canteens, tents, even cannons—and in some cases, reenactors have original equipment. This may sound obsessive but it is no fringe activity. For the 125th anniversary of the Battle of Gettysburg, for instance, 14,000 people gathered on that famous battlefield for a reenactment of the bloody events that occurred there.

Many reenactors are drawn by the chance to study military history, while some take part in memory of an ancestor who fought in the war and others do it just for fun. Fun is the reason a boy named Max Perkins of Boone, Iowa, is involved. He started at age 10 as a powder monkey, supplying gunpowder to the artillery. Then he turned his ambitions toward becoming a bugler. His mother made him a Union uniform, and his father, James, made him this hickory chest in which to store his reenactment gear.

James box-joined the carcase and gave it a traditional reinforcing skirt on the bottom and around the top of the case. Inside, there is a sliding tray on runners to hold small items. Max especially wanted a secret compartment where he could keep stuff hidden from his sister, so his father built the chest with a false bottom.

*Fighting old battles* is a passion for thousands who spend their weekends reenacting Civil War battles. In addition to soldiers in period uniforms toting weapons true to the time, there are also field photographers recording the scene with cameras using Civil War–era glass-plate negatives.

*Military make-believe* is the metier of this chest, built by James Perkins for his son, Max, who participates in Civil War reenactments.

# Three and one-half cubic feet
# of personal gear

THIS ARMY-ISSUE FOOTLOCKER WILL BE FAMILIAR to millions of veterans of World War II. Measuring 2½ ft. long, 16 in. wide, and 1 ft. high, it represented all the space most GIs had for their personal gear. This one was used by Dr. James Irving, who lived most of his life in Hartford, Connecticut, and held the rank of captain when he served as a neurosurgeon during the war in American hospitals in the United States, England, and Western Europe.

What is most remarkable about Irving's chest is its meticulous state of preservation. Looking into it, you get the feeling you could be in the barracks, standing at the foot of a soldier's bunk. Everything in the chest is Army issue—T-shirts, fatigues, khaki shirts, web belt, mess kit, shaving kit, first-aid kit, and pup tent. Everything, that is, but a mysterious pair of woven rattan slippers.

The chest was donated to the Connecticut Historical Society by Irving's family some years after he died in 1972 at age 65. Curators there saw the chest as a time capsule; they thought perhaps it had been undisturbed since the war. But when they removed the contents to catalogue them, they found, spread neatly across the bottom of the chest, several pages from an issue of the *Hartford Courant* newspaper from 1965. The old soldier must have packed his footlocker one last time.

*The standard footlocker* distributed to GIs in World War II provided all the space they got for their clothes, gear, and personal supplies. Cheaply made by the thousands, the chests nonetheless held up well.

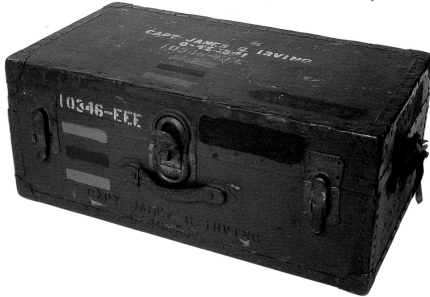

*Providing a snapshot of a* soldier's supplies, this chest used in World War II has remained virtually untouched since. It contains a complete kit of Army-issue gear.

# Past and present blended
# in a modern campaign chest

FURNITURE MAKER LES CIZEK WAS INTRIGUED when he saw an 18th-century French military officer's campaign chest in an antique shop in New Orleans. Designed for travel, like all campaign furniture, it was made in two parts, one stacked on the other. The upper unit was a desk, which had a fold-out writing surface, cubbyholes for papers, and compartments for pen and ink and other items. The lower unit was a small chest of drawers.

That old piece inspired Les to design a contemporary campaign chest. He built his in three parts: two chests and a stand. The upper chest is a secretary with cubbyholes for stationery. The cubbies are made of maple and can be removed from their boxes to reveal secret compartments behind. The hinged front of the unit becomes the writing surface, and when it is lowered, lopers automatically extend from beside the drawers to support it. Les veneered the outside of the secretary unit with teak, a traditional material for campaign chests, many of which were made in India and the Far East. He used curly maple veneer inside to brighten the interior.

Because they were so often moved, campaign chests typically had their corners bound in brass. Les adopted this detail for the upper unit of his chest. He also used brass flush-fall handles on both upper units, another traditional detail for campaign chests. But when it came to drawer and door handles, he made his own quite contemporary ones—elegant drop pulls made of brass and ironwood.

Like the upper unit, the lower one is clearly inspired by old campaign pieces. But the stand is another matter. Here, Les deliberately took a distinctly untraditional tack, making an open stand

*Campaign chests were part luggage,* **part furniture. To be extremely portable, they were made in stacking units. This contemporary version bends toward furniture with the addition of an elegant stand.**

*A secretary with a secret,* this chest made by Les Cizek has removable cubbies with hidden compartments behind.

*Lopers extend automatically* when the fall-front is dropped, providing support for the writing surface.

with slightly curved legs and building it of white oak. The unlikely combination works visually and also raises the upper chest enough to make the desk comfortable to use while standing.

Les's blend of period and contemporary touches works so well that one can easily imagine an 18th-century military officer using the chest, dipping his quill into the inkwell and writing orders and other correspondence by candlelight. But it is equally easy to visualize the modern corporate warrior standing at this campaign chest, with his laptop computer open on the desk, issuing orders by e-mail.

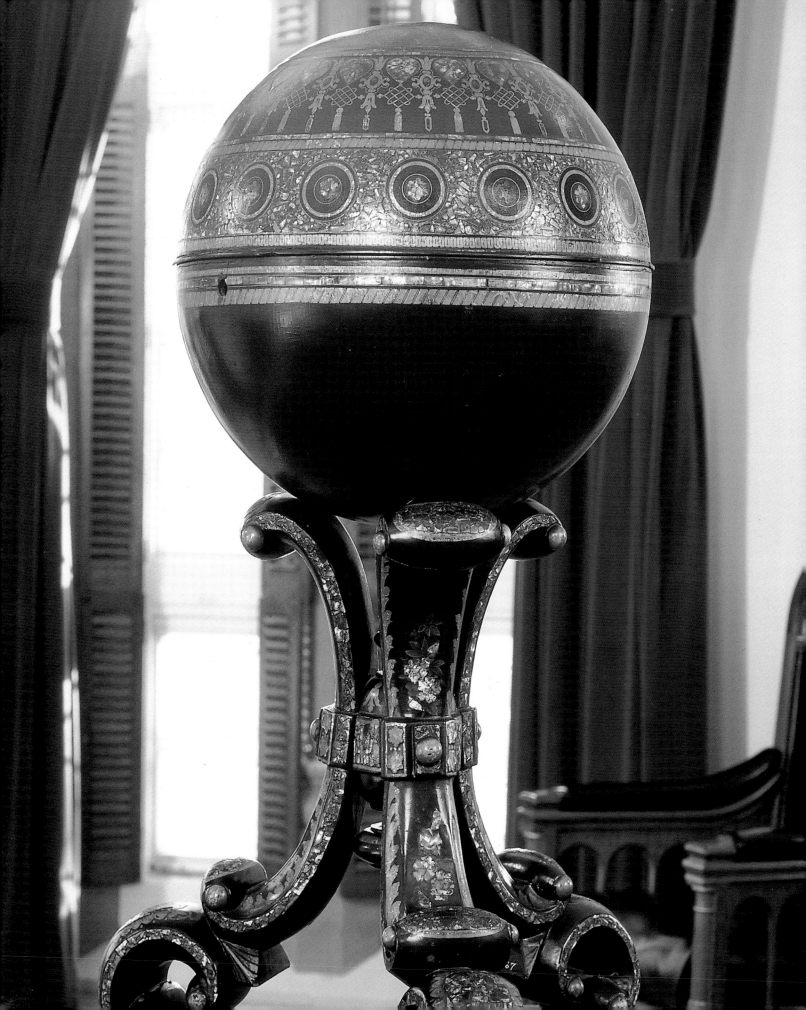

# Special-Purpose Chests

## *Where the Rules Begin to Bend*

CHESTS FOR SPECIAL PURPOSES could fill another book all by themselves. These are pieces that push the limits of the chest, expanding the definition of the term with respect to materials, shape, and function.

Where function is concerned, chests have always been extremely flexible. There's no limit to the number of ways the big, open well of a chest can be divided to accommodate special contents. But things really get interesting when the shape of the chest begins to change to suit a peculiar function or a specialized trade. The selection of such pieces includes, among others, chests custom-made for undertakers, vaudevillians, gamblers, and ice-cream salesmen. None of these chests is likely to look much like the one at the foot of your bed.

Form follows function. Well, sometimes it does. But in some chests, function is invisible: These are chests that serve a spiritual rather than a tangible need. People of all persuasions have made this sort of receptacle, and a small selection of chests for the spirit—including chests for contemplation, for prayer, for ceremonial regalia—hints at the greater diversity beyond these pages.

*Not every chest* **is rectangular. The chests in this chapter, like the extraordinary sewing chest on the facing page, take all sorts of shapes to suit all sorts of purposes.**

*It's not an ice chest,* and the Eskimo Pie is in no danger of melting. Driving home the point that just about every profession generates the need for a particular chest, this small box is an ice-cream salesman's sample case.

Most chests seem to want to be fairly rectilinear. Like houses, they're easier to build that way. And after we've seen many thousands of squarish chests, we become comfortable with the convention. But there are chest makers who break that barrier with great gusto. Some of them break it simply because it is there. That would seem to have been the case with the makers of several of the chests in this chapter, chests that have more in common with pure geometry than with practical considerations.

There is another group of special chests that seems to exist simply in order to be decorated. Whatever their ostensible function might be, the heart of the matter is on the exterior. They are canvases to be painted, whether the artist is using oils or acrylics, carving tools, or a palette of variously hued woods.

And then there are toys. If you've ever stumbled through a child's room delivering a drink of water in the dark, you know there's no such thing as too much storage space for toys. In this chapter, the need is met in a dozen different ways. There are toy chests built like fine furniture, toy chests built like architecture, and toy chests built like luggage. As a group, they're long on whimsy but they're not short on technical skill or innovation, either. Of all the chests in this book, these seem, as a group, the most personal. Almost all of them were made by a relative of the pint-sized recipient—a wood-

*Tools of the performer's trade* barely fill this small chest. Once used by a vaudeville performer, it expresses the transience of the profession. The chest has found a permanent home, however, in the Smithsonian.

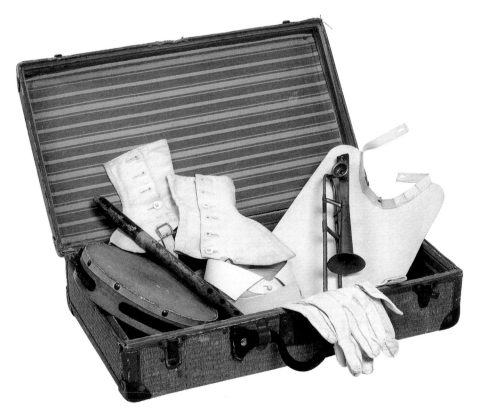

working grandmother or grandfather, a father, or an uncle—and the personalities of the makers and the children are clearly expressed in the finished chests.

If there is a theme running through this loose collection of chests, chests that range wildly in size, shape, materials, decoration, and intention, it is about the flexibility of the form—a chest can be made to hold anything—and the persistent need humans seem to have to make or find just the right chest for those things they value.

*A pine chest for the* **Charter Oak, this box holds relics made from Connecticut's most famous tree. When colonial governor Sir Edmund Andros traveled to Hartford in 1687 to retrieve the colony's rather liberal royal charter, colonists safely stashed it in a great, hollow white oak tree. The charter stayed in the tree for two years. When the tree, about 1,000 years old, blew down in 1856, souvenirs were made from its wood, some of which is to be found in this chest.**

# *If you ply an extraordinary trade,*
# *you might well need an extraordinary chest*

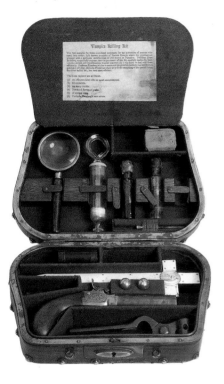

T HE ART OF PACKING ART was the specialty of the late John Douglas of Arlington, Virginia, who made custom crates for billions of dollars worth of paintings, sculpture, and furniture in his career. His chests were so beautifully suited to their purpose and his work was so highly acclaimed by the fastidious museum curators who hired him that this chest representing his superior skills has been accessioned into the permanent collection of the Smithsonian Institution. This crate was built to cradle a patent prototype that traveled to Japan for an exhibition in 1987.

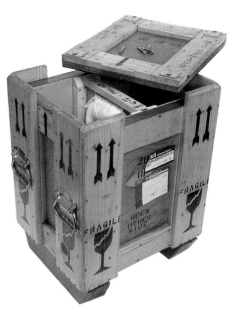

A NYONE ON THE TRAIL OF a vampire would do well to pack this handy chest. With its pistol and silver bullets, ivory crucifix, powdered flowers of garlic, and wooden stake, Professor Blomberg's Vampire Killing Kit provides all the means you could require to defang the monster and save your own neck. Now in the collection of the Mercer Museum in Doylestown, Pennsylvania, the kit shows little sign of wear.

N O NEED TO TRAVEL to try your luck if the owner of this portable roulette wheel comes to town. But it would be wise to hedge your bets because this device is rigged. A system of electromagnets within the wheel, tripped when the croupier presses on a certain loose screw, enables him to keep the ball from landing in the slots where the biggest bets are riding. Made by a Chicago firm in 1930, it was used in honky-tonks across the northwestern United States. The thoroughly banged-up shipping chest did its job so well that the wheel has not so much as a scratch on it.

UNDERTAKERS SOME-TIMES USED ICE in the late 19th century to preserve a body during the mourning period between a person's death and burial. Before the advent of refrigeration and before modern embalming techniques were widespread, this unusual device with a compartment for ice served to chill the corpse and keep it from decomposing before it was put in a coffin for interment. The body lay at the bottom of the chest, and the ice was in a shallow compartment at the top. Advertised in an 1876 catalog of funeral equipment, this black walnut "corpse preserver" was insulated with horsehair, had tubes to drain out the melted ice, and featured a glass port for viewing the deceased during a wake.

A FIREFIGHTER'S SEWING BOX? Yes. In the months before her wedding, Laila White, firefighter and seamstress, spent the long hours at the fire station between calls sewing her own wedding dress. Seeing her ancient metal sewing box, her groom, Bob White, custom-built this replacement. Self-taught and working with only a block plane, some chisels, a circular saw, and some materials scavenged from a woodworker friend's discard pile, Bob built quite a nice sewing chest. How nice? Laila has decided it's too good to take to the fire station.

# Chests that serve when the spirit needs a receptacle

CEREMONIAL CHESTS OF the Lummi Indians, these traditional pieces shown at left were made by Felix Solomon, the tribe's first boxmaker in three or four generations. Built on the Lummi Reservation near Bellingham, Washington, each box is made by scoring and folding a single board, a technique used for many centuries by Northwest Coast Indians. The plank is first carved with deep grooves where the corners will be and then it is steamed. Once the plank is folded into a box, the last corner is laced together with bark thread. Using this technique, chests can be made that hold water. Felix's chests will hold ceremonial regalia used when the Lummi gather.

FINE BOX FOR A SMOOTH STONE. The U.S. government commissioned this chest (shown in the two photos above) built by Baltimore woodworker Carl Swensson. It and the viewing stone it was made to house were a gift to the visiting Japanese prime minister. Carl, a student and practitioner of Japanese woodworking techniques, built the poplar chest with impeccably cut box joints and secured them with bamboo pegs—and no glue. Carl was familiar with the Japanese practice of *sui secki,* the contemplation of an aesthetically interesting stone, but had little time to indulge in it while making the chest: From the time he received the commission to the time he was to deliver the chest, he had six days.

A CHEST FOR SOLACE in the face of horror, the log-cabin-like container and chess set shown below were carved in secret by a father and son held in a Nazi death camp. During World War II, Carl Steinbrenner and his father were imprisoned in Auschwitz, the complex of concentration camps outside Krakow, Poland. Sharing a love of chess, they built this set in complete secrecy, with the hope of one day having the freedom to use it. At the very end of the war, Carl's father was executed; a week later, Russian troops liberated the camp. Carl emigrated to the United States, bringing the chess set with him. It is now in the collection of the Smithsonian Institution.

S YMBOLIC, SCULPTURAL, AND SPIRITUAL, this reliquary chest was built by Cincinnati woodworker Robert Winland to honor the memory and hold the ashes of four departed felines. Robert studies Japanese history, art, and woodworking, and his design was inspired in part by a traditional Japanese traveling chest that is slung from a pole and carried by two men. Robert also incorporated a medallion like the Japanese mon, or crest, which is used as an identifying symbol on clothing and furniture. The chest is entitled "Sleeping cats dream of dolphins in the waves."

# Evidently not everybody believes that a chest has to be flat and square

Part bench, part chest, part canoe, this functional sculpture is the work of Russel Krysiak. The chest's hybrid nature is a reflection of Russel's multifaceted education in crafts and fine art. He learned leatherworking from his grandfather, textile weaving and basket making from his mother, and earned a degree in metalsmithing. Then he spent two years studying with sculptor Martin Puryear, from whom he learned to integrate a variety of materials to create sculptural forms.

Can a chest be triangular? This was the puzzle Robert Schultz solved when he built this piece while a graduate student in the woodworking program at Rochester Institute of Technology in 1965. As the design took shape on paper, he realized that unless he could figure out a way to gain ready access to the interior, the chest would remain an art piece. He decided to make the lid with one of its sloping sides short and the other long. This enabled him to provide a large opening to the interior while keeping the lid relatively light. It also meant he could hinge the lid near the top of the chest so that opening it would be easier. The clever design for the lid turned an exercise in pure geometry into a fully functioning chest.

A SEWING CHEST ON A ROYAL SCALE, this gilded extravaganza made around 1860 looks like something a queen might have commissioned. But according to records of the Smithsonian, it was originally owned by a family in Omaha, Nebraska. The ornately scrolled base is carved from wood, but the spherical container is made of papier-mache, then painted, inlaid with mother-of-pearl, and gilded.

# Sometimes a chest is built to be decorated

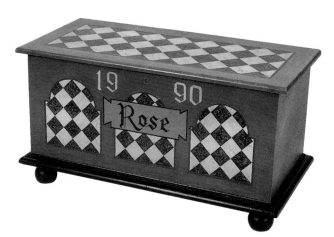

CURVED LEGS AND CURVED carving bring out the animal in Tom Volk's cherry and walnut chest. At first glance, the sweeping, V-shaped detail on the front panel may appear to be a simple groove in the wood. In fact, Tom produced it by relieving the areas on either side of the V, leaving the center section standing proud.

DOVETAILS ARE THE DECORATION on Uli Kirchler's small chest. Uli, who made his living for 10 years performing in public as a one-man band, found his new profession when he saw an Incra jig at a woodworking show. Fascinated by this gadget and all the decorative joints it could cut with a router, he learned how to use it and then built a business on the skills he acquired.

PAINT IS ERASABLE ON the anniversary chest Mario Rodriguez built for his sister. Mario uses a layered method of applying paint that allows him to remove color cleanly if he doesn't like the way it looks. After sketching the layout on the chest, he begins filling it in with latex paints. When he has one color the way he wants it, he seals it by spraying on a light coat of lacquer. The next color is applied over the lacquer and is then itself sealed with another coat of lacquer. At any point, if Mario applies a color and is unhappy with the result, he can remove it with a sponge, leaving previous layers untouched.

Reaching into the past and around the world for their inspiration, Alison Kirkley and Rich Carswell, who live in British Columbia, collaborated on this Art Deco chest with a tropical theme. Rich, a former banker, built the maple, alder, and aromatic cedar chest, and Alison, a special education teacher, painted it with artists' acrylics. It was the first piece of furniture they built together, and it launched their custom-furniture business.

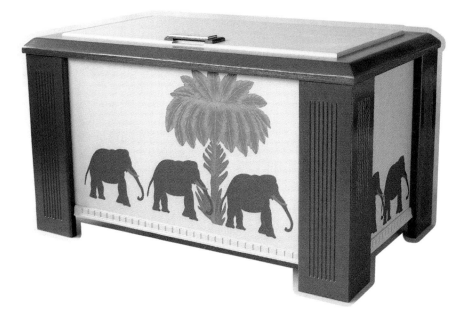

# A toy chest isn't always
# a simple plywood box

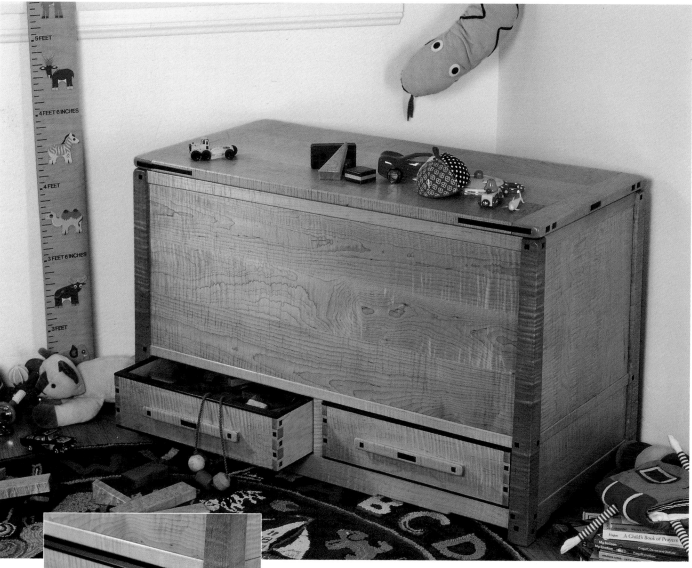

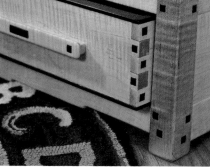

FINE CABINETMAKING FINDS ITS WAY into the children's room in Richard Muller's maple toy chest for his firstborn son. The chest's finger-joined drawers and meticulous ebony detailing recall the furniture of California Arts and Crafts designers Greene and Greene. That is no coincidence, since Richard is so passionate about their work that he serves as a docent at Pasadena's Gamble House, one of the Greenes' extraordinary bungalows, which is now a museum.

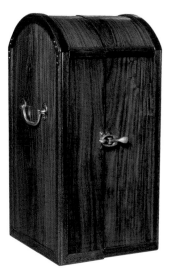

Brass and rosewood bring a burnished elegance to the doll's chest Jim Korndorfer built for his granddaughter Kristin. Influenced by old steamer trunks, Jim made the chest in clamshell style with drawers and a clothes pole for the doll's wardrobe and shelves for the rest of her wee belongings, including a brass lunch pail and miniature school books.

A cleverly placed drawer provides an easily accessible place to store small toys that normally filter to the bottom of a toy chest and disappear until the next dumping. Lennart Andersson built this maple and walnut chest for his nine-year-old grandson, Cody, who helped design the inlay and lent a hand with sanding and oiling the chest.

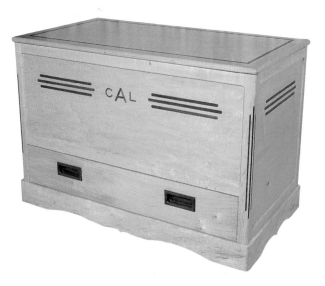

# Decoration can make
# a simple toy chest sing

MARQUETRY LETTERING PERSONALIZES this toy chest Pat Curci made for his granddaughter. Pat, who teaches marquetry and veneering at Palomar College near San Diego, veneered the chest with bird's-eye maple and used cherry veneer for the lettering. The overall design of the chest, with its domed lid, is based on the 1940s toy chest Pat's parents gave him as a boy. He's still got it standing proudly in his living room and considers its design just about ideal for a toy chest.

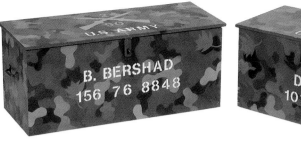

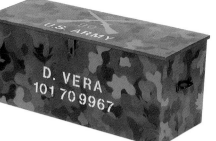

STENCILS AND SPRAY CANS were the tools Mario Rodriguez employed in creating the camouflage pattern on these chests he built for his nephews. He began the design by spraying a background of drab green. Then he cut a variety of stencils out of paper and used spray adhesive to hold them down while he sprayed.

DEEP-RELIEF CARVING IN A RUSTIC MODE gives these pine toy chests an original twist. Jack Taylor, an amateur woodworker in Philadelphia, made and carved the chests for his three grandchildren—he knew he'd never get away with making a chest for just one of them. Jack distressed, shellacked, and added burnt umber highlights to the carving to heighten the rustic effect.

# Sometimes a toy chest has more on its mind than simply holding toys

Providing a place to read, write, and play, Ron Carter's solid-oak toy chest was built for a church nursery. Ron incorporated the chalkboard to save the nursery walls from being used for the same purpose. He added shelves for book storage but made the lower shelf so that it can be pulled out easily to free up the whole chalkboard.

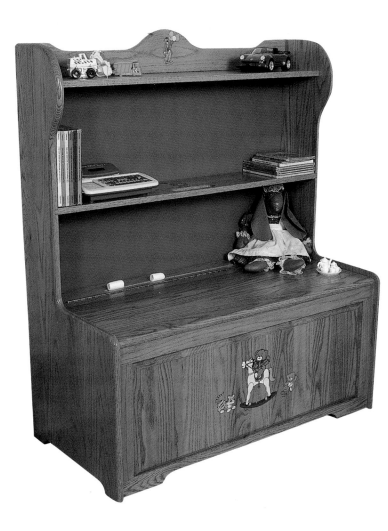

Both stage and storage, the stepped toy chest Judy Linhart built for her granddaughter Tobey has plenty of space for toys but also serves as a stage for puppet shows. The steps are covered with magnetic board that can be written on and erased. Access to the main storage compartment is through the steps, which are hinged. The doors at the back of the chest open onto a set of shelves.

A BENCH, A BOX, AND A PLAYTHING combine in Judy Linhart's toy chest for her grand-daughter Jenna. The various brightly painted animals on the chest are mounted on dowels so they are removable. Jenna can spin them or switch them around to other parts of the chest.

# If the designer has a streak of the kid in him, a toy chest can be as fun as anything inside it

A BARN IS ALWAYS BEST for storing large machinery. This turns out to be true even if the barn is only knee-high. Alfred Spitzer, born and raised on a farm in New Hampshire, built this toy chest for his daughter while living in New York City and dreaming of New England. These days, the family is back in New Hampshire, and Alfred's son—the owner of a fleet of Tonka trucks—has inherited the barn from his sister.

THE BOXCAR IS A BRUTE, having stood up to heavy use by three boys in the 1960s and another generation today. Driscoll Nina built the 4-ft.-long train-car toy chest for his sons and watched them straddle it, hide inside it, fill it with toys, and push it around the playroom. The rolling chest still occupies a place in the corner of the kitchen, where Driscoll's grandsons seek it out when they come over to play.

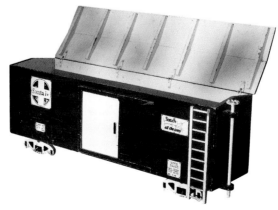

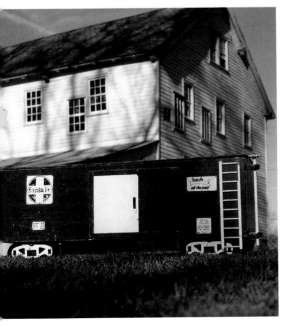

A TOY HOUSE TO FILL WITH toys. David and Bernise Shiller are furniture makers who share a dream of owning a small adobe or stucco pueblo-style house one day. Until they get it, they're turning out scores of miniature versions of their dream house ranging in size from something suited for a box of tissues to this one for toys. If they sell enough of them, they plan to build the full-scale model and live in it.

# Glossary

**Bird's-eye** Figure appearing particularly in maple that looks like the eye of a bird.

**Bombé chest** An elegantly shaped chest with outwardly curving sides and front.

**Box joint** Sometimes called a finger joint. Used in the manufacture of boxes, the joint is a square version of a dovetail joint. Equal-sized pins and slots cut on the ends of the board join the corners.

**Breadboard end** A cap on the end of a panel of solid wood. It helps keep the panel flat and caps the end grain. Typically the cap is mortised and the panel is tenoned, allowing the panel to freely expand and contract with changes in moisture.

**Closed grain** Wood with closed grain has a very smooth surface free from large pores. Examples of closed-grain woods are cherry and maple.

**Coopered** A coopered panel is made up of several boards or staves each having a bevel cut on its edges so that when the boards are glued together, they form a curve.

**Cross-grain** Perpendicular to the long grain of a board. Long grain normally goes lengthwise on a given board.

**Curly** Undulating figure found most commonly in cherry and maple.

**Dovetail** A joint with two parts: pins and tails. The wedge-shaped tails look like tails on birds. The pins and tails interlock to create a powerful mechanical joint.

**Ebonizing** A process by which wood is turned black to look like ebony.

**Edge grain** The grain on the edge of a board, as opposed to on its end or its face.

**End grain** The grain on the end of a board, as opposed to its edge or its face.

**Epoxy** A two-part glue used extensively in boatbuilding and in places where moisture or pressure prevent the use of ordinary woodworking glue.

**Face grain** The grain on the face of a board, as opposed to its edge or its end.

**Figure** The grain pattern on a board. More figure implies more prominent grain.

**Flatsawn** A flatsawn board has more or less horizontal end grain.

**Frame and panel** A system of building with solid wood in which large panels are set into narrow frames. The panels are not glued in place, so they can expand and contract with the seasons.

**Hardwoods** Deciduous or leaf-bearing trees. This term has nothing to do with the hardness or softness of the wood.

**Heartwood** Wood found in the interior of a tree that is typically darker in color than the sapwood that surrounds it.

**Inlay** A technique by which the surface wood is removed and replaced with a contrasting wood. This is most commonly done with veneer.

**Lapstrake** Horizontal planks on boats are often called strakes. Strakes that overlap one another where they meet in a boat hull form a style of boatbuilding known as lapstrake.

**Loper** A support for the writing surface on a folding desk.

**Marquetry** Decorative inlay work that typically involves designs, artistic scenes, or lettering.

**Miter** An angle cut on a board, typically on its end. It mates up with a matching angle on another board. A picture frame, for example, has mitered corners.

**Mortise** The cavity or hole in which a tenon fits in a mortise-and-tenon joint.

**Open grain** Open-grained wood has prominent pores. Oak and mahogany are good examples of open-grained wood.

**Panel** Typically refers to a fairly large slab of solid wood.

**Pin** The half of a dovetail joint that shows a wedge shape on its end grain.

**Quartersawn** Wood cut with the face of the board parallel to the radius of the log. In species like oak, this produces extremely attractive flecked figure.

**Rabbet** A slot or groove cut along the edge or end of a board so one side of the groove is open.

**Rail** The horizontal member of a frame-and-panel assembly.

**Raised panel** Frequently seen in furniture and cabinets, a panel in which the perimeter has been relieved making it appear that the center of the panel is protruding, or raised.

**Riftsawn** Lumber that is riftsawn has end grain running at a diagonal.

**Sapwood** Typically lighter in color than heartwood, this wood is found closer to the exterior of the tree.

**Softwoods** Coniferous or cone-bearing trees. This term has nothing to do with hardness or softness of the wood.

**Spline** A thin piece of wood used to align two boards as they are being glued together. A groove or dado is cut into each board, then the spline is fit into this groove.

**Stile** The vertical member of a frame-and-panel assembly.

**Substrate** The core of a veneered panel. The veneer is glued to both sides of a substrate, often plywood, to make the panel appear to be solid wood.

**Tail** The part of a dovetail joint whose end grain is a rectangle. The cutout between the tails makes them look like the tail of a dove, hence the name dovetail joint.

**Tansu** Although tansu means portable box, it implies a style of wooden storage furniture that was developed in Asia. Tansu chests, which take many forms, typically have a combination of drawers and doors, metal braces on the corners, and prominent hardware.

**Tenon** The male portion of a mortise-and-tenon joint. It can be either fixed, in which case it is cut on the end of one board, or loose, which means it is cut to fit mortises in both pieces being joined.

**Till** A small often lidded tray at one end of a chest. Often there is a false bottom in the till that houses a secret compartment.

**Tongue and groove** Boards joined with tongue and groove have a male and female portion along their edges to align the boards as they fit together. Most hardwood flooring is fit together with tongue-and-groove joints.

**Veneer** Wood cut into very thin layers. Plywood is made up of veneers glued to one another in cross-grain layers.

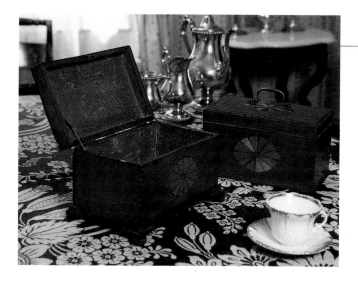

# Credits

SPECIAL THANKS: Several people went out of their way to provide information or photo access including Karen Lystra; Tobey Sharpe; Aaron King; Nancy Fister; Hollis and Katie Clanton; Mr. Nichols of McLean, Virginia; Bob Bridges; Shelby Foote; Fred Dalinger of the Circus World Museum; Richard Malley of the Connecticut Historical Society; Amanda Young of the Smithsonian Air and Space Museum; Philip Budlong and Rob Mathieson of the Mystic Seaport Museum; Laurie Dunn of the New Milford Historical Society; Mary Payne of the Warren County Historical Society; Robert Novak of the Derby Historical Society; Jennifer Lock Jones, Margaret Vining, and Fath Davis Ruffins of the Smithsonian American History Museum; Stephen Rice and Maryanne Curling of the Mark Twain House; Susan Taylor of the Long Beach Public Library; the very helpful staff at Louis Vuitton, Paris; Anne Ruta and Patrick Sheary of the Daughters of the American Revolution Museum; Hamtramck's Jennifer Ford, E. Tamara Sochacka, and Greg Kowalski; William Lopez and Miriam Blieka of the Metropolitan Museum of Art; Johanna Brown of the Museum of Early Southern Decorative Arts; and the nice folks at the Bucks County Historical Society's Mercer Museum.

CONTRIBUTORS: Paul Babcock; Ernie and Susan Conover; James Wiley; Cliff and Linda Trimble; Lyman Everett; Jeni Sue Wilburn; Jim Kollath; Sharon Cica; Ted Wong; Jeff Dilks; Richard Dunham; Gene Agress; Charles Caswell; Peter Follansbee; John Alexander; Michael Siemsen; Lois Wilson-Schleining; James and Amy Fontenot; Don Walsh and Maryann Rozanski; The Lane Company; Ken Cowell and John B. Stokes; Thomas Miller; Greg Zall; Kerry Medina; Felix Solomon; Mario Rodriguez; Robert Winland; Carl Swensson; Les Cizek; Willie McArthur; James and Max Perkins and Sylvia Tiala; Strother Purdy; Lee Hanson; King Heiple, M.D.; Bryan Phinney; Cullen and Beth Wilder; Lui Venator; John and Sarah Webster; Ernie Baird; Wayne Chimenti; Ejler Hjorth-Westh; Ken Newell; John Barbee; Murray Kernaghan; John Wilson and Lynne McQuilkin-Wilson; Kim Beran of H. Gerstner & Sons; Ed Kramer; Carl and Hanna Shafer; Jay Fisher; Alfred Spitzer Jr.; Judy Linhart; Driscoll Nina; Jim Korndorffer; Pat Curci; Richard Muller; Lennart Andersson; Ron Nelson; Jack Taylor; David and Bernice Schiller; Ron Carter; Robert Bell; Dennis Cooney; Erin Foley; Linda Schmitz; D. R. Rawlings & Sons, Inc.; Silvio A. Bedini; Willis Bowman and Rich Gotz of the Minnesota Woodworkers Guild; Bob and Mandy Karnauskas; Pat McCarty; John Nesset; Brent Merkley; John Nyquist; Niall Barrett; Preston Frazier; Peggy Hume Hudson; Richard Hatch Jr.; Russell Krysiak; Robert Schultz; Bob White; Kayoko Kuroiwa; Evert Sodergren; Uli Kirchler; Tom Volk; David Crofcheck; Jim Lewis and Jean Gallagher; Bruce Zeitlin; Richard Carswell; and Alison Kirkley.

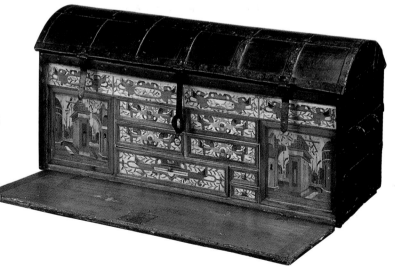

## PHOTOGRAPHS:

cover: Photos © Randy O'Rourke.
flap: (front flap, top; back flap) Photos © Randy O'Rourke; (front flap, bottom) Photo by Zack Gaulkin, courtesy of *Home Furniture* magazine, © The Taunton Press, Inc.

**All text photos © Randy O'Rourke, except those noted below.**

p. 6: Photograph © 1978, The Metropolitan Museum of Art.

p. 7: Photo © Mystic Seaport, Mystic, Conn.

p. 8 (top and bottom): Photos by Jonathan Binzen, courtesy *Fine Woodworking* magazine, © The Taunton Press, Inc.

p. 9: Photo © Richard Bienkowski, courtesy the Newell Gallery.

p. 10: Medical Chest by the Dunneford Family Chemist, mahogany, late 19th century with bottles of drugs and syringes; Private Collection/Bridgeman Art Library.

p. 11: (top) Egyptian Scribe's Chest, painted wood, New Kingdom, 1555-1080 B.C., Louvre, Paris, France/Bridgeman Art Library; (bottom) Archives Louis Vuitton.

p. 13: Ivory Chest from Palencia Cathedral, from the Aben Zeyan de Cuenca Workshops, 1049-50, Museo Arqueologico Nacional, Madrid, Spain/INDEX/Bridgeman Art Library.

p. 14: "SH" chest with drawers; Hadley, Hatfield, or Deerfield, Mass.; c.1710; Pocumtuck Valley Memorial Association, Memorial Hall Museum, Deerfield, Mass.

p. 18: (top) Photo by Jefferson Kolle, courtesy *Fine Woodworking* magazine, © The Taunton Press, Inc.; (bottom) Photo by Michael Pekovich, courtesy *Fine Woodworking* magazine, © The Taunton Press, Inc.

p. 21 (bottom): Photo by Jonathan Binzen, courtesy *Fine Woodworking* magazine, © The Taunton Press, Inc.

p. 22: Photo © Richard Bienkowski, courtesy the Newell Gallery.

p. 24: Photo courtesy U.S. Senate Collection.

p. 25: Photo © Richard Bienkowski, courtesy the Newell Gallery.

p. 28: Photo © The Daughters of the American Revolution Museum, Washington, D.C.; on loan from the Boston Tea Party Chapter.

p. 32: Photo © National Museum of American History/Smithsonian Institution (neg. #99-3087-11).

p. 33: Photo © Mark Avino/National Air & Space Museum/ Smithsonian Institution (neg. #97-15094).

p. 44: (top) Cassone with panels depicting The Continence of Scipio and allegories of Fortitude and Prudence, attributed to the workshop of Apollonio di Giovanni, c. 1460-65 (tempera on panel), Bonhams, London, UK/Bridgeman Art Library; (bottom) Photo by Jonathan Binzen, courtesy *Home Furniture* magazine, © The Taunton Press, Inc.

p. 45: Private collection; photo courtesy James and Nancy Antiques.

p. 46, p. 47 (top): Photos © The Daughters of the American Revolution Museum, Washington, D.C.; gift of Mrs. Carlos E. Pitkin.

p. 47 (bottom): Photo © Randy O'Rourke; photo taken at Plimoth Plantation, Plymouth, Mass.

pp. 50–51: Photos © Randy O'Rourke, courtesy Old Salem/MESDA.

p. 86: Photos © The Mark Twain House, Hartford, Conn.

p. 88: Photo by Jonathan Binzen, courtesy *Fine Woodworking* magazine, © The Taunton Press, Inc.

p. 89: Photo © The Metropolitan Museum of Art; gift of Ben Wiles Jr., 1983.

p. 112 (bottom), p. 113: Photos © Mystic Seaport, Mystic, Conn.

pp. 128–29: Photos © Bill Grant/Mystic Seaport, Mystic, Conn.

p. 130 (bottom): Photo by Kevin Shea, courtesy Eljer Hjorth-Westh.

pp. 135–36: Archives Louis Vuitton.

p. 137: (top) Photo © Richard Bienkowski, courtesy the Newell Gallery; (bottom) Archives Louis Vuitton.

pp. 144–45: Photo © Randy O'Rourke, courtesy National Museum of American History/Smithsonian Institution.

p. 146: Photo by Michael Pekovich, courtesy *Fine Woodworking* magazine, © The Taunton Press, Inc.

p. 147: Photo © National Museum of American History/ Smithsonian Institution (neg. #73-10283).

p. 157: Photos © Richard Bienkowski, courtesy the Newell Gallery.

p. 158: Photo © National Museum of American History/ Smithsonian Institution (neg. #99-4030).

p. 159: Photo © National Museum of American History/ Smithsonian Institution (neg. #99-3088-5).

pp. 160–63: Photo © Randy O'Rourke, courtesy West Point Museum Collections, United States Military Academy.

p. 166: (top) Photo © National Museum of American History/ Smithsonian Institution (neg. #99-3088-4); (bottom) Photo © Culver Pictures.

p. 167: Photo © National Museum of American History/ Smithsonian Institution (neg. #99-3088-7).

p. 168: Photo © National Museum of American History/ Smithsonian Institution (neg. #99-3087-1).

p. 169: Photo © Randy O'Rourke, courtesy West Point Museum Collections, United States Military Academy.

p. 170: Photo © CORBIS/Bob Krist.

pp. 174–75: Photos by Zack Gaulkin, courtesy of *Home Furniture* magazine, © The Taunton Press, Inc.

p. 177, p. 187 (bottom): Photo courtesy Alison Kirkley and Rick Carswell.

p. 178: Photos © Randy O'Rourke, courtesy National Museum of American History/Smithsonian Institution.

p. 180: (top left) Photo © Randy O'Rourke, courtesy Collection of the Mercer Museum of the Bucks County Historical Society; (top right and bottom) Photos © Randy O'Rourke, courtesy National Museum of American History/Smithsonian Institution.